This book is due for return on or before the last date shown below.

Paul Klee

JEAN-LOUIS FERRIER

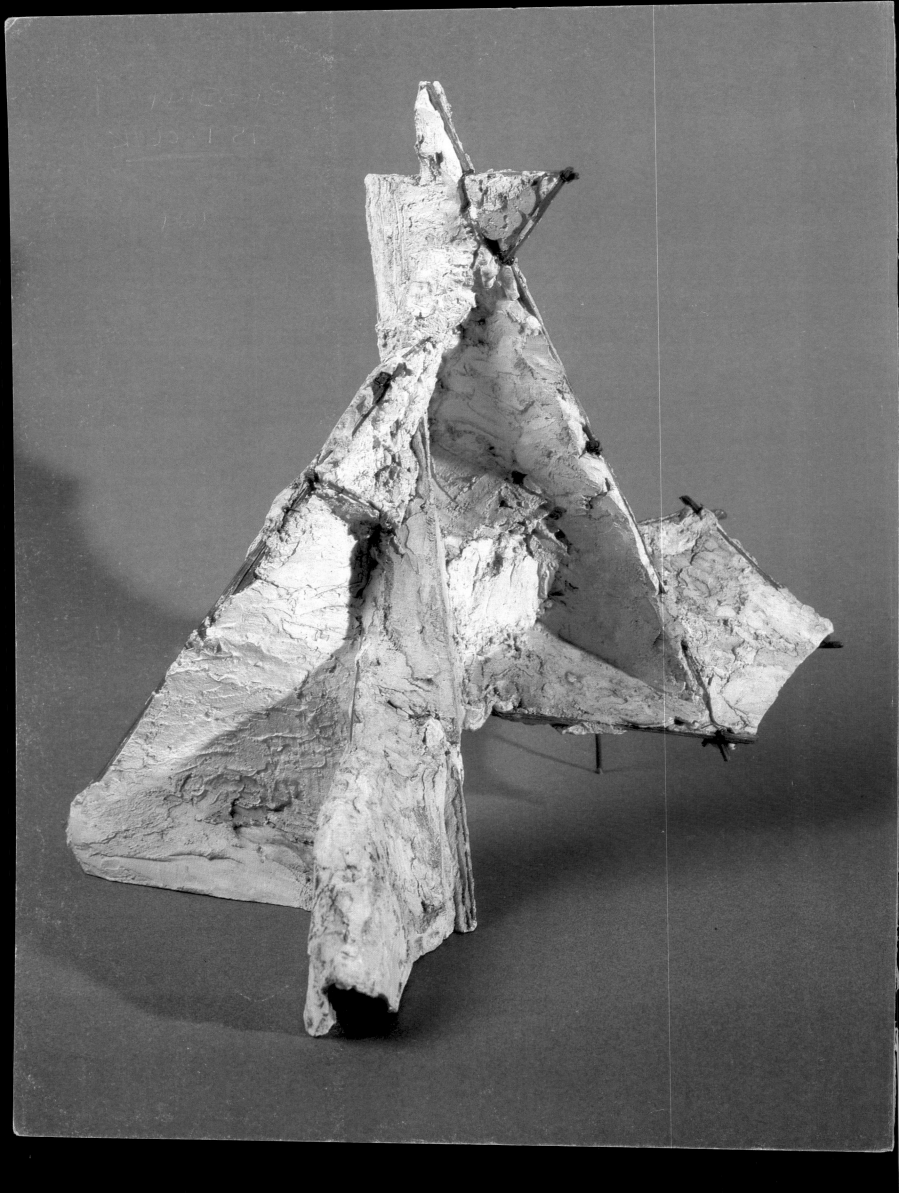

Paul Klee

Jean-Louis Ferrier

| Cover Illustration
ORIENTAL SWEETNESS
Detail, 1938, 120 *(H 20)*
Oil on paper and burlap,
50 × 66 cm (19.6 × 25.9 in.).
Paul-Klee-Stiftung, Kunstmuseum, Bern.

| Page 2
FREE COMPOSITION
1920-1921, plaster,
40 × 40 × 29 cm
(15.7 × 15.7 × 11.4 in.).
Paul-Klee-Stiftung,
Kunstmuseum, Bern.

*The numbers and letters in italics in the captions
are taken from the catalogue drawn up by Klee.
Up to 1925, the works were simply numbered
within each year's production;
after that date, Klee gave them a coded
reference made up of letters and numbers.*

English Translation: Malcolm Imrie
Editorial Director: Jean-Claude Dubost
Editorial Assistants: Hélène Roquejoffre and Christine Mormina
Editorial Aide: Chris Miller and Béatrice Weité
Cover Design: Laurent Gudin
Iconography: Frédéric Mazuy
Typesetting and Filmsetting: DV Arts Graphiques, Chartres
Photoengraving: Litho Service T. Zamboni, Verona

© FINEST SA/PIERRE TERRAIL EDITIONS, PARIS 1998
The Art Book Subsidiary of BAYARD PRESSE SA
English edition: © 1999
Publisher's n°: 249
ISBN 2-87939-201-2
Printed in Italy

ANATOMY OF APHRODITE
1915, *48*, two watercolours
on paper on chalk-coated
ground, mounted on cardboard,
23.3 × 19.4 cm (9.17 × 7.6 in.)
Private Collection, Switzerland.

Page 6 |
HAMMAMET WITH MOSQUE
1914, *199*, watercolour
on paper, mounted on cardboard,
20.5 × 19.2 cm (8.1 × 7.5 in.)
Metropolitan Museum of Art,
Berggruen Klee Collection, New York.

Klee

1915. 48.

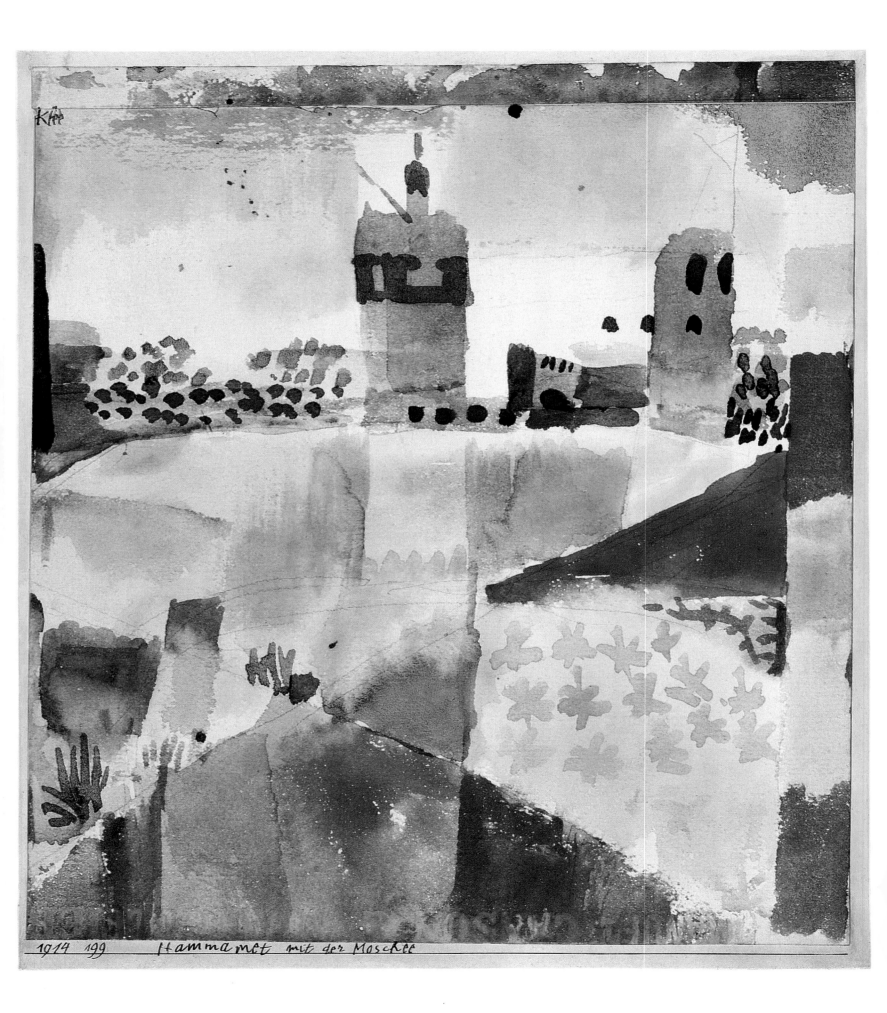

Klee

1914 199 Hammamet mit der Moschee

Contents

Introduction

Klee regarded Picasso as the greatest modern artist, and the sentiment was reciprocated. Knowing Klee to be very ill, Picasso came to Bern in November 1937 to study Klee's work, and the arrow protruding from the shoe of the wounded horse in *Guernica* is probably a homage to Klee, who made frequent use of arrows in his work. That same year Braque too went to Bern and spent several hours in discussion with Klee, examining his sketches. Outside Hitler's Germany, where a ponderously academic official art had dominated the scene for several years, Klee was highly esteemed by his peers; the visits of Picasso and Braque, though intended as an expression of sympathy for the ordeal he was facing, merely confirmed a widely held view.

The public and the critics, on the other hand, were much more reticent. In France, Klee was long regarded as a 'miniaturist', an unflattering description, and even as a *petit maître*, because his paintings are generally small. He was also criticized for being more a poet than a painter, on account of the fact that his 8,926 oils, watercolours, etchings and drawings are accompanied by bizarre phrases which supplement – or subvert – their meaning. Another misunderstanding affected his reception: when the Georges-Pompidou Centre finally devoted a large-scale exhibition to his work, in 1985, they did so under the title 'Paul Klee and Music' because, like Ingres, Klee played the violin. This seriously downplayed the significance of his achievement. In the United States, the artist had a small group of admirers well before the outbreak of the Second World War. But the eminent critic Clement Greenberg deprecated the attraction exercised over his compatriots by Klee's mysticism, which he found rather rudimentary, and felt that he encouraged them to dream dangerous dreams.

Today no one contests Klee's position among the great founding figures of 20th-century painting. His work is constantly varied, rich and inventive. The force and mystery of his art transpire from even the tiniest of his watercolours or the most rapidly executed drawing. He was also an important theorist whose writings reveal a precise understanding of his endeavours. A poet he surely was, and a musician too – he was a knowledgeable music-lover – but his originality lies above all in his scrupulous quest for reality, which was, in his eyes, the supreme enigma. The aim of this book will be to chart a course through 150 representative works from among the 8,926 the artist created, to examine those works in detail and pay tribute to their strange beauty.

1. From Music to Painting

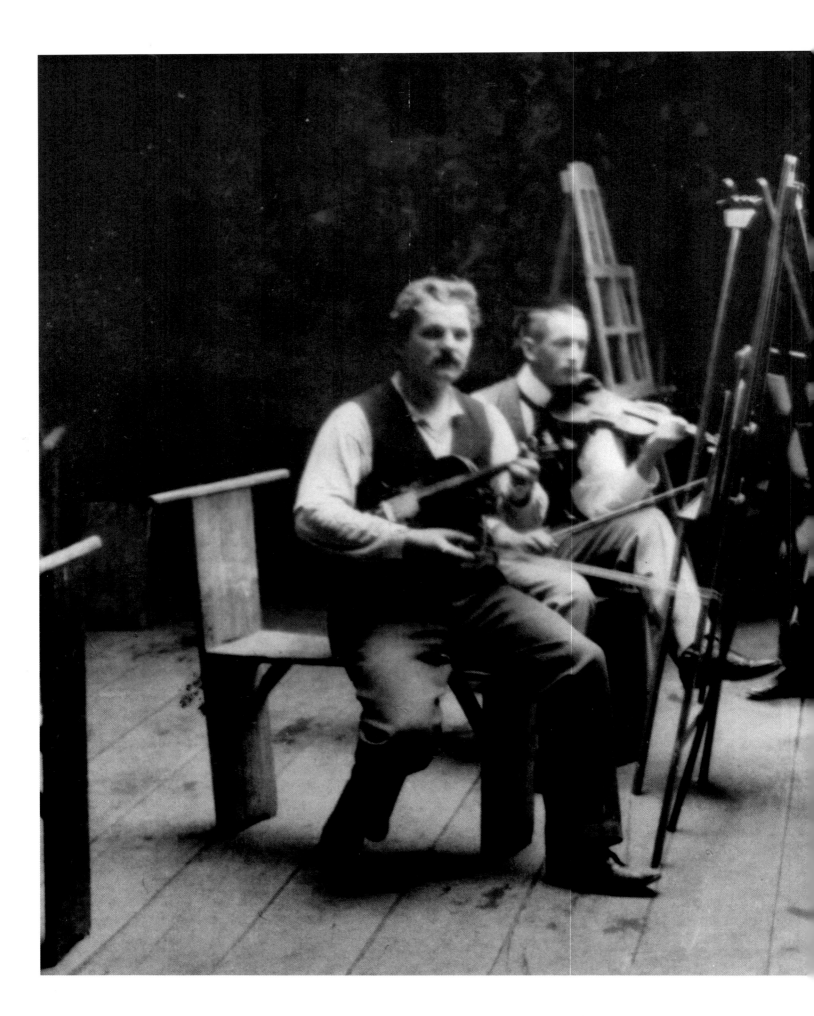

**PAUL KLEE (FIRST FROM RIGHT)
AND THE SCHUBERT QUINTET
OF THE KNIRR SCHOOL.**

Munich, 1900.

Paul-Klee-Stiftung, Felix Klee Photographic
Archives, Kunstmuseum, Bern.

**GARDEN IN SAINT-GERMAIN,
THE EUROPEAN COLONY NEAR TUNIS**
1914, *213*, watercolour on paper,
mounted on board,
21.6 × 27.3 cm (8.5 × 10.7 in.).
The Metropolitan Museum of Art,
Berggruen Klee Collection, New York.

Paul Klee came from a musical family. His father, Hans, taught singing at the Bern-Hofwyl teacher training college. His mother, Ida Maria, had received a musical education in Stuttgart and would have been happy for her son to devote his life to music; she encouraged him to study the violin from the age of seven. A great-grandfather on his father's side had been an organist in Thuringia, and his father too was been born in the native region of Johann-Sebastian Bach. Lily Stumpf, whom Klee married in 1906, was a pianist. Klee himself never began painting without playing the violin for an hour, and only gave up this habit during his last two years when he was seriously weakened by the scleroderma affecting his whole body. "Music, for me, is a love bewitched", he writes in his *Diaries*.[1] Though Euterpe had bestowed her favours on him, he did not contemplate a musical career; he was an able violinist, but he knew he lacked the talent for a career as a virtuoso.

Because Klee happened, during his youth, to be second violinist in the City of Bern Orchestra, some have jumped to the conclusion that he was an accomplished musician. But this was a very mediocre ensemble; it had only four professional members and its field of artistic activity barely extended beyond Berthoud, a large market town outside Bern, and Neuchâtel, which lay some forty kilometres away. In those towns the orchestra gave subscription concerts that are now best forgotten. Klee had no illusions about this. He writes ironically about the frequently out-of-tune harp, and of Fräulein Sommerhalder, a singer brought in from Basel to bolster up the performance; she "narrated Christ's sorrows with

1 *The Diaries of Paul Klee 1898-1918*, edited, with an introduction by Felix Klee, University of California Press, Berkeley/Los Angeles/London, 1964, p. 26.

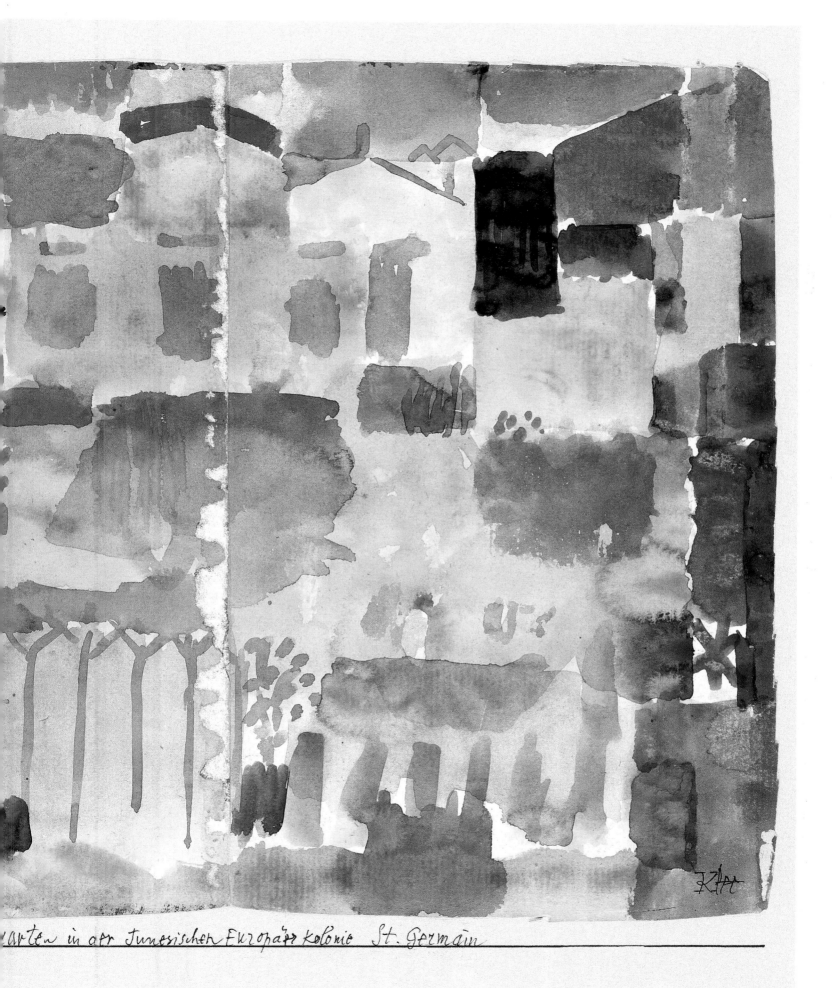

arten in der Tunesischen Europäer Kolonie St. Germain

BATTLEFIELD

1913, *2*, gouache on paper,
11.6 × 28.8 cm (4.6 × 11.3 in.).

Beyeler Gallery, Basel.

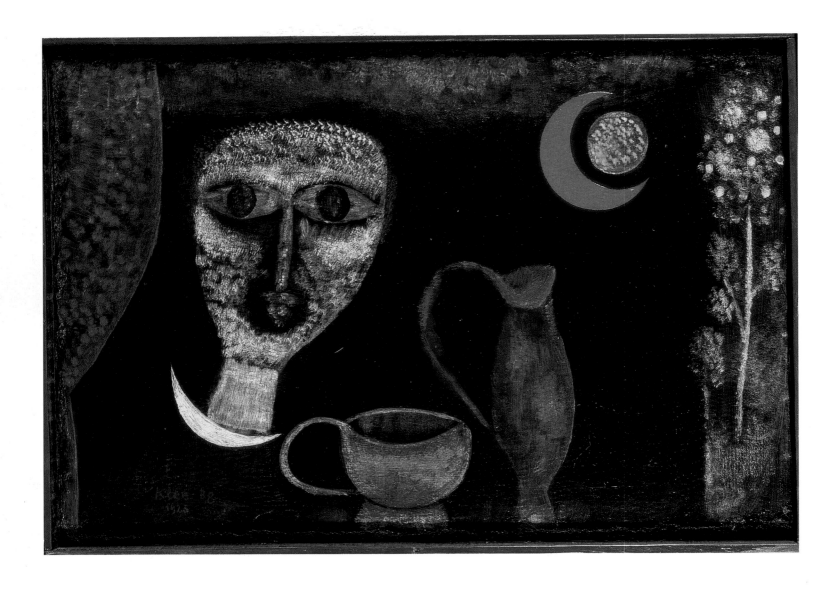

CERAMIC MYSTIC

1925, *118*, oil on a black ground
on board,
31.3 × 46 cm (12.3 × 18.1 in.).
Location unknown.

pious commiseration, and so much for her own private benefit that the thread snapped and she was suddenly lost". A certain Sistermanns is described as "a virtuoso, and a drunk!"[1] And then there was the amusing episode with the cellist Pablo Casals, "one of the most marvellous musicians who ever lived!" whom some extraordinary stroke of fate threw in with this hapless crew one evening in January 1905. He left them in high dudgeon, exclaiming in French, "*Ah, c'est terrible de jouer avec cet orchestre!*"[2]

Though not sufficiently gifted for a musical career, Klee was a passionate and knowledgeable music-lover. Throughout his life, music held an irresistible attraction for him. During his adolescence in Bern and his travels in Italy, and while living in Paris,

1 *Ibid.*, p. 132.
2 *Ibid.*, p. 167.

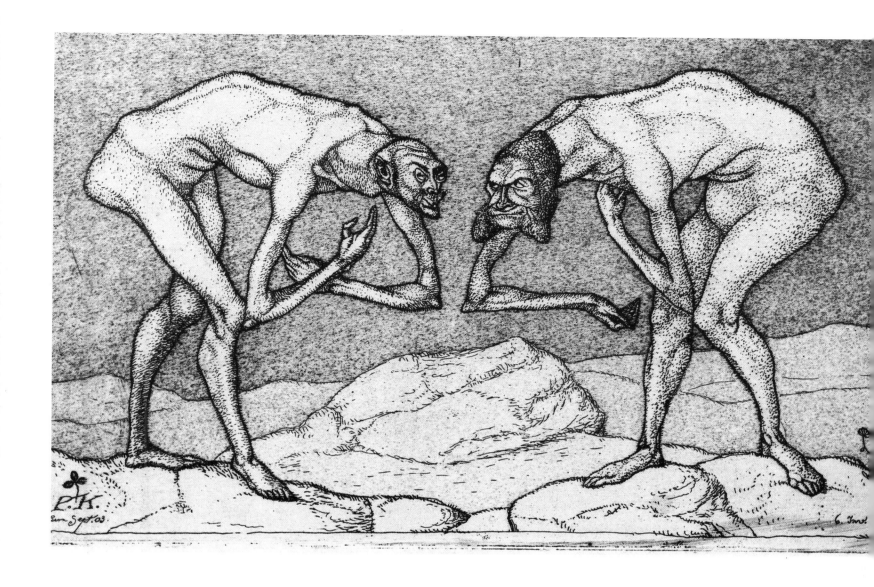

**TWO MEN MEET,
EACH PRESUMING THE OTHER
TO BE OF HIGHER RANK**
1903, 5, etching,
11.7 × 22.4 cm (5 × 9.6 in.).
Paul-Klee-Stiftung, Kunstmuseum, Bern.

Munich (where he studied painting and subsequently settled), Weimar, Dessau and Düsseldorf, he rarely missed a chance to attend a concert or an opera. In many pages of his *Diaries* and letters, and in the musical criticism he wrote for various publications, he conveys his impressions of what he saw and heard. One of his hobby-horses was the final sextet of Mozart's *Don Giovanni*. In Klee's day, it was generally omitted, so that the opera ended with the hero plunging into the flames of hell. Klee called for it to be reinstated on the grounds that it would restore balance to a finale in which the diabolical harmonizes significantly with the celestial.

Rhythmic pictures

Many painters, from Seurat to Kandinsky and Raoul Dufy, have had affinities with music. In his memoirs, *Rückblicke*, Kandinsky tells how, alongside Monet's *Haystacks*, which he saw at an

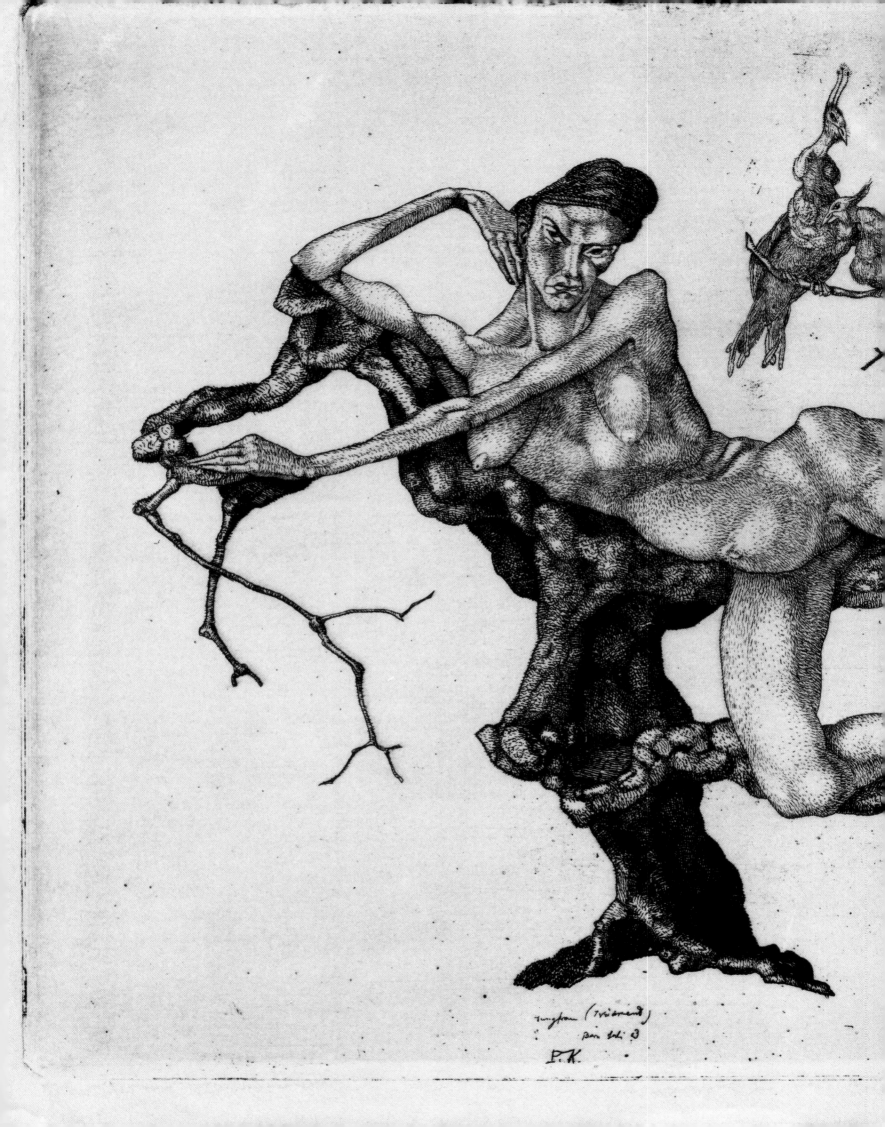

VIRGIN IN A TREE
1903, 2, etching,
23.6 × 29.8 cm (9.3 × 11.7 in.).
Paul-Klee-Stiftung, Kunstmuseum, Bern.

exhibition, it was an 1895 performance of Wagner's *Lohengrin* at the Court Theatre in Moscow that decided his future. "The violins, the deep bass notes and, most especially, the wind instruments," he writes, "then personified the whole force of the twilight hour. I saw all my colours in my mind, they were all before my eyes. Wild lines sprang up before me." Dufy, too, was an enthusiastic music-lover who, during his student years, even went without food so as not to miss the matinée performances of the concerts Colonne. In more mature years he noted on the back of a watercolour study for his famous *Orchestras* series the relation between forms, colours and instruments. These included Veronese green to highlight the detached timbre of the flute, brown with a light blue or red tint for the oboe and the clarinet, horizontal wavy lines for the violins, vertical wavy lines for the cellos, and wavy lines radiating out like stars for the trumpets and trombones. When looking at one of the paintings in the series, his friend Casals, the same Casals who thirty years before had plumbed the musical depths in Bern, exclaimed: "I can't say what piece your orchestra is playing, but I know what key it's in." Kandinsky also observes, "It became very clear to me that art is in general much more powerful than I had thought at first, and, moreover, that painting could exploit the same forces as music." Klee expresses the same idea in reverse when he holds up Mozart not merely as a composer of genius but as the greatest artist of all time. All this is consonant with Baudelaire's theory of a correspondence between the arts, a theory that enjoyed widespread currency in the latter half of the 19th century.

A small number of Klee's drawings represent musicians as such: pianists, singers, harpists, kettle-drummers, and so on. More often, Klee goes straight to the essential, conceiving the relationship of painting to music in structural terms, whatever the subject of the picture. Thus we may speak of tone, harmony, rhythm, sonority, and linear polyphony. In the polyphony of planes, Klee makes the tonal and the colour planes resound by placing one transparent layer upon another in such a way that the colour planes continue to resonate beneath the overlaid ones. It is possible to create rhythm by the use of lines. To communicate this, Klee made drawings depicting the strokes of a conductor's baton. Some of his paintings are in major modes, some in minor; others suggest fugues. Klee saw the composition of his works, too, in musical

AGED PHOENIX
1905, 36, etching,
25.7 × 16 cm (10.1 × 6.2 in.).
Paul-Klee-Stiftung, Kunstmuseum, Bern.

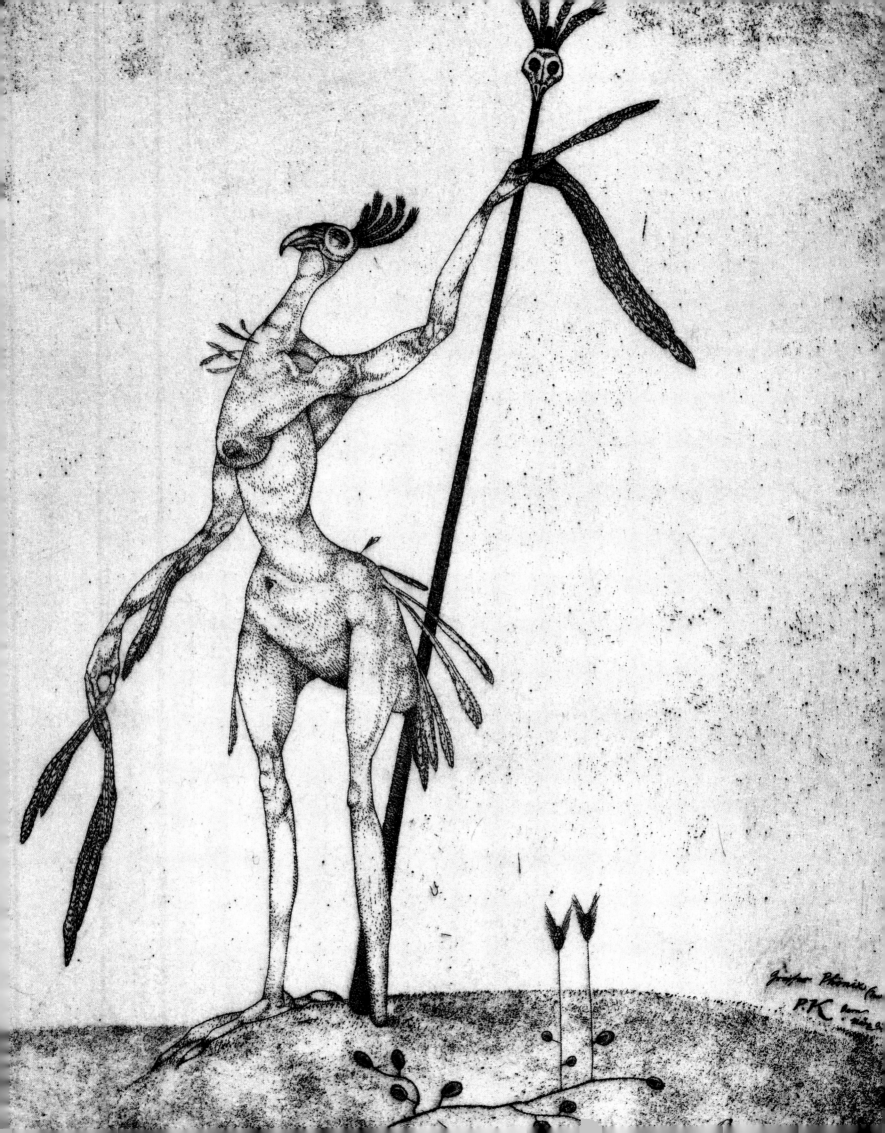

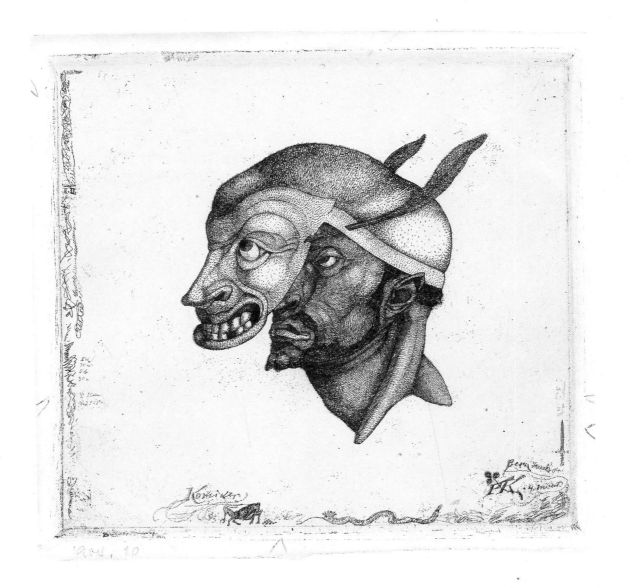

Comedian

1904, *10*, etching,
14.7 × 15.3 cm (5.8 × 6 in.).
Paul-Klee-Stiftung, Kunstmuseum, Bern.

terms, defining it as the juxtaposition and development of themes, their reprise and their dissolution. The artist achieved his aims by diversification of techniques (for example, the re-use of dried paint), by the use of a wide range of different supports and primers, and the superposition of media. His studio contained so many phials of mysterious essences and oils that his friends likened it to a chemist's shop.

This is the opposite of the approach taken by Seurat. It was the aim of that painter's neo-impressionism to make painting a discipline as precise as music. Basing himself on the law of simultaneous contrasts, which states that complementary colours – red and green, yellow and violet, blue and orange – enhance one another, he compared the coloured dots of which his works were made to so many notes reacting one to another according to stable rules. In this way, he arrived at a calculated style of painting: the way he

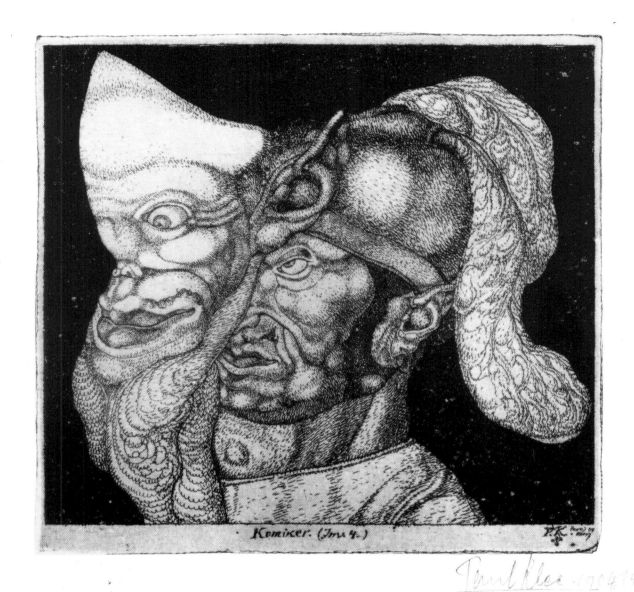

Komiker. (Inv 4.)

COMEDIAN, SECOND VERSION
1904, *14*, etching,
15.5 × 17 cm (6.1 × 6.7 in.).
Paul-Klee-Stiftung, Kunstmuseum, Bern.

executed the final version of *A Sunday Afternoon on the Island of la Grande-Jatte* in 1886 demonstrates this. Having decreed each brush stroke and each colour in advance, he saw no difficulty in working late into the night, perched on a ladder to reach the top of his immense canvas. The gas lighting distorted the colours, but this was no obstacle, for everything had already taken shape in his mind before he picked up his brush, and his hand was guided by intellect alone. Of the few critics who praised his painting, he remarked: "They see poetry in what I do. No, I apply my method, that's all." Though some of Klee's paintings are close in style to neo-impressionism, as we shall see in the next chapter, neither his technique nor his inspiration bears out this resemblance. Seurat was the product of a 19th-century France dominated by positivism and scientism. He thought science could free us from all uncertainties, and that it was insulting both to art and to science

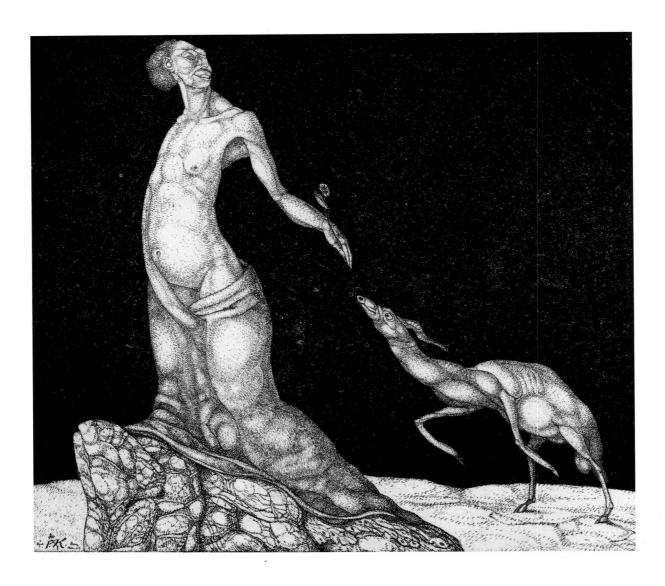

WOMAN AND BEAST
1904, 13, etching,
19.7 × 22.5 cm
(7.7 × 8.8 in.).
Paul-Klee-Stiftung,
Kunstmuseum, Bern.

THREATENING HEAD
1905, 37, etching,
19.5 × 14.3 cm
(7.7 × 5.6 in.).
Paul-Klee-Stiftung,
Kunstmuseum, Bern.

to see the two as mutually exclusive. Klee did not turn his back on scientific knowledge: his writings testify to his keen interest in the natural sciences, biology and mathematics. Attempts to explain his painting by the influence of music alone are therefore futile. But he was a child of Goethe, with all the poetic, scientific and metaphysical dualities that heritage implies. And, like Goethe, he ascribed to music, more than to any other art, the aspiration to impose order on the material of the universe. Nevertheless, in the fifteen etchings (1903-1905) usually taken as defining the start of his career, music is curiously absent. Klee comments on some of these in his *Diaries*, apparently feeling the need, after several years of trial and error, to explain to himself what he had achieved. One of these etchings is *Woman and Beast*, in which a skinny, *lop-sided Venus de Milo* clutches with one hand at a drapery, which fails to conceal her sex, and with the other holds out a

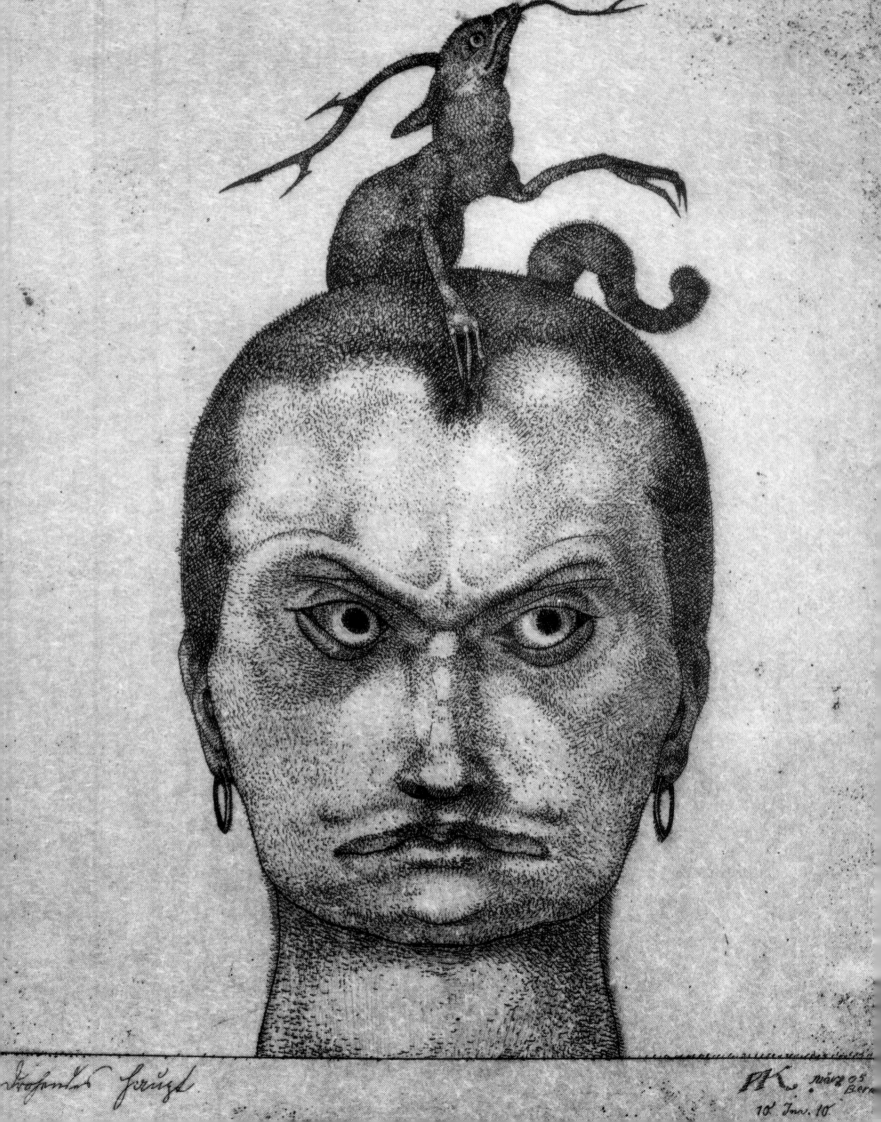

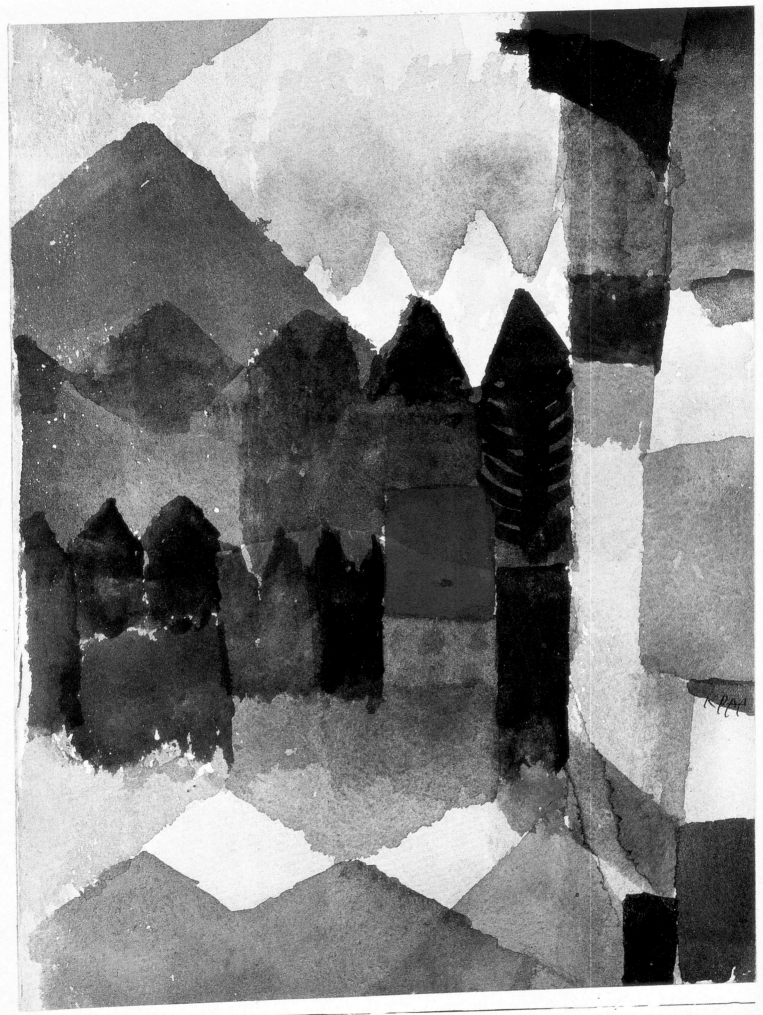

1915 102

flower to a greyhound. Klee writes about it: "The beast in man pursues the woman, who seems not entirely insensible to it. Affinities of the lady with the bestial. Unveiling a bit the feminine psyche."[1] Of *Perseus* (also known as *Wit Has Triumphed Over Misfortune*), which shows two heads, one full face, one in profile, Klee says that "the action is reflected by the physiognomy of the man whose face functions as a mirror of the scene. The underlying marks of pain become mixed with laughter, which finally retains the upper hand. Viewed from one angle, unmixed suffering is carried *ad absurdum* in the Gorgon's head added on the side. The expression is stupid, rather, the head robbed of its nobility and of its crown of snakes except for some ridiculous vestiges."[2] By contrast, he is very happy with the two versions of the *Comedian*, inspired by Aristophanes. Here, he writes, "the mask represents art, and behind it hides man".[3]

The most striking of these etchings, *Virgin in a Tree*, receives little comment from Klee: "First I etched and engraved the contours of the tree. Then, the modelling of the tree and the contours of the bodies, then the modelling of the bodies and of the pair of birds."[4] The woman, apparently sterile and ageless, lying in the branches of a withered tree, might have distant origins in a comment Klee heard his father make when he was six years old: the elder Klee referred to a spinster as a "dry girl".[5] Insofar as her limbs mingle with the branches of the tree, the maiden evokes the Daphne myth, but here the metamorphosis here seems wintry and lethal. The work seems to me to contain a crucial reference to the Italian symbolist painter Giovanni Segantini. This is nowhere mentioned by the commentators, who have related the etching to Pisanello's *Allegory of Luxury*. Segantini lived alone in an isolated chalet above Saint-Moritz some 1,800 metres above sea-level, and enjoyed great notoriety in this period. He painted a great many pictures representing spindly trees in snowy, mountainous landscapes. And one of these, *Unnatural Mothers*, includes a woman caught in the torturing branches of a tree.

Of *The Hero with the Wing*, an aged wretch with an enormous goitre, whose wooden leg is taking root, Klee writes: "The man,

Föhn Wind: in Franz Marc's Garden
1915, *102*, watercolour on paper mounted on board,
20 × 15 cm (7.9 × 5.9 in.).
Lenbachhaus Gallery, Munich.

1 *Ibid.*, p. 143.
2 *Ibid.*, pp. 160-161.
3 *Ibid.*, p. 173.
4 *Ibid.*, p. 143.
5 *Ibid.*, p. 5.

RELATIONS BETWEEN MUSIC AND PAINTING. RHYTHMIC EXERCISE.

Taken from *Beiträge zur bildnerischen Formlehre* (*Contributions to a Theory of Pictorial Form*).
16 January 1922,
fig. 2, p. 49, lesson 4.
Paul-Klee-Stiftung,
Kunstmuseum, Bern.

born with only one wing, in contrast with divine creatures, makes incessant efforts to fly. In doing so, he breaks his arms and legs, but persists under the banner of his idea. The contrast between his statue-like, solemn attitude and his already ruined state needed especially to be captured, as an emblem of the tragicomic."[1] It is, however, also possible to see this as an unusual interpretation of the myth of Icarus, an Icarus who has fallen to earth rather than being engulfed by the waves and who has consequently been saved, though his condition is pitiable. And insofar as the famous myth is a warning against the megalomania of those who believe they can use technology to transgress the laws of nature, it seems entirely consonant with the artist's deepest concerns.

1 *Ibid.*, p. 162.

These first etchings are pessimistic, decadent, "unhinged", to use Klee's own expression. They are closer to the apocalyptic William Blake and the Goya of *Los Desastres de la Guerra* than to symbolism. But this is more a question of encounters than influence. They have a literary quality which appealed to the surrealists in the twenties, by which time Klee had long since moved on to other things. The last of them, *The Threatening Head*, which he finds "gloomy enough",[1] and which might be seen as a self-portrait, encapsulates the spirit of this sombre series. But sarcasm and irony are never far away, as we see with *Two Men, Each Presuming the Other to be of Higher Rank*, in which the two protagonists engage in ridiculous bowing and scraping. It is, however, Klee's long commentary on *The Aged Phoenix*, with its notions of a mingling

RELATIONS BETWEEN MUSIC AND PAINTING. RHYTHMIC EXERCISE.
Taken from *Beiträge zur bildnerischen Formlehre* (*Contributions to a Theory of Pictorial Form*). 30 January 1922, fig. 3, p. 58, lesson 5. Paul-Klee-Stiftung, Kunstmuseum, Bern.

1 *Ibid.*, p. 169.

of the ages – the figure is really 500 years old – and of "a partheno-genesis [that] doesn't open any cheering perspectives", that more broadly sets the tone of his art. [1]

Klee was reasonably satisfied with these etchings, but soon came to see them as "historic" relative to his future work. He also gained an increasingly strong sense of the ties between his painting and music, while confessing that the relationship remained mysterious to him. Almost the whole of Klee's later work can, in fact, be described as 'musical', even if some of his paintings – which, like a Beethoven quartet or a Mozart concerto, resonate in the most intimate depths of our being – are more musical than others. They contrast with those, say, of Léger, who writes that his "is an age of slogans" and, intent on reaching the modern crowds in

1 *Ibid.*, p. 168.

A LEAF FROM THE BOOK OF CITIES
1928, *46 (N 6)*,
chalk preparation
on paper mounted on wood,
42.5 × 31.5 cm (16.7 × 12.4 in.).
Öffentliche Kunstsammlung, Basel.

PASTORALE (RHYTHMS)
1927, *20 (K10)*,
oil on canvas mounted on board,
original frame,
69 × 52 cm (27.1 × 20.4 in.).
The Museum of Modern Art, New York.

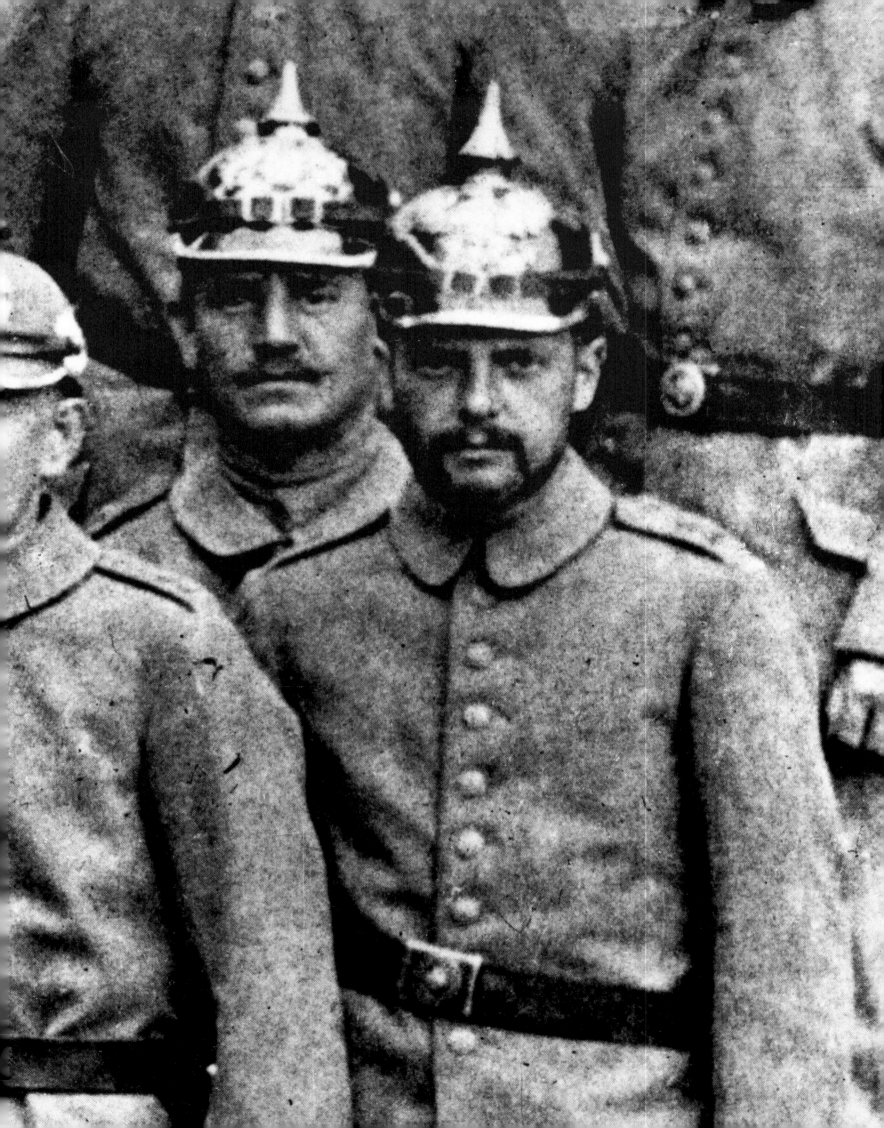

**PAUL KLEE WITH THE ARMY
(DETAIL), LANDSHUT, 1916**

Paul-Klee-Stiftung,
Felix Klee Photographic Archives,
Kunstmuseum, Bern.

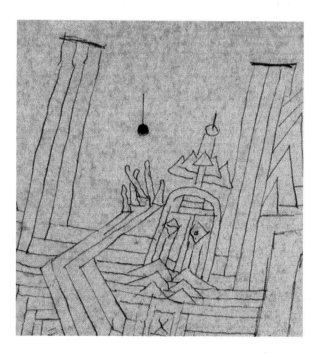

OLYMPUS IN RUIN
1926, 5, pen drawing
and watercolour
on paper mounted on board,
26.2 × 30 cm (10.3 × 11.8 in.).
Angela Rosengart Collection, Lucerne.

OLYMPUS IN RUIN
Detail of Zeus's
pointed helmet
on the summit of Olympus.

street, stadium and factory, hardens his pictorial language to the extreme in order to "speak out loud".

Most prominent among Klee's borrowings from music are the score and the fugue. The orchestral score is, of course, the graphic representation of several simultaneous instrumental, and, on occasion, vocal parts. Its function, achieved by placing the musical staves with their notation (and, in vocal works, the lines of text) one above the other, is to represent the music visually. Each stave can be intended for one or more players, or indeed several categories of players. It enables the conductor to direct the performance of the whole piece, and each musician to play his or her part. Working from the top to the bottom, it generally includes the woodwind parts, from the highest to the lowest – flutes, oboes, clarinets, bassoons – then the brass – from the trumpets to the tubas – then harp, piano, percussion and choirs, with the strings coming last – violins, cellos and basses.

Klee, as a player, knew many scores, and it is easy to see how the complexity of their lines might have inspired the texture of many of his works. But these are never literal transcriptions, even if parallel lines like those of staves often organize his compositions. In the course of creation, there is a transition from what enters the painter's ear to what enters the eye of the spectator to whom these paintings are directed. It is, therefore, quite legitimate to speak here of a performance/interpretation of these scores in the orchestral sense of the term, given that the artist's works are primarily forms of psychic seismography, translating the musical vibrations into their visual equivalents. Klee's method resembled that of the musician, who writes note by note, starts out from a motif and arrives at a theme, brings in a second motif, and so on. Ascending and descending rhythms, blazing or *diminuendo* tones, and harmonic phrases are clearly recognizable in his work. And one might even speak of sonatas, solos and chamber music.

A picture like *Pastorale (Rhythms)*, one of a group of paintings made in late 1926-early 1927, is an excellent example of this. By its title it evokes Beethoven's Sixth Symphony – or any other piece with rustic overtones – and, at the same time, refers to an agreeable landscape of meadows and groves. The topmost section of the picture is studded with stars and planets strung out beneath a blue sky, while the one below is planted with trees. Then come arches, combining with the greenery all around to make an architectural

THE SUN WHICH ALREADY FINDS THE WORLD OF COLOURS, COMPLICATED COMPOSITION
1916, *19*, watercolour and ink on paper, 19.8 × 12.8 cm (7.8 × 5 in.). Private collection.

1916 . 19.

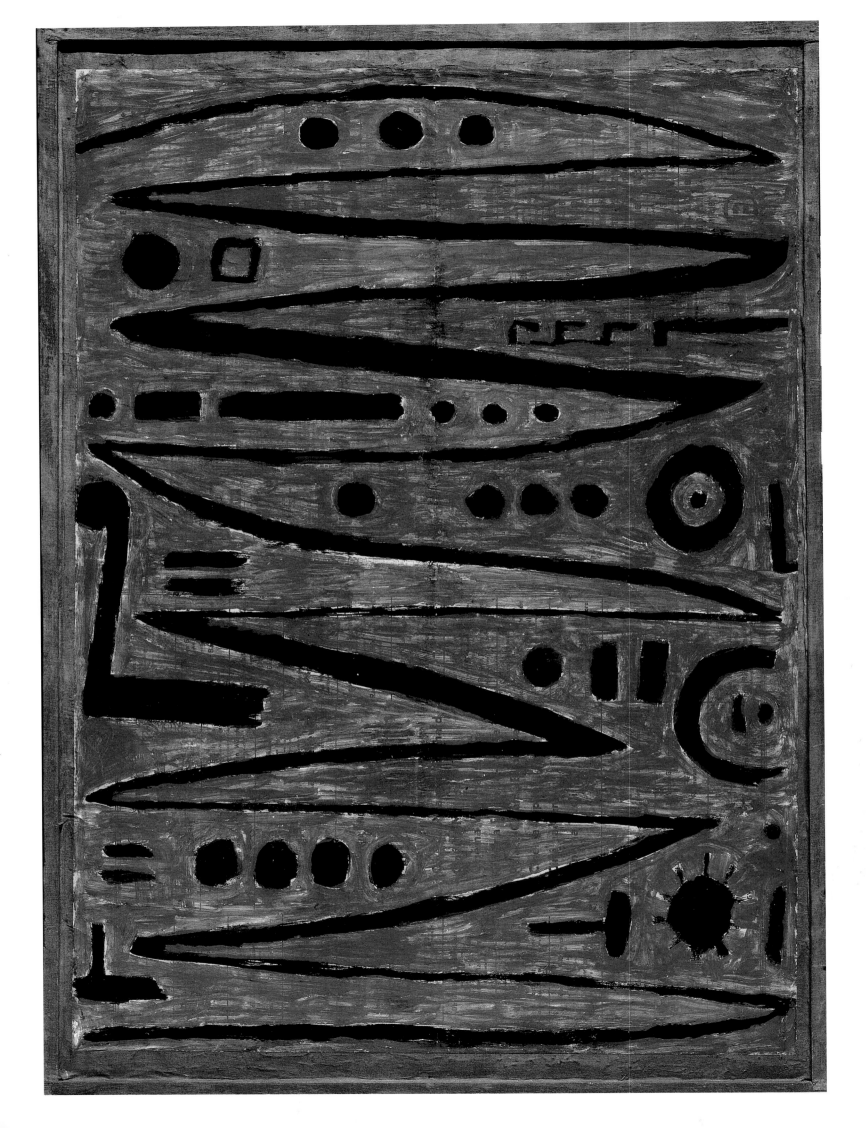

landscape. Then again trees, candelabra-like trees, with garden fences, made up of little circles and crosses, dividing up the space laterally. As we move down the picture, the arches become more numerous, the fences more tightly drawn, and other, less identifiable signs appear, such as broken lines and strings of small arches. The ground of the painting is light green, and the figurative elements, apparently traced in pencil on to the paint while it was still fresh, dark green. The painting's surface is rhythmic and the painting as a whole has its own sonority, as is often the case with Klee. Are we to conclude that Klee has moved from the woodwind to the brass and the strings, following the arrangement of an orchestral score? It is difficult to be categorical about this, but there must have been an aria floating around in his head as he was executing the painting, since for him an orchestral score was not just 'music paper', as it was for Braque or Picasso in their collages. In spite of the – almost obligatory – reference to Beethoven, this is not a soaring, symphonic work. One is put in mind, rather, of Vivaldi's *Four Seasons* or Jean-Jacques Rousseau's *Le devin du village*, now forgotten, but for many years a regular item in the repertoire. Appropriately, Rousseau spent blissful days on the Island of Saint-Pierre in the middle of the Lake of Bienne, not far from Bern, as he relates – in prose of unrivalled musicality – in the 'fifth walk' of his *Reveries of the Solitary Walker*.[1] A similar notation appears in *A Leaf from the Book of Cities*, one of the same series of paintings, in which the pictograms may suggest ramparts, rows of detached houses, and the flags and arcades of an urban environment. Overall, it is close to *Pastorale* in invention, but here the impression is of sentences made up of indecipherable words and letters from some ancient past, such as one might find in those registers of births, deaths and marriages that record our descent. The tones, dominated by greys and beiges, apparently mixed with white chalk, are opaque and hard. It is a book of stone beneath an extinct sun; we are put in touch here with all the human history that a town conceals within its immemorial buildings. Feeling greater affinity for the dead than the living, Klee was fascinated by past civilizations. And we might say in conclusion that, in this case, the echo of the orchestral instruments is that of the bassoon and the bass, so muted is the picture's resonance.

1 Jean-Jacques Rousseau: *Reveries of the Solitary Walker*, tr. P. France, Penguin, Harmondsworth, 1979, p. 81.

1921/69 Fuge in

CRYSTAL GRADATION
1921, 88, watercolour on paper,
mounted on board,
24.5 × 31.5 cm (9.6 × 12.4 in.).
Öffentliche Kunstsammlung, Basel.

Klee adopted a comparable system in *Heroic Fiddling* of 1938, a late work painted as a homage to his friend, the great violinist Adolf Busch, whose supple, energetic playing is brought to life for us in the picture. The black down-strokes of varying thickness that structure the composition reflect the artist's desire to give music a directly pictorial representation. Alongside the flying bow cleaving through space, other figurative elements appear, including the scroll and bridge of a violin. The dots reminiscent of notes are accompanied by a circle, a semicircle, a wheel and straight lines of various lengths, and suggest elements designed to create a rhythm. Three deeply resonant blues, a deep blue in the inner section and turquoise in the surround, have put some writers in mind of Bach's music and, more precisely, of a fugue.

There are a number of fugues in Klee's painting, such as the *Fugue in Red*, *Dream City*, or *The Growth of Nocturnal Plants*. The fugue is one of the most highly developed forms in Western music; we find it in the work of Bach, in particular, where it reaches its peak, in Mozart, Beethoven, Mendelssohn, and in many other composers from the second half of the 17th century onwards. An extremely rigorous contrapuntal form, it is divided into three main sections: the exposition of the main subject, the answer, and a section, known as the *stretto*, in which the two overlap. There is no need to go more deeply here into the details of its structure. To understand the role it played in Klee's painting, let us simply note that it involves one part of a work answering another in strict polyphony. We find this feature in *Fugue in Red*, where the four main thematic elements, among which a jug is recognisable, develop and respond to one another, both on the formal level and in terms of their colour, which runs from pink to yellow and violet. The analogy with the fugue is striking. The 'beat' or rhythm of the

1921 /88 Kristall - Stufung

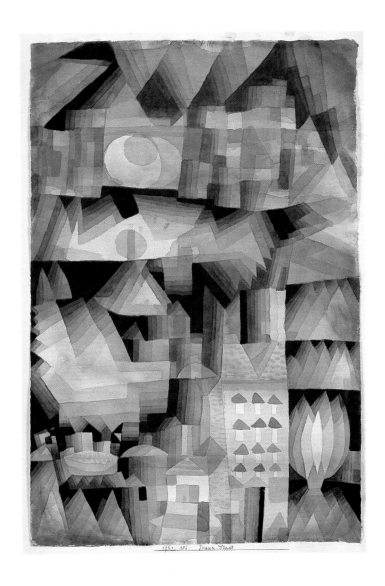

DREAM CITY

1921, *106*, watercolour
on paper mounted on board,
47.5 × 31 cm (18.7 × 12.2 in.).
Berggruen Collection,
Staatliche Museen, Berlin.

painting – indeed everything about it – seems ordered with metronomic precision.

The contrapuntal composition of *Dream City*, in which forms are clearly delineated and yet allowed to float beyond their own boundaries, similarly evokes the art of fugue. We see a juxtaposition of houses, trees, plants and abstract motifs which are echoed to the very edges of the painting. The green scale is dominant, various shades of green being overlaid on a primitive black ground which sustains the composition. This is a dream city, but also a glass city, so transparent is it to the mind's eye. And it is perhaps also an ideal city, like the one designed by Laurana during the Renaissance, but never built. The work breaks entirely with the descriptive canvases with which we are familiar from the Western tradition of painting, but it is not destructive; it opens up other worlds which do not exist or exist only in our imaginations. Similarly, *Growth of*

Nocturnal Plants plays on the use of 'false' pairings of colours, whose clashes contrast with the harmony of the complementary shades, and this, in combination with the flattening of the geometric figures, suggests a modal form.

Klee thought that music had reached its peak in the perfection of polyphony achieved by the late 18th-century composers, and this is the music by which most of his work is inspired. However, Will Grohmann, the foremost Klee scholar, has demonstrated that some of Klee's pictures, such *as Gradation of Colours from the Static to the Dynamic* (1923), are organized around a basic tone row; there are twelve tones, as prescribed by Schönberg's dodecaphonic system. In Klee's papers, Grohmann found a diagram for chequerboard composition, organized in terms of corresponding series of discontinuous, decreasing numbers. This is very similar to the pattern of Klee's famous magic squares. We must, however, be wary of overstating the comparison between painting and music. The rules of the two art forms are not the same and musical terminology can only provide relative descriptions of Klee's work.

The musical is undoubtedly one of the most intense aspects of Klee's painting. But to these musical sources we should add opera, which he adored, and indeed theatre. Klee read not only German authors, but Molière, Racine, Shakespeare and Aeschylus, all in the original. Some five hundred of his nine thousand works are devoted to characters or scenes from opera or drama.

A theatrical universe

The Singer L. as Fiordiligi, an oil and watercolour work on a chalk ground from 1923, depicting a celebrated soprano, whom Klee had often heard and who appears several times in his work, is particularly significant in this connection. Her torso, spiral breasts, head, hair and snail-shaped hat are those of an articulated doll with upraised arms. The colours are uniform as ceramics, as though meant to convey a sense of the singer's superior calm. The work seems to be an allusion to Fiordiligi's aria "Firm as a rock" in *Così fan tutte*, to which the painting's subtitle explicitly refers. Yet the unreal character of the acting and gesture is closer to what Goethe envisaged for operatic characters: he saw them as "neutral characters", almost puppets. The background carries no indication of props or the theatre: it consists, indeed, of a range of indistinct tones running from grey to pinkish grey and to an ochre which is brownish at the edges, so that everything is left in suspense.

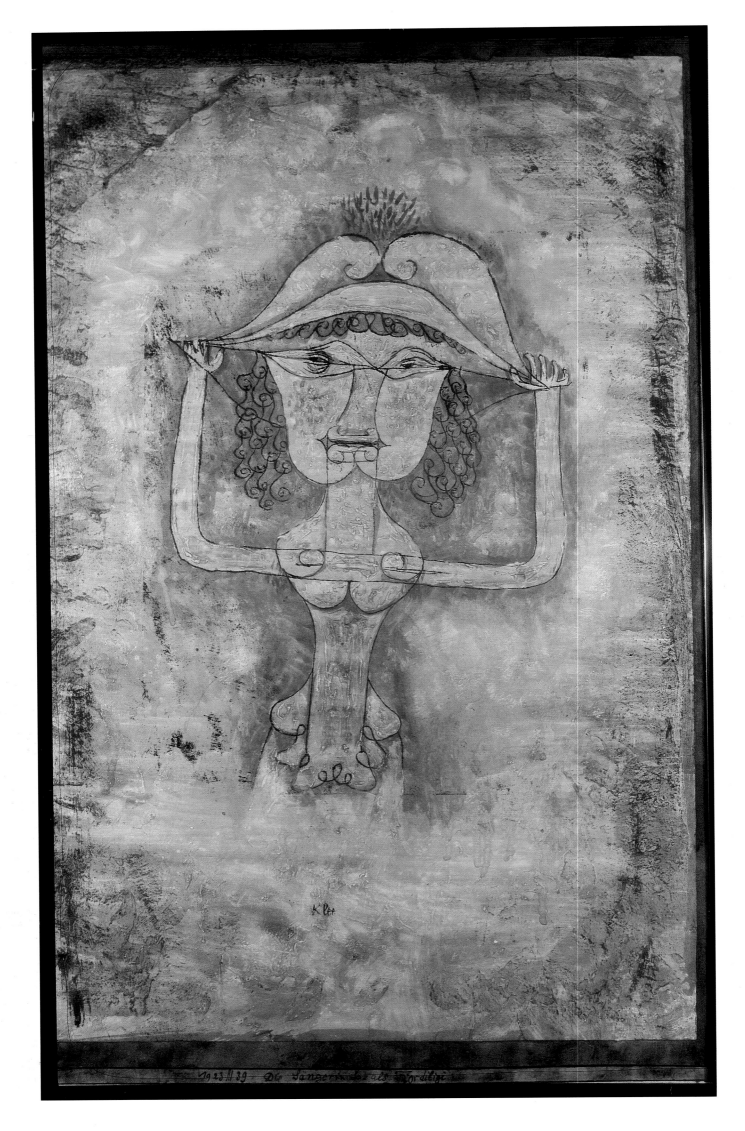

Grohmann is led to comment: "Fiordiligi… rises from this sphere like Aphrodite from the sea foam; she is here, she alone, and nothing else matters." [1]

A number of strange paintings, such as *Botanical Theatre* (1934) have their origins in theatre. In that work the artificial and natural worlds combine in a disturbing ambiguity; the plants that grow luxuriantly in the scenic space have the stiffness of actors acknowledging the audience's applause at the end of a performance. In spite of the marked Bauhaus taste for theatrical activity and the many plays staged at that institution by both staff and students, we do not know whether Klee ever designed costumes or painted sets. Far from turning his back on dramatic activity, however, he kept it for the family circle. In Munich in 1916 he built a little

1 Will Grohmann: *Paul Klee (The Library of Great Painters)*, tr. Norbert Gutermann, Harry N. Abrams Inc., New York, undated, p. 96.

**THE SINGER L.
AS FIORDILIGI**
1923, 39,
oil and watercolour
on chalk-coated ground,
50 × 33 cm (19.7 × 12.9 in.).
Private collection.

SELF-PORTRAIT
1922, plaster, ox bone,
9 × 5.5 × 6.5 cm
(3.5 × 2.2 × 2.5 in.).
Private collection, Switzerland.

Pages 46-47
ELECTRIC GHOST
1923, plaster, electrical plug,
9 × 6 × 5 cm (3.5 × 2.4 × 1.9 in.).
Private collection, Switzerland.

MADAM DEATH
1916, plaster,
8 × 5 × 5.5 cm (3.1 × 1.9 × 2.2 in.).
Private collection, Switzerland.

WHITE-HAIRED ESKIMO
1924, wood, horseshoe, plaster,
15 × 8 × 6 cm (5.9 × 3.1 × 2.4 in.).
Private collection, Switzerland.

MATCHBOX SPIRIT
1925, matchbox, feather,
20 × 10 × 8.5 cm (7.8 × 3.9 × 3.3 in.).
Private collection, Switzerland.

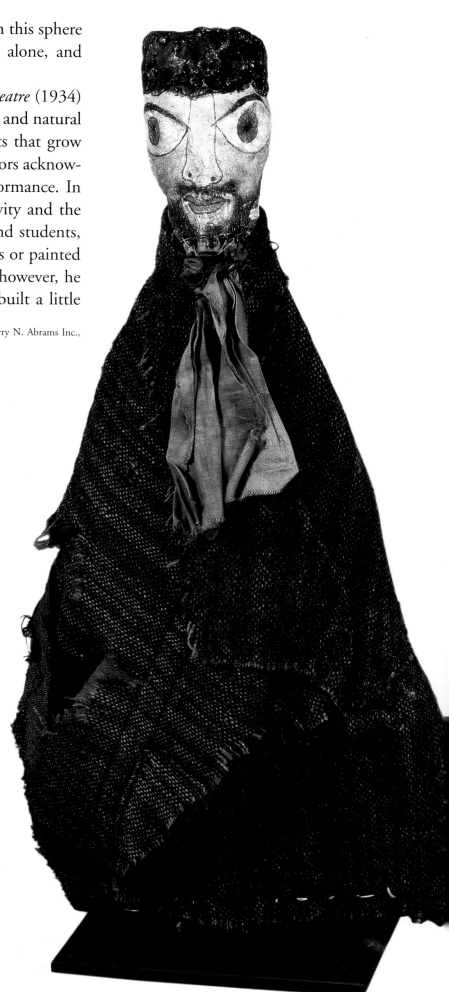

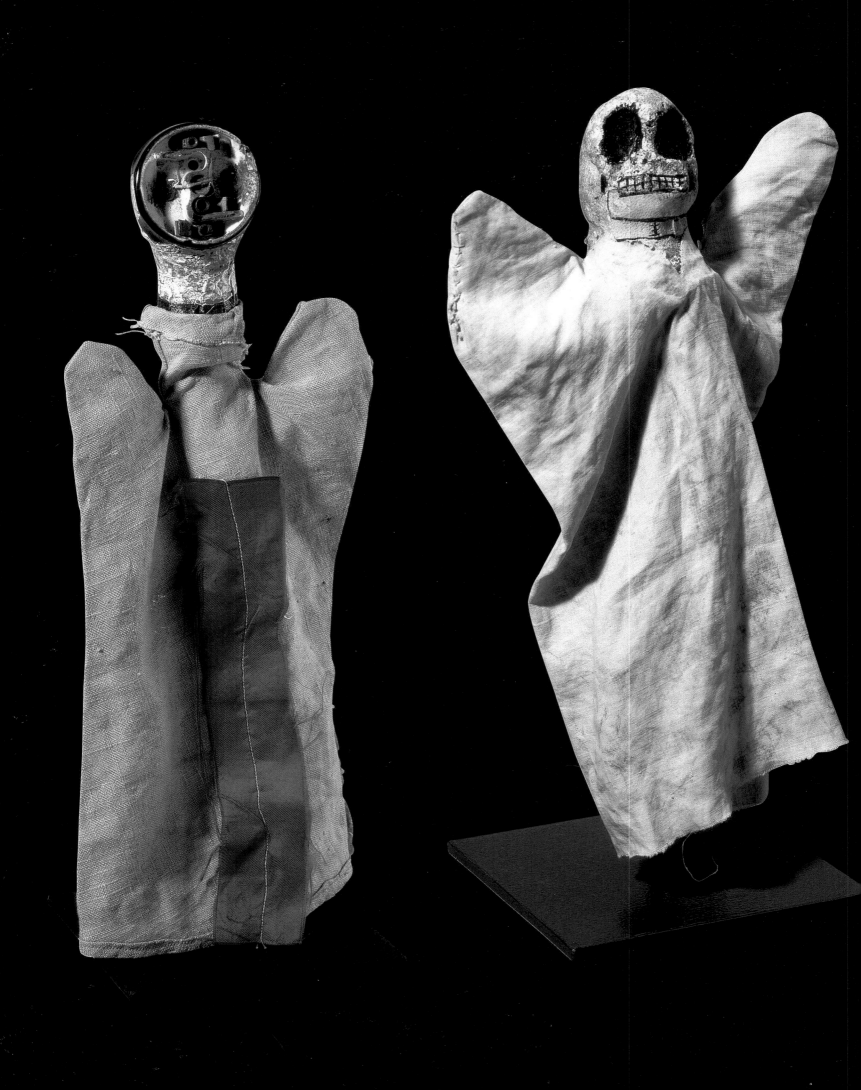

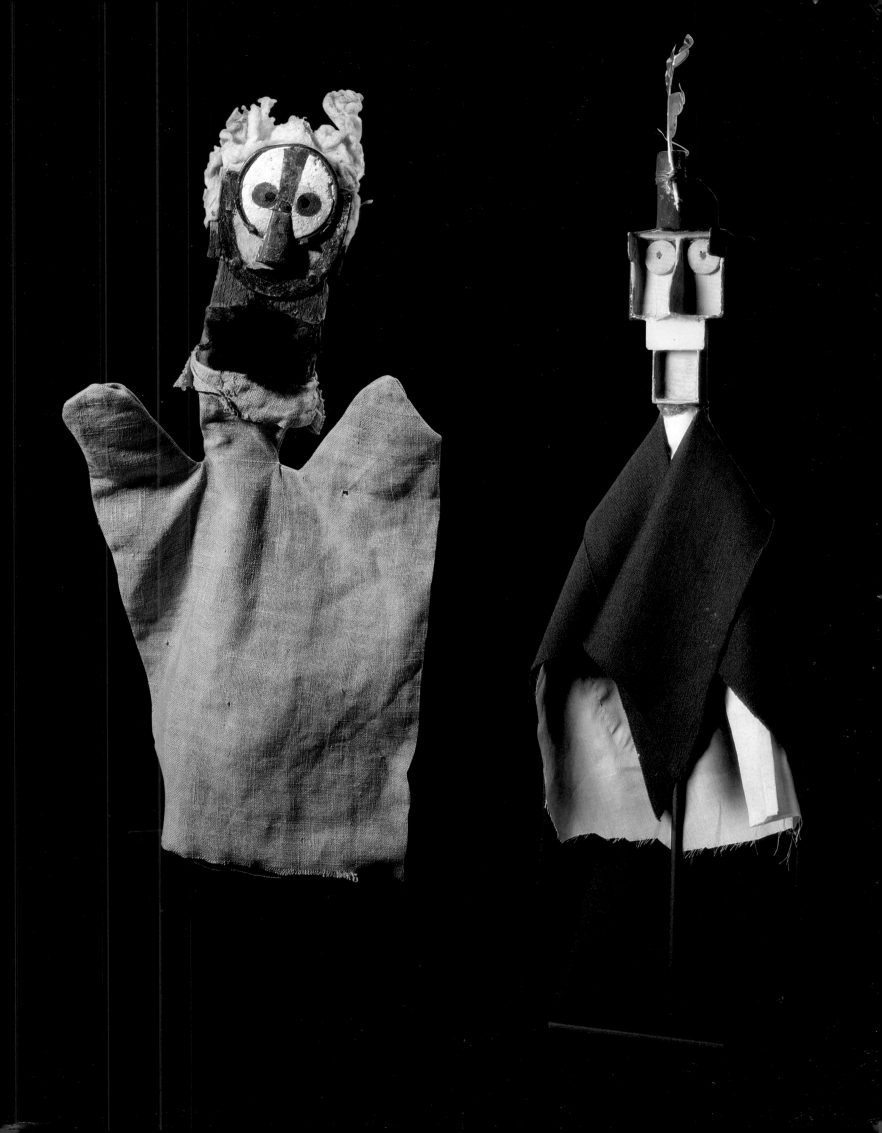

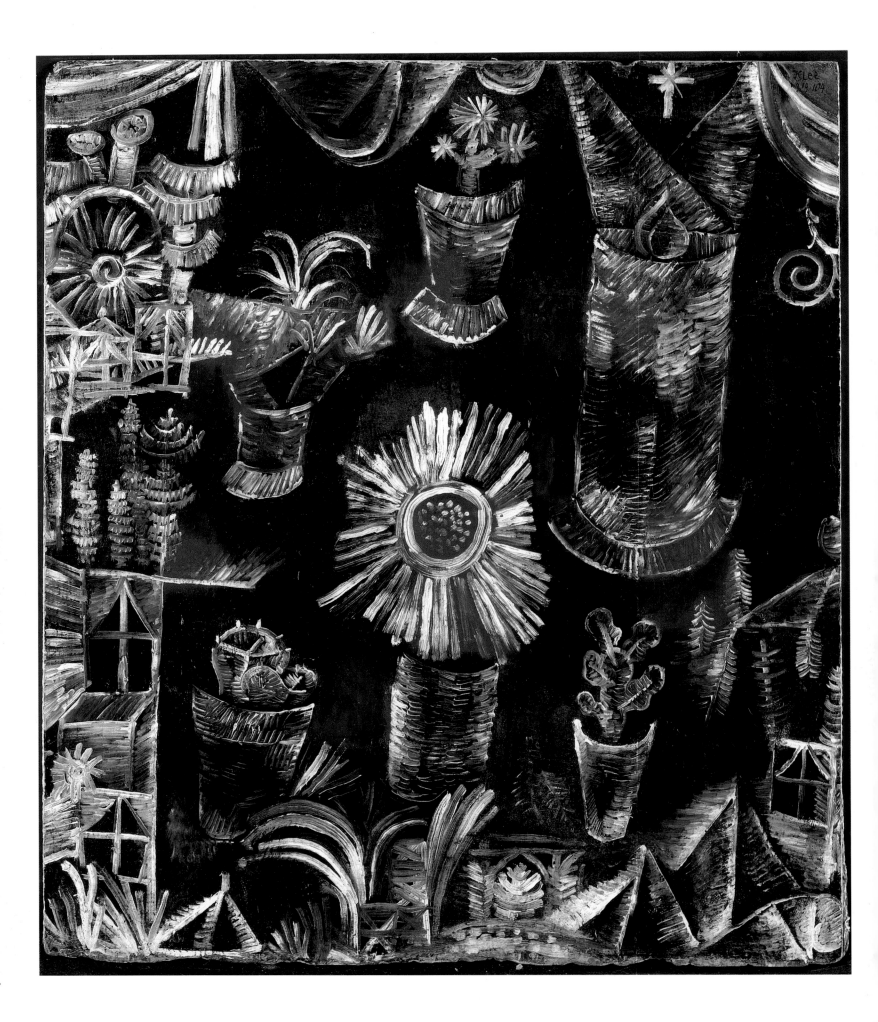

STILL LIFE
WITH THISTLE FLOWER
1919 *104*, oil on board,
48.5 × 43.3 cm (19 × 17 in.).
Jan and Marie-Anne Krugier-Poniatowski
Collection, Geneva.

theatre for his son Felix, then aged nine, and over the years he made fifty puppets, some funny, others frightening, which he gave him as birthday and Christmas presents. Thirty of these fantastic toys have survived, and they form an integral part of his œuvre. The puppet theatre created by Klee for his son had a backcloth that was part painted, part made up from old fabric, representing a church with an oversized clock. Felix Klee tells that performances were staged in the doorway leading from the living room to the bedroom. Some of these were very lively indeed, as for example when Punch locked up the Devil in a magic chest and then chased him out of it before finally locking him up again. Paul Klee sat smoking his pipe as he watched Felix's shows, accompanied by Rascal, a big, wild, tabby cat. He was royally entertained by Felix's farces, including one featuring a man from Munich and another from Bern, each speaking their own dialect, which turned on complete mutual incomprehension. New characters were added annually: one year Crocodile, another Madame Death, whose eyes were made from the tips of umbrella ribs. The Crocodile gobbled up the 'baddies', but vomited the 'goodies' up unhurt. The puppets later became more and more fantastical. Klee took great pleasure in developing new ones, and their numbers went on increasing till 1925.

Crazy performances, inspired by the then adolescent Felix Klee, also took place at the Weimar Bauhaus, during which daring satirical scenes on various subjects were staged, to the great chagrin of those who were the butt of them and the great joy of those watching. Using plaster and an ox-bone, Klee made a puppet of himself, a self-portrait with huge eyes, topped off with a fur cap. One of these satires, performed for the 1922 solstice celebrations, was particularly well-received. In it Emmy Galka-Scheyer was trying desperately to sell a picture by the expressionist painter Jawlensky to Klee, who systematically declined and remained entirely unmoved by her efforts. In her rage, poor Emmy took the painting and smashed it over Klee's head.

It was one thing to make the heads of the puppets, another to create their costumes. With the exception of the earliest puppets, whose costumes were made by a friend of his, Klee put the costumes together himself. Taking pieces of material from the darning drawer of Lily's chiffonier, he made them up on a basic, hand-driven Singer sewing machine.

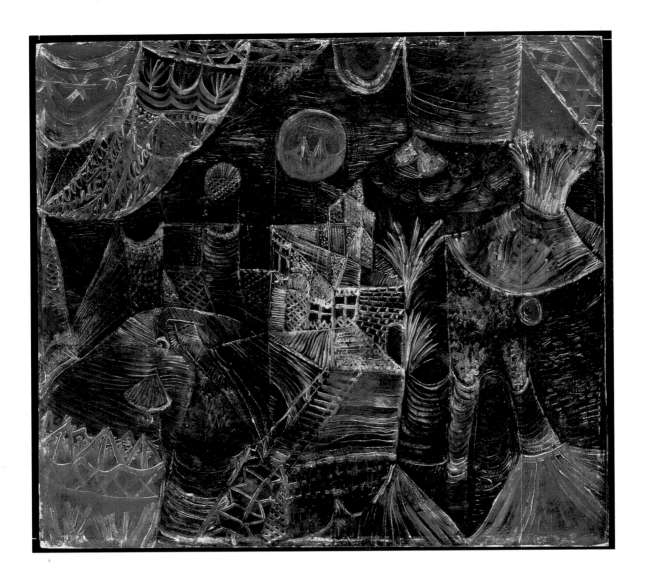

STAGE LANDSCAPE
1922, *178*, oil on board,
46 × 52 cm (18.1 × 20.4 in.).
Galerie Jan Krugier,
Ditesheim et Cie, Geneva.

GARDEN LANDSCAPE
1918, 76, oil on board,
21 × 17 cm (8.2 × 6.7 in.).
Private collection.

Felix had formed a desire for a puppet theatre while at the Munich flea market. Klee went there twice a year to buy old frames, which often determined the format of his works. While he was making his purchases, he sat his son down to watch the Punch and Judy show. Felix – who in later life became a theatre designer and director – expressed a burning wish to have something similar at home which he could operate himself. The shows he was to present, however, must have been very different from those at the flea market, to judge by the puppets he used in them.

One of the main characters, the evil-looking 'Madam Death', hardly inspires laughter. 'The Electric Spirit', which owes its name to the cast-off electrical plug which serves as its head, has something demoniac about it. A hat with a feather in it makes 'Matchbox Spirit' somewhat more amiable; its neck, chin and cheeks are made from the rearranged parts of three matchboxes. 'White-

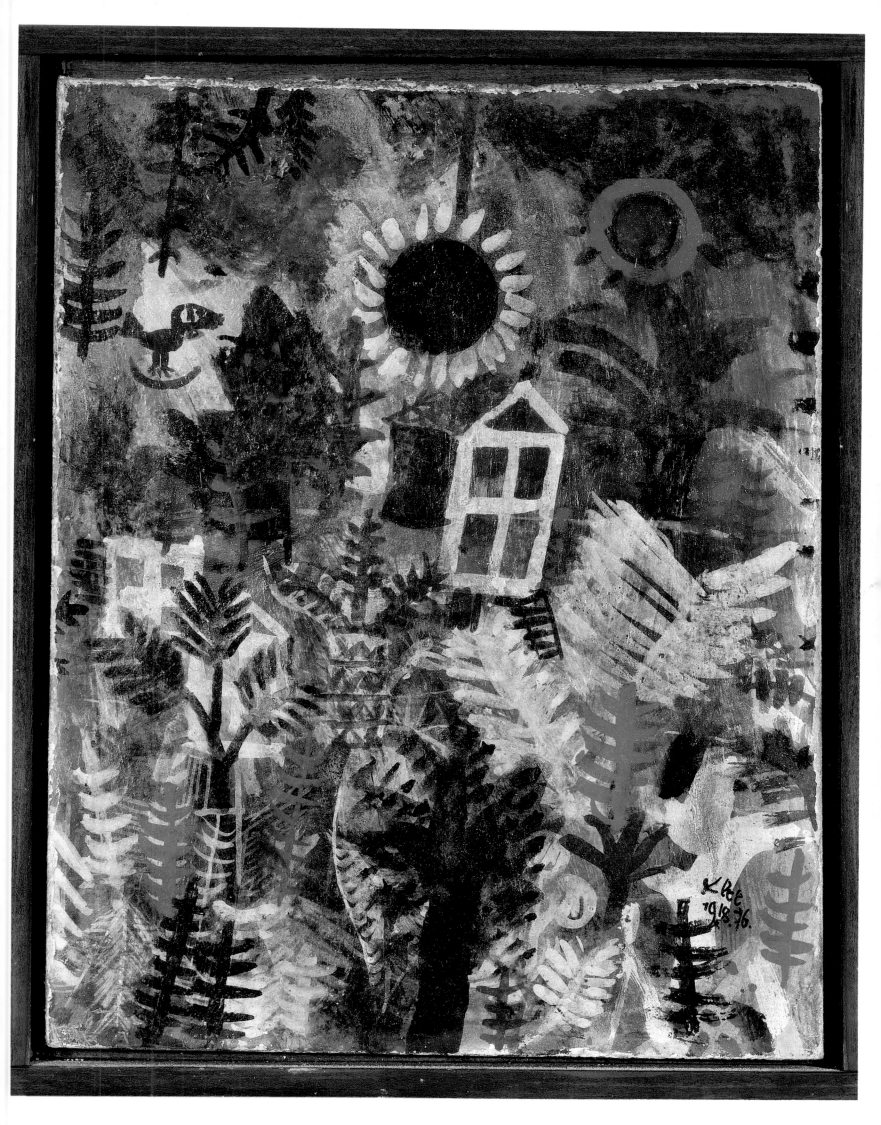

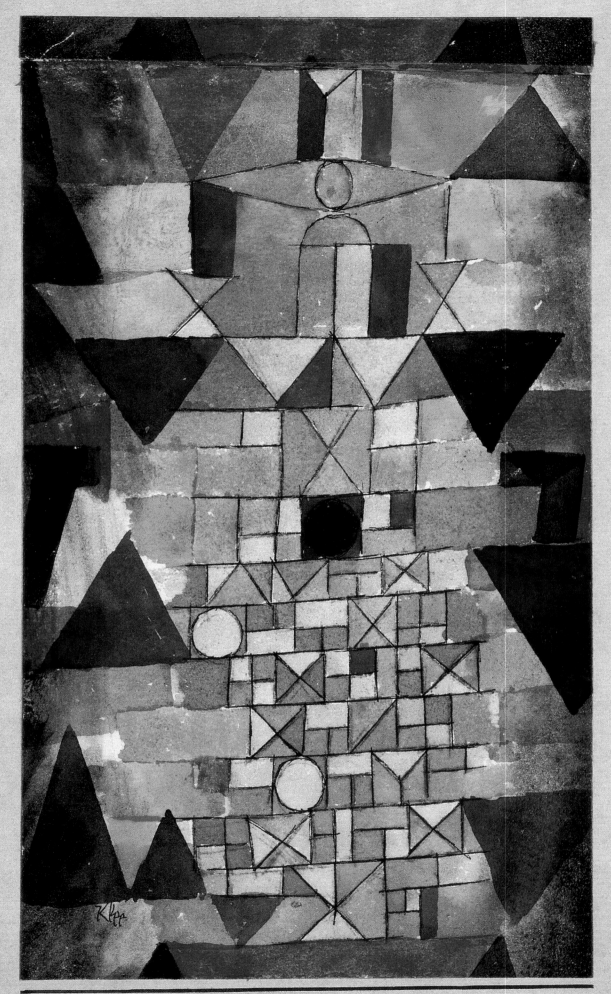

Klee

1918 . 8 .

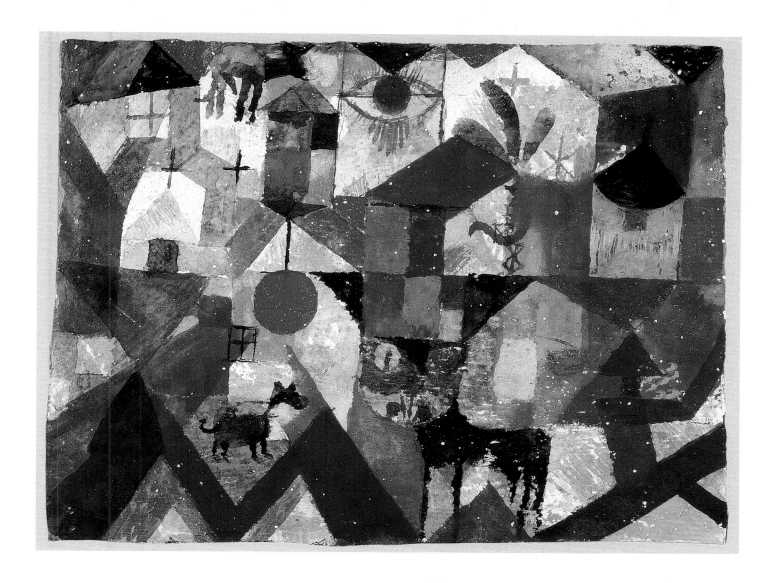

ZOOLOGICAL GARDEN
1918, *42*, watercolour on board,
17.1 × 23.1 cm (6.7 × 9 in.).
Paul-Klee-Stiftung, Kunstmuseum, Bern.

ARCHITECTURAL SCRIPT
1918, *8*, watercolour on paper,
19.5 × 11.5 cm (7.7 × 4.5 in.).
Private collection.

haired Eskimo', his jaw marked out by a little horseshoe doubtless taken from a rocking horse, looks astonished at finding himself in our latitudes. The faces of the other puppets are made of cockleshells, trouser buttons, feathers, fur and such like.

In 1916, Dada was born in Zurich. Klee was familiar with its slogans and protagonists, and may have been affected by it. One sign of this came in 1918, when, following on from the creation of his puppets, Klee made some little sculptures of oddly assorted materials. While walking near Augsburg he found, on the shore of the River Lech, some bits of broken brick polished by the waters, and these formed part of his inspiration. He also made a bull standing firmly on outspread legs and a ship with an iron smokestack.

LANDSCAPE WITH YELLOW CHURCH TOWER

1920, *122*, oil on board,
48.2 × 54 cm (18.9 × 21.2 in.).

Staatsgalerie moderner Kunst, Munich.

2. Creative Thought

THREE WHITE BELLFLOWERS
192C, *182*, oil on board,
26.5 × 19 cm (10.4 × 7.5 in.).
Private collection, Switzerland.

Klee was the first modern painter to accord creative value to the art of mental patients. In an article for the journal *Die Alpen* in 1912, he wrote: "When it comes to reforming art today, the works of mental patients are to be taken more seriously than all the world's galleries." No doubt he had had an opportunity to visit the little gallery Dr. Morgenthaler had established to exhibit the work of his patients at the Waldau psychiatric hospital near Bern.

He makes the same point in similar terms in his *Diaries*, though there he compares the work of the mentally ill to that of children. "Do not laugh, reader! Children also have artistic ability, and there is wisdom in their having it! The more helpless they are, the more instructive are the examples they furnish us; and they must be preserved free of corruption from an early age. Parallel phenomena are provided by the works of the mentally diseased; neither childish behaviour nor madness are insulting words here, as they commonly are. All this is to be taken very seriously, more seriously than all the public galleries, when it comes to reforming today's art. If, as I believe, the currents of yesterday's tradition are really becoming lost in the sand and the so-called unflinching pioneers (liberal gentlemen) display only apparently fresh and healthy faces, but actually, in the light of long-term history, are the very incarnation of exhaustion, then a great moment has arrived, and I hail those who are working toward the impending reformation." [1] These are surprising comments from an artist who noted in those same *Diaries* in 1901, before he had made the series of fifteen etchings that marks the beginning of his career: "I wish never to have to reproach myself with drawing badly out of ignorance." [2] Klee and Picasso are at opposite poles in this regard. Picasso, with his very first pencil stroke, began drawing pigeons – with every detail of their plumage – under the guidance of his father (a second-rate academic painter), and only recovered childlike spontaneity and freshness late in his work. Klee, by his own admission, in early childhood drew clumsy figures like everyone else. One of his specialities at that age was drawing devils, who "suddenly acquired real presence", [3] frightening him and sending him running into the arms of his mother. Among the drawings that have survived, some

1 *Diaries, op. cit.,* p. 266.
2 *Ibid.,* p. 91.
3 *Ibid.,* p. 4.

show these figures covered in swollen lumps, and are anything but comforting. *With the Hare*, which he drew at the age of five, is one such. Others take as their themes the baby Jesus in front of a Christmas tree, little girls with beribboned hair, or parents out walking with their children. Klee remained attached to his evil spirits, seeing them as the earliest core of his work, and at least one will usually be found in retrospective exhibitions.

The art of apes (studied by Desmond Morris in *The Biology of Art*) never goes beyond non-figurative daubs. By contrast, children's drawing represents the first stage of symbolization: the representation of beings and things. The child also begins with daubs, but these turn progressively into simple geometrical figures, such as circles, squares, triangles and crosses. The later arrangement of these in significant combinations subsequently gives way to the famous 'tadpole', with arms and legs joined directly to the head. This is followed by a rudimentary 'human' with a fully constituted body. It is not, however, lack of skill alone that is significant in children's drawing, as psychologists have shown. Crucial also is the lack of any distinction between the internal and the external, so that creatures and things are mere apparitions without substance or permanence. This regression to the unstable zones where images are primitive, because their reality is not yet objectively defined, fascinated Klee. In the art of mental patients, he discerned an *in-between world* with no set boundaries.

A dialogue with the art of mental patients and children

In 1922, Klee came to a wider knowledge of that art through Hans Prinzhorn's *Artistry of the Insane*, a book that figured in Klee's library at the Weimar Bauhaus. This work gave rise to impassioned discussions with his friend and colleague Kandinsky, a fellow teacher at the Bauhaus.

Though psychiatrists had in the past used the pictures produced by their patients for therapeutic purposes, Prinzhorn studied them in their own right as a way of better understanding the process of artistic creation. He had been a student of philosophy and history of art before going on to study singing (his long-cherished aim, since he had a fine baritone voice). However, when in the very early stages of their marriage his second wife began to suffer from a mental disorder, he decided to "take up a profession in which one

ROSE GARDEN
1920, 44, oil on board,
49 × 42.5 cm (19.2 × 16.7 in.).
Galerie Lenbachhaus, Munich.

Pages 60-61 |
PAUL KLEE
WITH EMMY (GALKA) SHEYER
Photographed by Felix Klee
at Weimar in 1922.
Paul-Klee-Stiftung, Felix Klee
Photographic Archives,
Kunstmuseum, Bern.

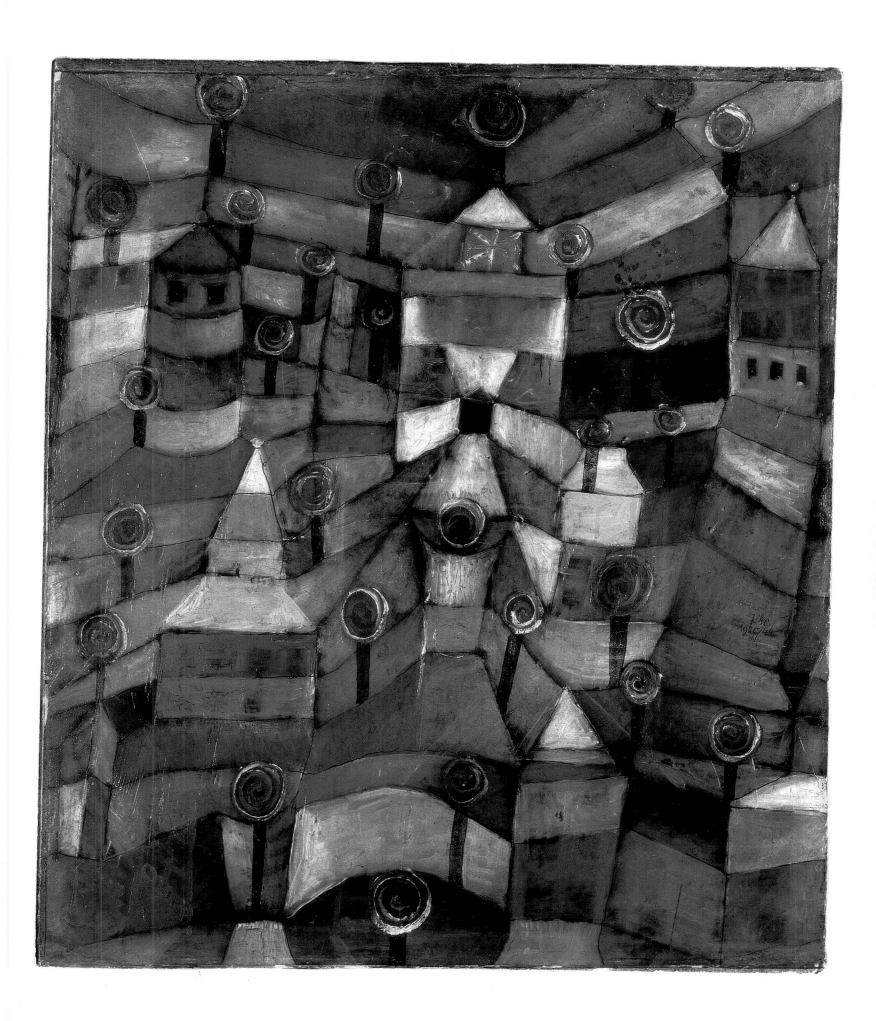

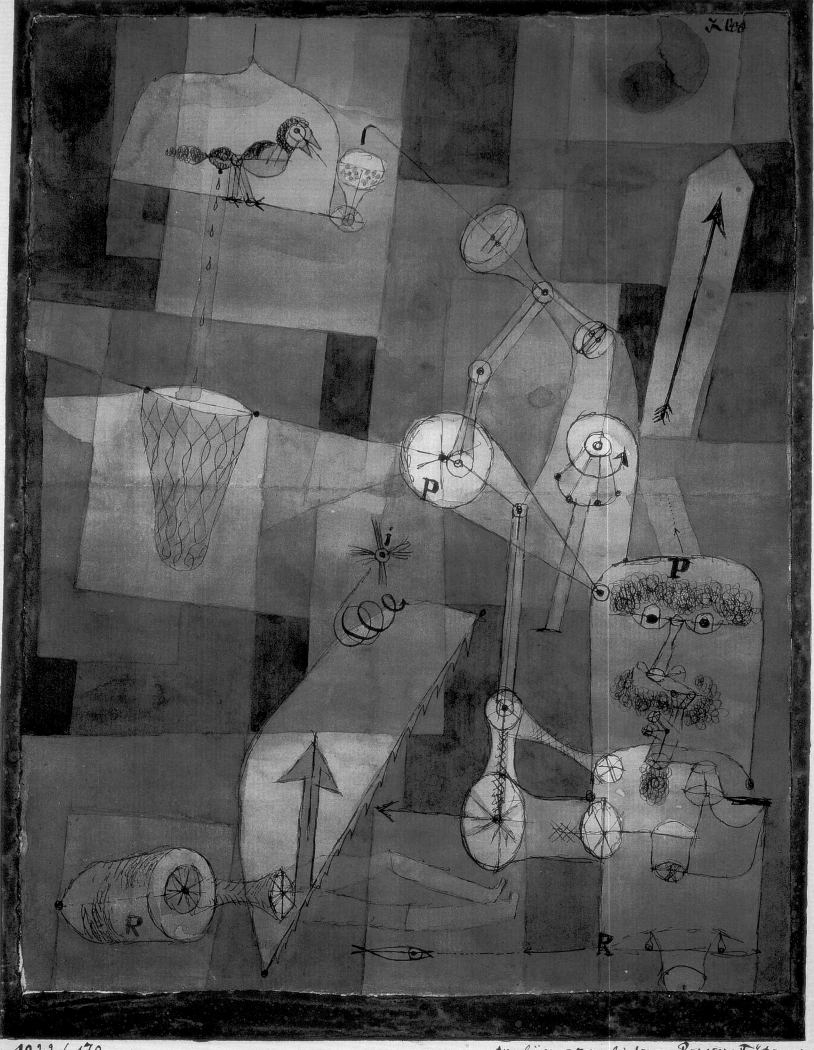

Klee

1922/170 Analyse verschiedener Perversitäten *

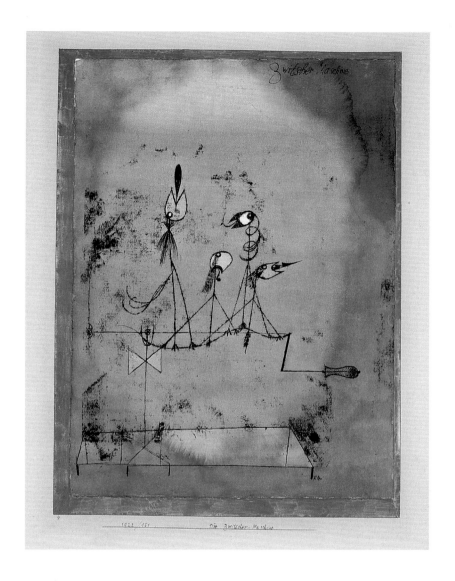

is forced to do good", and turned to medicine. Dr. Willmanns, the head of the Heidelberg University psychiatric clinic, gave him the job of creating and studying a collection of works by mental patients. Prinzhorn set about the task with such eagerness that the collection soon included 4,000 artworks by some 400 patients from Germany, Switzerland, Austria and Italy, along with a great quantity of written material.

Prinzhorn's basic intention was to show that mentally-ill artists are artists in the natural state, as it were uncorrupted by society; he saw their works as originating in the deep layers of the psyche and regarded mental patients as members of an 'elect' with access to ultimate truths. Prinzhorn was strongly influenced by the vitalist and metaphysical theories of expressionism, which was then the embodiment of the avant-garde in Germany, and borrowed from it the notions of the primordial, spiritualization and *Einfühlung*.

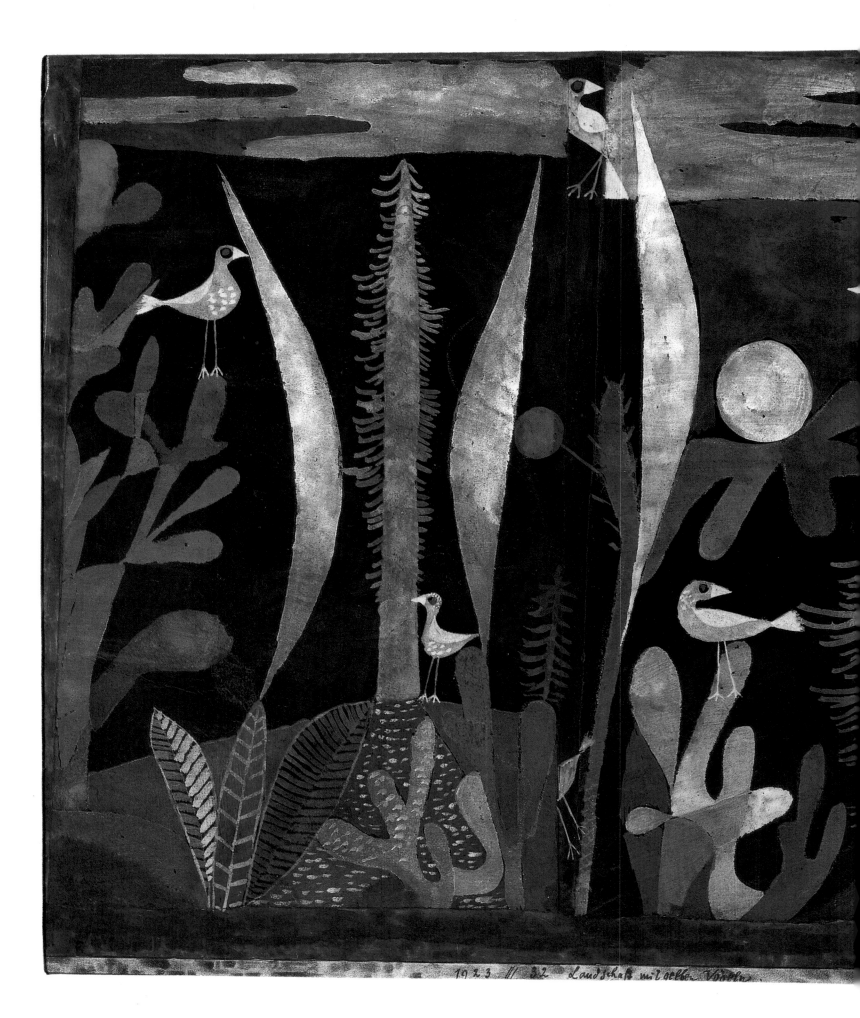

1923 // 32 Landschaft mit gelben Vögeln.

Expressionism also inspired his desire to transgress traditional pictorial conventions, and, most importantly, his aversion for an over-simplified conception of reality, one reduced to mere external appearances at the expense of self-expression. He consequently stressed the mental function of art; the roots of the power to shape and fashion images consisted, he felt, not in observation of the visible and its virtuoso reproduction, but in an overall vision of life.

To what extent was Klee affected by this? Flicking through the illustrations to Prinzhorn's work, one can easily imagine his unease. Paintings such as Adolf Schudel's *Horses at the Trough* or *Toad Pond at Full Moon* are close kin to his own in spirit and execution; the same might be said of an anonymous artist's *Collision of Planets*, apparently heralding the end of the world, and of so many other paintings excluded from the category of 'museum' art. In 1923, Klee declared: "In the works that (we hope) are successful, is it really poise and calm that we are expressing or communicating? Isn't it rather the agitation within us? Is the 'balance' of a composition anything other than the pot in which that agitation is boiling? […] You know Prinzhorn's excellent work. We can see it for ourselves! Take a look at those religious pictures: a depth and a force of expression I shall never achieve. A truly sublime art!" Klee's own behaviour never showed signs of full-blown 'insanity', but it was at times decidedly strange. For example, Herbert Bayer, who occupied a studio below his at the Dessau Bauhaus, tells how one day he heard a scratching, scraping and muffled banging above his head. Believing that Fritzi, Klee's cat, was wrecking his master's work, he dashed upstairs in the hope of preventing further damage. As he crossed the threshold of the studio, intending to put an end to the cat's trail of destruction, he was confronted by an unforgettable spectacle. Klee himself, who usually worked on several pieces simultaneously, endlessly re-touching them, was hopping energetically from one work to another, scratching at a colour here and drawing a line there. He was in a state of such exaltation that Bayer withdrew before Klee noticed his intrusion. Henry Kahnweiler reports that, during a trip to the Swiss National Park, a nature reserve in the Canton of Grisons, he lost sight of Klee. After vainly shouting his name for some time, he eventually discovered him sitting on a large rock. Klee's eyes were rooted to the ground, but as he raised his head, he announced, "I've just had

1923, 32, watercolour
on blackened ground,
35.5 × 44 cm (13.9 × 17.3 in.).
Private collection, Switzerland.

a long conversation with a snake!" He said this so persuasively that it was impossible to doubt him.

Even his most enchanting works are little mental earthquakes that throw up splendid fossils. In the works of his early maturity, such as *Nocturnal Flowers* (1918), *Analysis of Various Perversities* (1922) or *Landscape with Yellow Birds* (1924), if we look closely, there is always something secretly disquieting, which troubles the eye and grates on the nerves.

Nocturnal Flowers is a landscape entirely submerged by the blue of the sea and blue gouache, in which a red tower sprouts up from a world of flowers, trees and exotic plants. The sense of mystery is enhanced by the fact that the plants are taking root in all four sides of the composition, and converging towards a black central sun. The second, *Analysis of Various Perversities*, shows a kind of laboratory, with a bird warbling in a glass bell and a magician; his arms are manipulating the levers of what seems to be a strange alembic. This is an evocation of alchemy. As Will Grohmann remarks, the colour, which runs from pink through mauve and blue to violet and black, sets the tone for the action here. Two arrows running up the picture emphasize this. At the bottom of the composition lie the legs of a man whose body and head are caught in a lobster pot; a little above this, a spiral suggests the flight of an insect. Klee valued this work highly. It bore the letters S. CL. on the back. According to Grohmann, this stood for "Sonderclasse" (special class) and meant that it was only to be sold to a connoisseur.

Landscape with Yellow Birds is remarkable for its mixture of the precise and the dream-like. According to Grohmann, the plants are taken from Indo-Iranian art and the chrome-yellow birds, arranged on all sides like motifs in an oriental carpet, come from Sassanid chased metalwork. The whitish-blue lianas and the familiar pine-trees which stand between them – a Nordic presence in an Oriental garden – comprise a large part of the strangeness of the composition. The upper level of the scene is overcast with clouds, whilst the lower is covered with a mossy earth which has ribbed leaves and curious plants growing from it. The most important thing about the work is that these brightly-coloured elements stand out against an underlying black 'psychic ground', as is frequently the case in Klee's work.

Klee stated "black is an energy". In his youth he had drawn some lines with the point of a needle on a pane of asphalt-coated glass, and had been thrilled at the result, which was akin to engraving.

DRY, COOL GARDEN

1921, 83, watercolour on paper,
24.1 × 30.5 cm (9.5 × 12 in.).
Öffentliche Kunstsammlung, Basel.

He writes: "To represent light by means of light elements is old stuff. Light as colour movement is somewhat newer. I am now trying to render light simply as unfolding energy. And when I handle energy in black on a white surface, I ought to hit the mark again."[1] Elsewhere, he notes: "I was so pleased with the creation of my black watercolours. First, applying a layer, I left the main points of light blank. This extremely light grey layer gives at once a very tolerable effect, because it appears quite dark against the blanks. But when I leave out the points of light of secondary importance, and apply a second layer on the first dried layer, I enrich the picture greatly and produce a new stage of logical development. Naturally the parts left blank in the earlier phases remain blank in the ensuing process. In this way I advance step by

1 *Ibid.*, p. 253.

1977. 130.

ab ovo

| Pages 68-69

AB OVO

1917, 130, watercolour on gauze
and paper, on a chalk-coated ground,
14.9 × 26.6 cm (5.8 × 10.4 in.).
Paul-Klee-Stiftung,
Kunstmuseum Bern.

step toward the greatest depth, and consider this time-measuring technique fundamental as regards tonality." [1]

Klee's perception of black as an "unfolding energy", and the tonality that resulted from this perception, turned the traditional notion of chiaroscuro on its head. That notion was, primarily, one of material and spiritual *illumination*, which had its origins in the Neoplatonism of Marsilio Ficino, a devotee of Plato in the Florence of the Medici. Ficino is famed for finding a prefiguration of Christian theology in classical thought, and for having attempted to reconcile the two. The light which gives rise to chiaroscuro is light with a capital 'L'. This is the *Fiat lux* of the Bible: divine light from above, in the form of sun, fire, primeval force, or the laughter of the heavens, shimmering down upon creatures and creation, enveloping them in its spiritual radiance, and sweeping across the surface of the painting. In Klee's works, by contrast, light comes from Darkness. Black was the primordial foundation of things, as he told his Bauhaus students. The time of Neoplatonist gradations and relief was past. Colours are things suffered – *pathos*. Goethe described colours as the actions and passions of light. Not only are there a great many moons in Klee's works, but the luminosity of those works is lunar. Theirs is the nocturnal energy exuded by Chaos.

Romanticism had been fascinated by Night, as witness Novalis's *Hymns to Night*. "How poor and childish does the light now seem [...]. More heavenly than those glittering stars seem the unnumbered eyes that Night has opened within us." The realm of night has neither time nor space: the queen of the night is an absolute monarch of mystical worth. Tieck speaks of the experience of night as supreme. Caspar David Friedrich, who took long nocturnal walks around the Island of Rügen, saw the moon as an emanation of the soul of the world. Schelling believed it was an enormous energy demanding to be set free. "If the night itself rose," he wrote, "if a nocturnal day and a diurnal night could embrace us all, this would at last be the supreme goal of our desires. Is that why the moonlit night so marvellously stirs our souls, and instils in us the quivering presentiment of a life so close at hand?" For Klee too, the Moon plays a more decisive role in the symphony of the universe than the Sun; like the stars and constellations, it has, in his eyes, a magical power.

1 *Ibid.*, p. 243.

This can be seen particularly clearly in *The Niesen*, a watercolour from 1916. The Niesen, situated to the south of the Thunersee in the Bernese Oberland, is a pyramidal mountain, which stands out from those around it by its almost perfect geometry. One can see it towering over the landscape, standing out against the sky like no other. Ascending it is a thrilling experience. Hardly have you left the lush meadows with their grazing cattle than you pass through a forest of beech and pine. The trees thin out as you climb up to a summit of completely bare rock. How should one paint this picture-postcard mountain, which combines the picturesque and the sublime? Setting aside the naturalistic option, Klee produced an image of the Niesen divided into two distinct zones. The rocky walls become a blue pyramid with clearly marked edges, straight out of ancient Egypt. The most important feature of the picture is the inexpressible light in which the pyramid is bathed, as though

RIDER UNHORSED AND BEWITCHED

1920, 62, pen and black ink on wove paper mounted on light board, 19.4 × 21.3 cm (7.6 × 8.4 in.). The Metropolitan Museum of Art, Berggruen Klee Collection, New York

Pages 72-73 | **THE NIESEN** 1915, *250,* watercolour on paper and board, 17.7 × 26 cm (6.9 × 10.2 in.). Hermann and Margrit Rupf Foundation, Kunstmuseum, Bern.

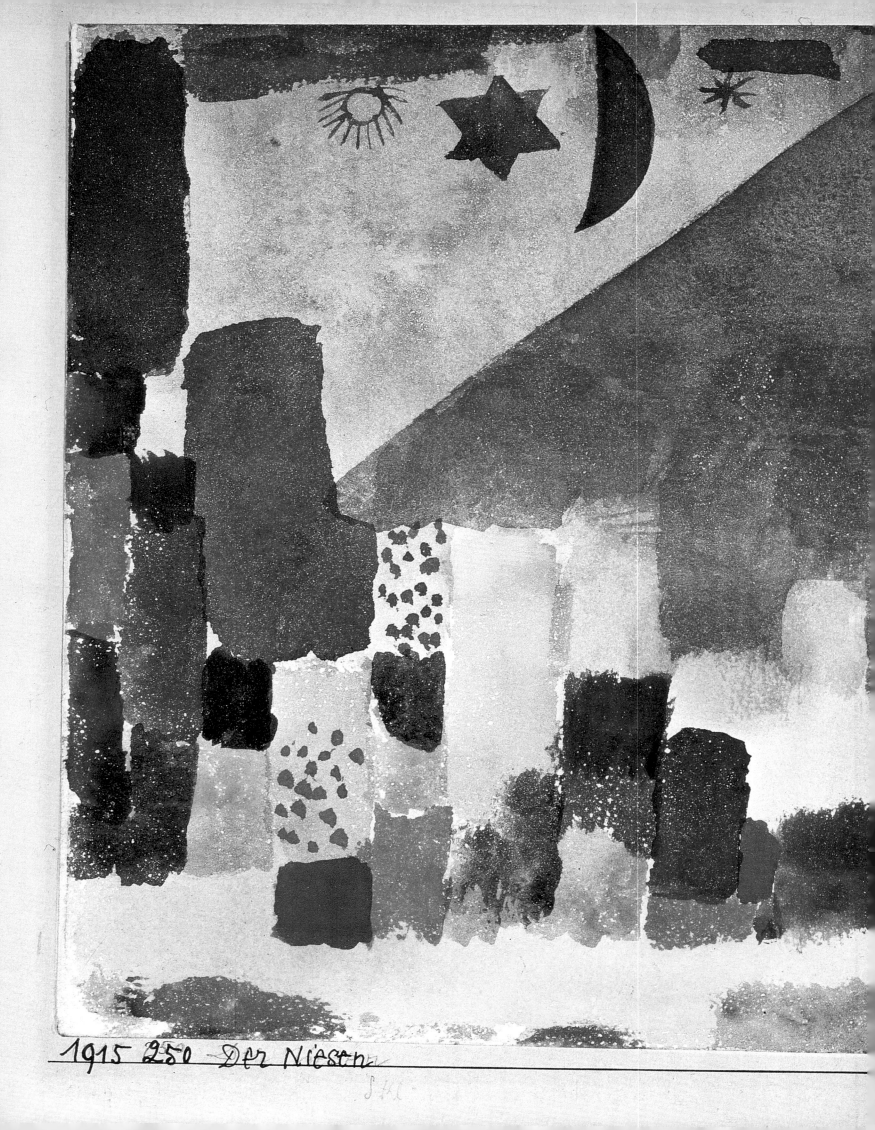

1915 250 Der Niesen

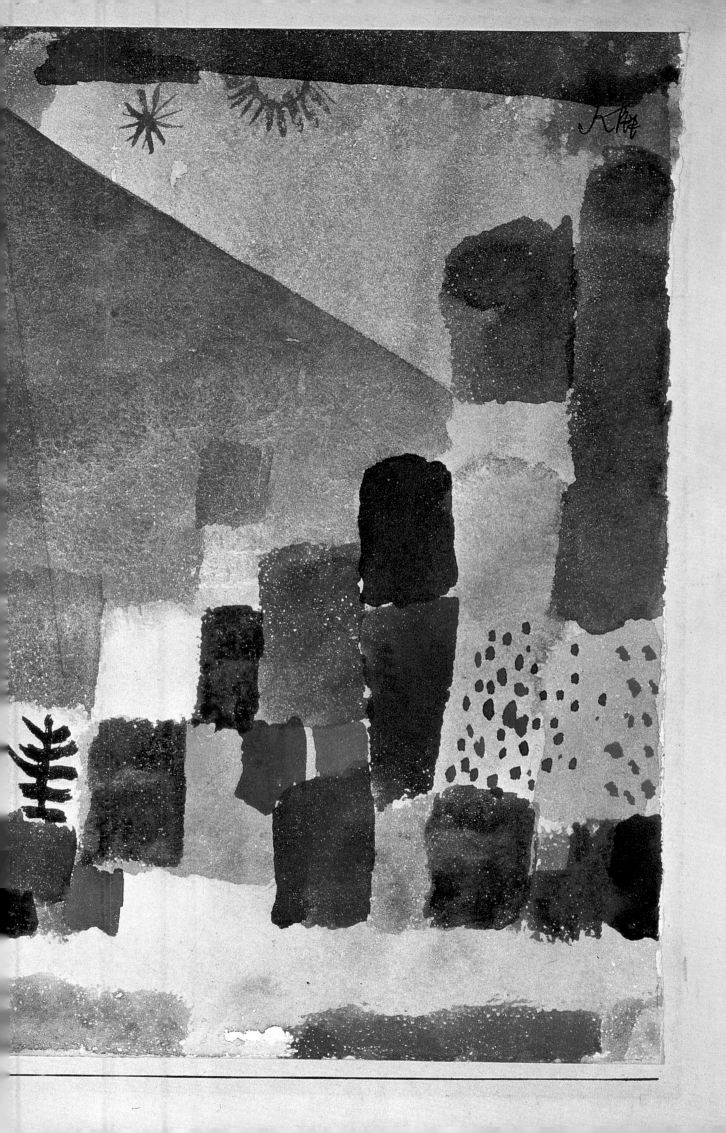

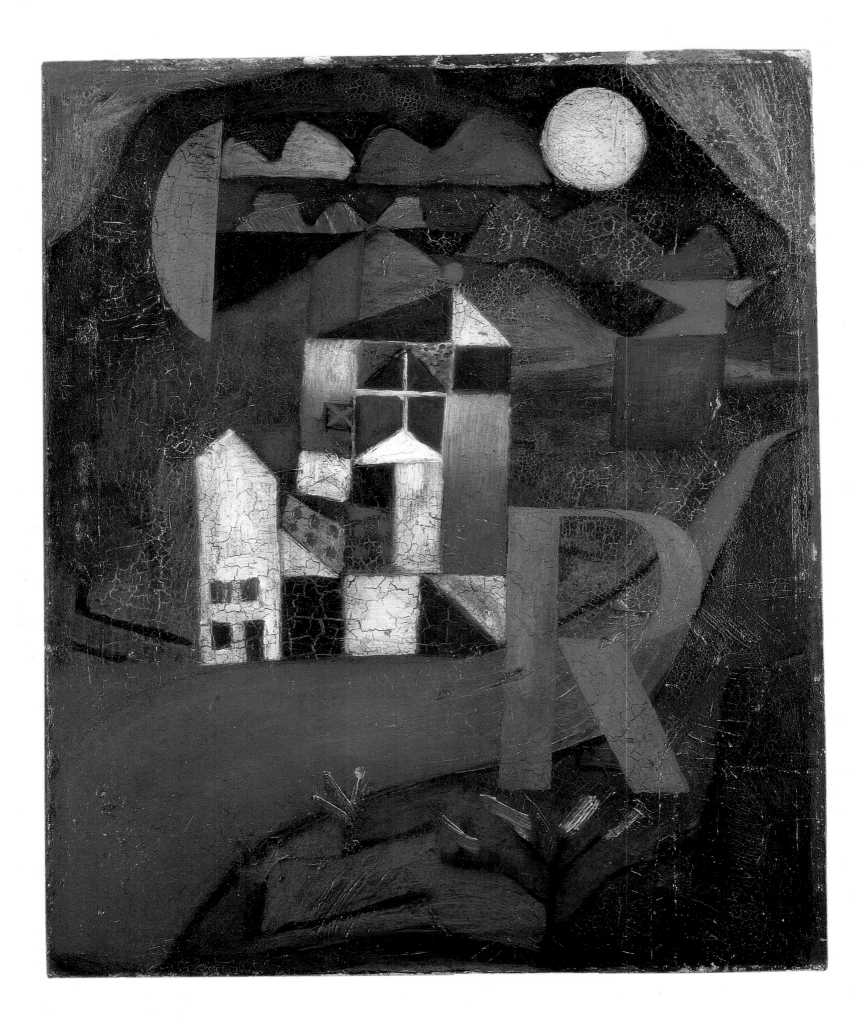

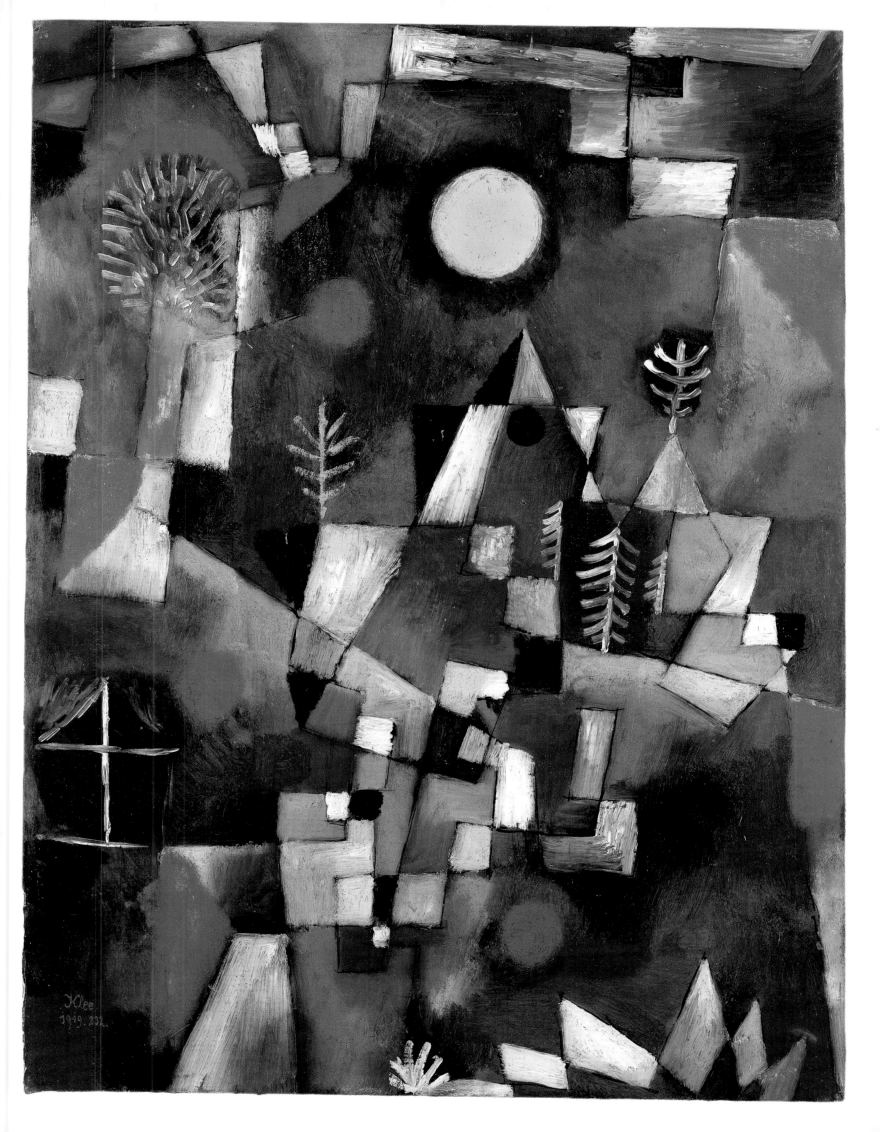

a nocturnal day had been fused with a diurnal night – the supreme realization of Romantic Night. The pyramid seems to hover in the ether. Klee often repeated that he had a cosmic vision both of himself and of beings and things.

Yet he is more often close to Novalis than to Schelling. In his famous *Villa R*, painted in 1919, in which moon and sun face each other from the upper corners of the composition, nocturnal tones dominate. Against a background of hills, the painting depicts an ornate dwelling, beside a winding road that runs off to the horizon. Next to the building stands a large enigmatic letter 'R', almost equally high. At the centre of the dwelling, a casement window pierces the façade. Klee notes in his *Diaries*, "I cannot find sleep. In me the fire still glows, in me it still burns here and there. Seeking a breath of fresh air, I go to the window and see all the lights darkened outside. Only very far away a small window is still lit. Is not another like me sitting there? There must be some place where I am not completely alone! And now the strains of an old piano reach me, the moans of the other wounded person." [1] Thus Klee records a moment of anxious expectancy beneath the infinite eyes of Night.

Clearly, the Night of the Romantics is an image of the unconscious. Not the Freudian, psychological unconscious, which is merely the sum of our repressed or miscarried acts and feelings, but the ontological unconscious of Carus, the friend of Goethe. Carl-Gustav Carus was, in his lifetime, well known in German-speaking countries; a philosopher, physician and landscape painter, he regarded the unconscious as "the subjective term for what we designate objectively as nature", the point of humanity's insertion into "the great chain of being", the passage through us of the universal flow, "the obscure dialogue of the All with itself". Our organic and psychic existence was, he felt, merely one of the aspects of this unconscious, which is assimilated to the life of the universe. The human being, as microcosm reflecting the macrocosm, is, Carus believed, in intimate communion with the flowers, animals, seasons and astral ages. This might be Klee himself speaking – or one of his pictures speaking for him.

1 *Ibid.*, p. 229.

| Page 74
VILLA R
| 1919, *153*, oil on board,
26.5 × 22 cm (10.4 × 8.7 in.).
| Öffentliche Kunstsammlung, Basel.

| Page 75
FULL MOON
| 1919, *232*, oil on paper,
mounted on board,
49 × 37 cm (19.2 × 14.6 in.).
| Galerie Otto Stangel, Munich.

LANDSCAPE NEAR E. (BAVARIA)
1921, *182*, oil and Indian ink
on paper, mounted on board,
49.8 × 35.2 cm (19.6 × 13.8 in.).
Paul-Klee-Stiftung, Kunstmuseum, Bern.

Though Klee championed the art of mental patients and children, and preserved distant affinities with romanticism, he was fully aware of the revolutionary movements at the origins of 20th-century painting, particularly cubism and neo-impressionism. As I noted in my introduction, he regarded Picasso as the greatest modern artist, and in 1914 painted a *Homage to Picasso* that is close, in its quadrangular structures, to analytic cubism.

As has often been said, cubism represents an intense struggle with the object. The pictures of analytic cubism provide a multiplicity of viewpoints and depths of field. Guitars, glasses and water jugs, depicted from several angles simultaneously, painted from a distance or exaggeratedly close up, are shown distorted, disintegrated or shattered. Cubism is the ultimate form of a realism that destroys itself by pushing the analysis of reality to extremes; it reconstructs reality at the conceptual level. None of this applies to Klee's cubism. True, in many of his works there are offsets and fragmentation. But these are in the service of an irrationality that plumbs the depths of life in quest of enchantment. We see this, for example, in *Ab Ovo* (1917) – a very tiny painting on a piece of gauze. Though its tones and interstices are cubist in kind, it is, as the title indicates, a speculation on our genesis. We might also cite those lunar canvases in which skewed squares and rectangles of various sizes densely overlap amid the intersection of oblique lines; they too create a sense of inquisition and mystery.

The magic of colour

Klee met Robert Delaunay in the spring of 1912, and in the autumn translated several pages of his notes on colour and light for the journal *Der Sturm*. Delaunay was at the time working on his series of *Simultaneist Windows* paintings. For this, Delaunay had shut himself away in his studio, nailing the shutters closed. Then, using a brace and bit, he had drilled a little hole through which a ray of sunlight could penetrate. He unravelled and analyzed the colours of this ray, closely examining the light of the sun without any concern for figurative representation. The result was a number of paintings in which the cubist grid appeared, but haloed with the colours of the prism. The series inspired one of the poems in Guillaume Apollinaire's *Calligrammes*: "From red to green all the yellow dies" [...]; "fathomless violets" [...];

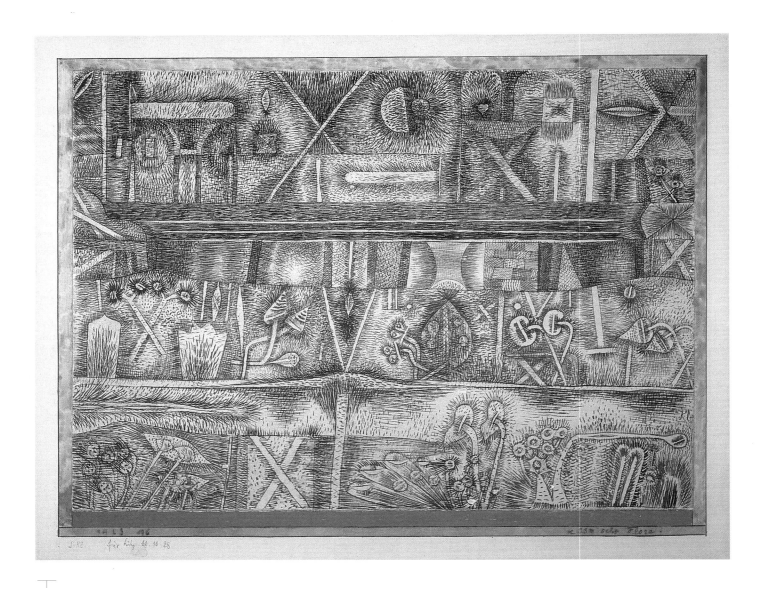

Cosmic Flora

1923, *176*, paintbrush drawing,
watercolour on chalk-coated paper
mounted on board
27.2 × 36.6 cm (10.7 × 14.4 in.).
Paul-Klee-Stiftung, Kunstmuseum, Bern.

| Page 79
The Creator

1934, *213 (U 13)*,
oil on canvas, original frame,
42 × 53 cm (16.5 × 20.9 in.).
Paul-Klee-Stiftung,
Kunstmuseum, Bern.

"The window opens… the lovely fruit of light." [1] One can easily imagine the impact on Klee's mind of these ethereal works, which, unlike those of the other cubists, do no violence to objects. Delaunay influenced Klee's vision of Tunisia. On Monday, 6 April 1914, Klee and his companions the painters August Macke and Louis Moilliet embarked at Marseilles on the *Carthage*, a big, handsome steamer of the Compagnie Transatlantique line. The three were old friends; they had pillow fights, bought pornographic photos and stuffed themselves with food. But an enthralled Klee also discovered Tunis with its sombre light, then Hammamet, with its cemetery walled by giant cacti. There, in a garden, he was presented with a biblical vision: a girl leading a dromedary up and down in order to fill a cistern with water. And, lastly, there was his

1 Guillaume Apollinaire: 'Windows', *Calligrammes*, tr. Anne Hyde Greet, University of California Press, Berkeley/London, 1980.

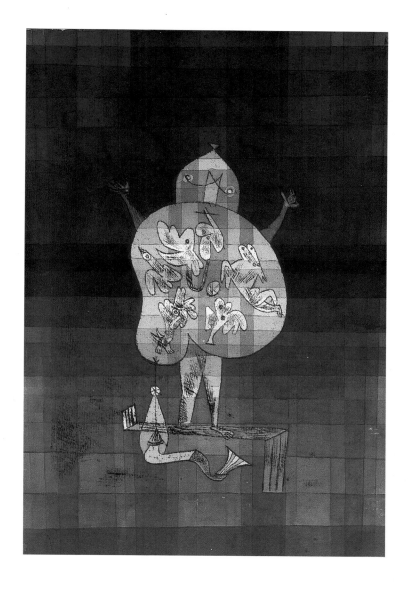

VENTRILOQUIST AND CRIER IN THE MOOR
1923, *103*, watercolour and ink
on paper, mounted on board,
41 × 29 cm (16.1 × 11.4 in.).
The Metropolitan Museum of Art,
Collection Berggruen Klee, New York.

arrival at the gates of Kairouan. "Completely at home here", he writes. [1] And there is a crucial confession from this man who had, till then, shown so much doubt: "Colour possesses me. I don't have to pursue it. It will possess me always, I know it. That is the meaning of this happy hour: Colour and I are one. I am a painter." [2] Klee was thirty-four years old.

In Tunisia, he painted watercolours of various themes that caught his attention. One of these was the garden of Dr. Jäggi, a Bernese doctor practising in Tunis, who had welcomed the happy trio into his house. There are clear similarities with Delaunay's work: the same way of squaring up the surface of the picture, the same way of laying out space vertically and suppressing depth. *Hammamet with Mosque*, a watercolour done from memory after returning

1 *Diaries. op. cit.*, p. 287.
2 *Ibid.*, p 297.

Pages 82-83 |
AD PARNASSUM
1932, *274 (X 14)*,
oil on canvas, original frame,
100 × 125 cm (39.4 × 49.2 in.).
Paul-Klee-Stiftung, Kunstmuseum, Bern.

home to Munich, is particularly striking in this regard. The coloured surfaces, unconfined by lines; in the lower part of the composition, the transparency of those surfaces, and the modulation from crimson to pink and from yellow to green; the emphasis on the intersection of geometric and non-geometric surfaces: all these are closely related to *Simultaneist Windows*. There is, however, one difference: Klee here and there scattered sparse vegetation, made up of lines of dots, dashes and crosses, while in the upper part of the picture, two minarets stand out against a background of faded blue sky. We have a paradox here: the man who was to be the painter of the lunar night first reached maturity painting sun-drenched landscapes. It seems to me mistaken to see in these pictures the influence of the 'southern moon', as most of Klee's commentators have argued.

The vertical disposition of space is a feature seen at every period of Klee's painting. This is particularly true of the famous magic squares, of the works depicting architectural façades, and even of his labyrinthine renderings of maze-like modern cities. Cubism, if only for the new freedoms that it offered, was the 20th-century pictorial movement that most informed Klee's thinking, and its multifarious influence is to be seen in a large number of his works.

Delaunay had initially been a neo-impressionist. That is to say, he had espoused the division of colour tones as practised by Seurat, together with the idea that the optical mixing of pure colours on the spectator's retina intensifies the luminosity of those colours. Klee was perhaps less influenced by neo-impressionism than by cubism, but in the early 1930's he painted a number of works that make use of chromatic division. As always, he transformed the system that he adopted. These works, like Seurat's, are made up of dots of paint. But Klee differentiated himself from neo-impressionism; he did not break down colour with the aim of achieving greater luminosity, nor did he distribute it in accordance with the law of simultaneous contrasts, in fact he painted rows of dots of the same colour. Other influences must be taken into account here, such as the Ravenna and Palermo mosaics, which greatly interested him, and which also bend the rules. Klee's was a composite art, which is one reason why he remained a resolute 'loner', never identifying with any of the great movements of modern art, though completely *au fait* with them.

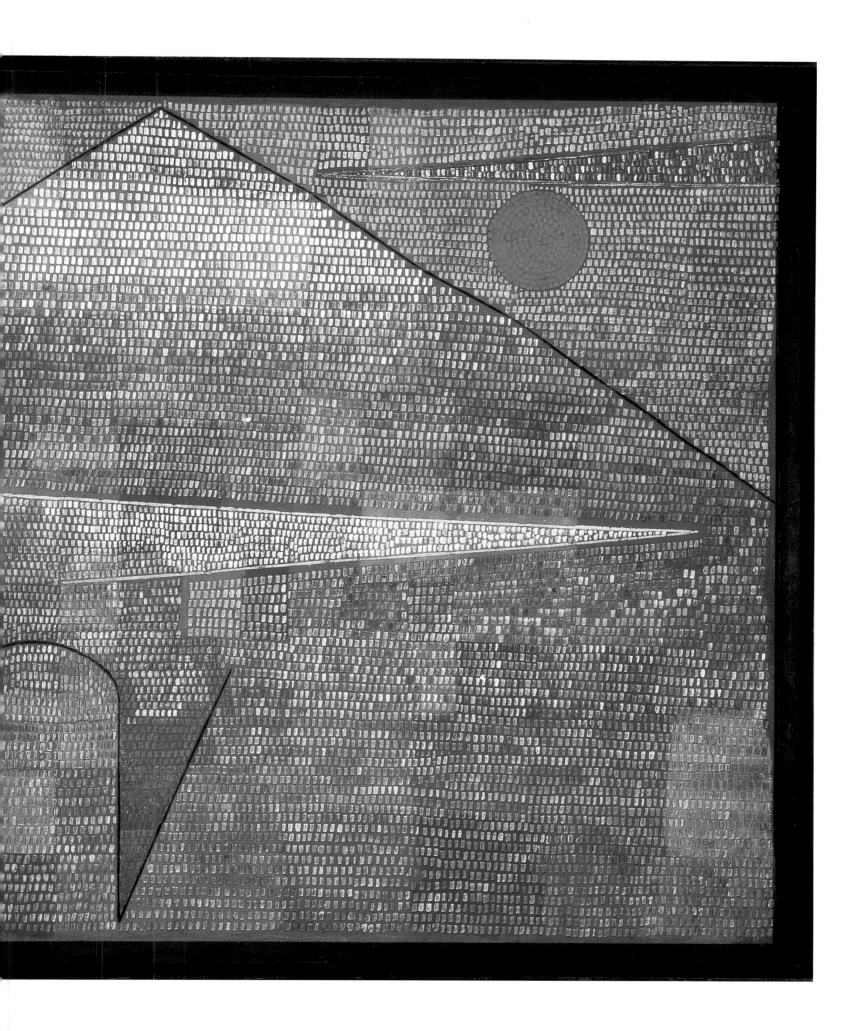

The first picture in the neo-impressionist series is *Sunset*. Against a muddy-coloured backdrop, a dragon-like figure is resting, made up of blue and violet parallelograms. Above this, there are two clearly delineated cloud shapes, the higher of the two studded with vermilion dots, the other with dots of matt blue. A red circle with an arrow pointing down is undoubtedly the sun, and a second circle, shedding tears, is man or moon; such were the sensations inspired in the painter by the sunset. But the *pointilliste* surfaces form only a part of this composition. Other works, such as *The Light and So Much Else* (1931) or *At Anchor* (1932), go further in this direction, producing mosaic effects like those of enamels. However, unlike the works of neo-impressionism, these paintings also have a spiritual dimension, and are not confined to the impact of light on the retina.

The most representative of the paintings produced in this style is certainly *Ad Parnassum*, a canvas of 1932, which is one of the largest (100 × 125 cm [39 × 49.6 ins.]) the artist ever tackled. The theme is Mount Parnassus, the mountain of muses and poets, at the foot of which lies a ruined temple. Will Grohmann provides a remarkable description of this: "The colours are fairly changeable, so that the viewer experiences the transformation of light from dawn to noon. The long narrow triangle above the sun signifies dawn, the pointed white wedge above the temple is noon – nowhere has Klee shown the phenomenon of time so clearly as here. The title, *Ad Parnassum*, is an invitation to ascend the mythical mountain in full daylight, not just to admire it from a distance. The temple portal at the bottom may mark the beginning of the ascent; the golden-orange triangle standing on its point may be an indication of more ruins. Did not the gorges of Parnassus contain the Delphic oracle and the Castalian spring? Might not the ruins refer to them, too, for instance? The light illumines a site dedicated to the Muses from the beginning of time."[1] In its use of line, this painting puts one in mind of the work of the physiologist and mathematician Charles Henry on the vectors of sensations. Henry found that lines rising towards the right were generative of pleasure and energy, whilst lines descending to the left evoked sadness and fatigue. His work was well known to the neo-impressionists, and a remote influence cannot

1 Will Grohmann: *Paul Klee (The Library of Great Painters), op. cit.,* p. 126.

be ruled out; the black lines that give *Ad Parnassum* its guiding geometrical structure have such mute expressive power. It seems that Klee makes partial use of neo-impressionist techniques, subverting them for his own purposes and profoundly transforming and reinventing them. If we look closely, we see that the surface of *Ad Parnassum* is not made up of dots, but of tiny rectangles laid out in rows. Moreover, these are set on a patchwork ground of different coloured squares in such a way that two 'grids' – the neo-impressionist and the cubist – are superimposed. Picasso had done this in certain works of his 'synthetic cubism' period, but had done it in a different spirit and with a different purpose. For what is striking in Klee's picture is the *polyphony*, in the musical sense of the term, obtained in this way. That is to say, the effect here is of many voices resonating simultaneously. Another picture in the same group, *Evening in the Valley*, uses the same technical resources, but does so to express the cosmic darkness falling on nature – nature as inhabited by the Teutonic gods. With the fall of darkness, it becomes the kingdom of the dead.

In his 'dialogues' with cubism, neo-impressionism, music, the art of mental patients and children's art, Klee invariably remains true to himself. He is an artist in whom the diurnal and nocturnal meet and fuse. They spill over into a corpus that comprises some nine thousand drawings and paintings. So far from annihilating it, the extreme diversity of this *œuvre* endows it with exceptional resonance.

3. An Operative Imagination

FIRE AT FULL MOON

1933, *C 13*, watercolour,
wax coated, on canvas,
50 × 60 cm (19.7 × 23.6 in.).
Folkwang Museum, Essen.

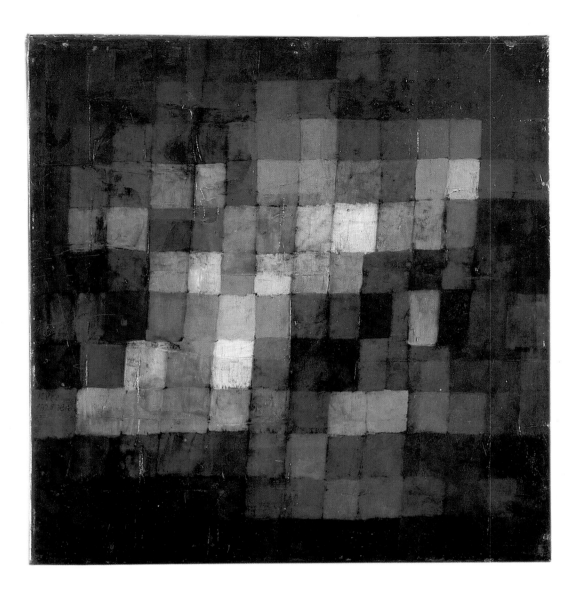

**ANCIENT SOUND,
ABSTRACT ON BLACK**

1925, *X* 6, oil on board,
38 × 38 cm (15 × 15 in.).
Öffentliche Kunstsammlung, Basel.

Klee's works weave a skein of wonder and mystery across the vacuity of the real. As we have seen, they speak of the nocturnal progression of life. It is our deep drives and *inner vision* that they express, not the naturalistic appearance of a mountain range or a wheat field. At times, they carry the troubling and disturbing to the point of obsession. Yet their haunting power is first and foremost that of an 'operative' approach (in the Piagetian sense of that term) to reality. In Klee's pictures, forms are forces. "We are looking not for form, but for function", he declared. When Klee explains his approach in *Creative Credo*, one of his most penetrating texts, he writes: "An apple tree in blossom, the roots, the rising sap, the trunk, a cross section with annual rings, the blossom, its structure, its sexual functions, the fruit, the core and seeds. An interplay of states of growth."[1] He goes on to

1 Paul Klee, *Notebooks. Volume 1. The Thinking Eye*, tr. Ralph Manheim, Lund Humphries, London, 1961, p. 79.

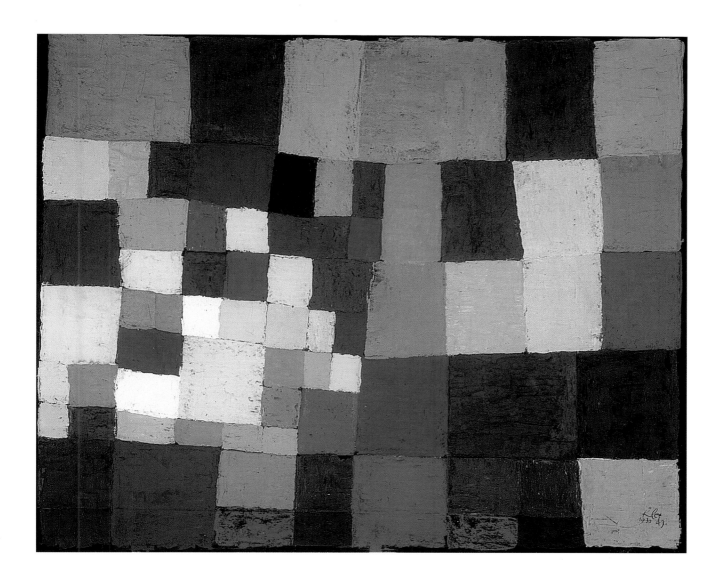

GARDEN IN BLOOM
1930, *199*, paint and pastel
with paste on a black ground on paper,
41 × 50 cm (16.1 × 19.7 in.).
Private collection, Switzerland.

speak of a man asleep, whose complexity he wishes to convey: "A sleeping man, the circulation of his blood, the measured breathing of the lungs, the delicate function of the kidneys, in his head a world of dreams, related to the powers of fate. An interplay of functions, united in rest."[1] The concern here is no longer with vast swathes of foliage or huge patches of shade in the Île-de-France, captured in iridescent light. We are no longer looking at an art of portraiture seeking to achieve an anecdotal resemblance to its model. The true knowledge of beings and things teaches us that there is much more to them than external appearance. The time has come to understand the functioning of beings and things in our civilization, and it is this task that Klee requires painting to perform.

We see this clearly in works that feature vegetation. The migration

1 *Ibid.*

of protozoa-like seeds and fruits in *Time of Plants* (1927) might equally be evocations of lacunary or palisade tissue, or of piliferous layers, tendrils or ligneous fibres; but they all retain a certain scientific verisimilitude in their very phantasmagoria. Extendable networks of routes and pathways, of spirals and concentric circles, feed into each other, assimilating and interbreeding to produce new species. Born of the artist's imagination, they institute a kind of vegetal physiology, with invented rules and laws, and yet they present us with a vision of the very origins of life. In the diversity and classification of genera, Botticelli found the elements of the floral décor in which he celebrated the glory of the Medici. He painted his *Primavera* at the dawn of the era in which botany came into existence. Klee, for his part, in each of his works featuring vegetation, takes us into the contemporary world of genetics and cytology. In the spring of 1906, while still working feverishly from nature, his *Diaries* relate: "In our garden I lavish pious attention on the bergamots that I brought back from Rome and replant them by making a strong branch grow independently. This procedure also provides a neat experiment in the field of capillary action.

(A) plant with two branches *a* and *b*
(B) Branch *b* is bent down and fastened to the ground by its middle
(C) After it has struck roots at this point, it is severed from branch *a*.
(D) The new plant *bII bII* grows independently; from now on, the circulation of the sap in branch *bI* is reversed." [1]

He illustrates his experiment with a drawing, in which we find the arrows that later became so characteristic of his work.

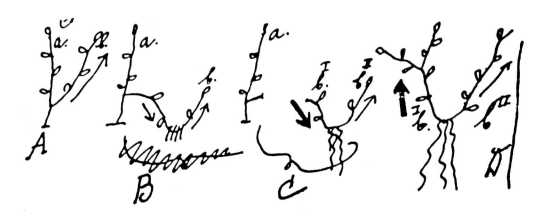

1 *Diaries, op. cit.,* p. 204.

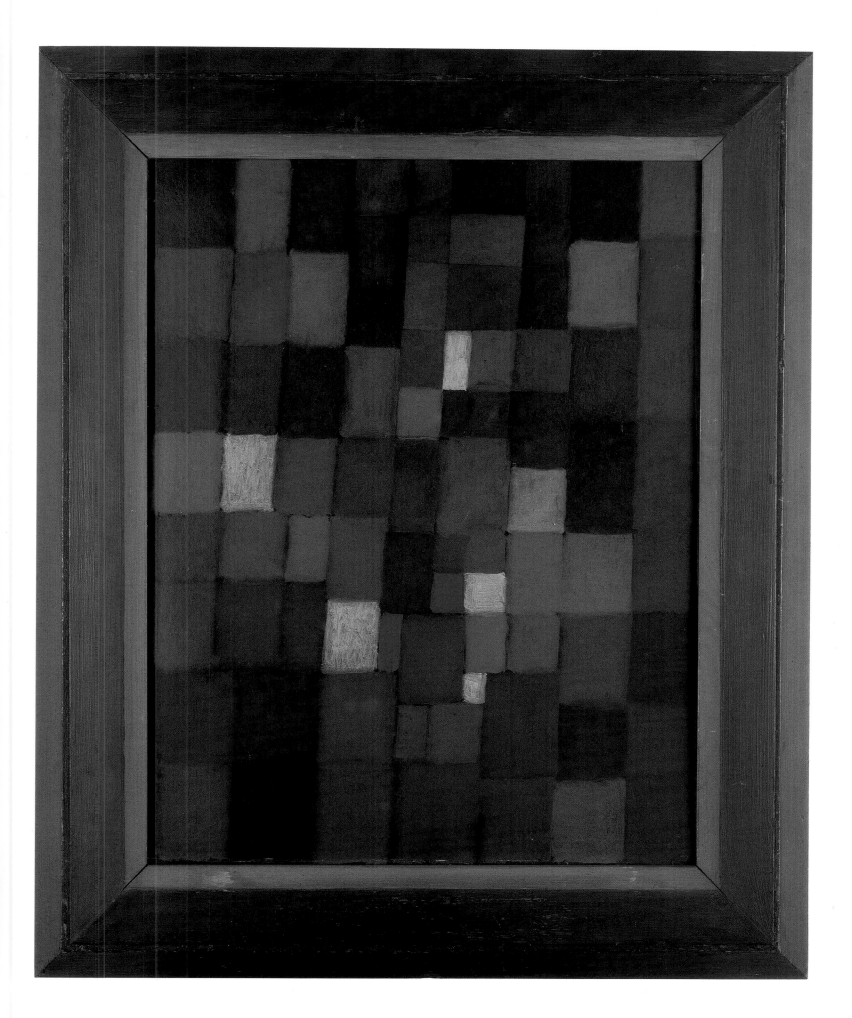

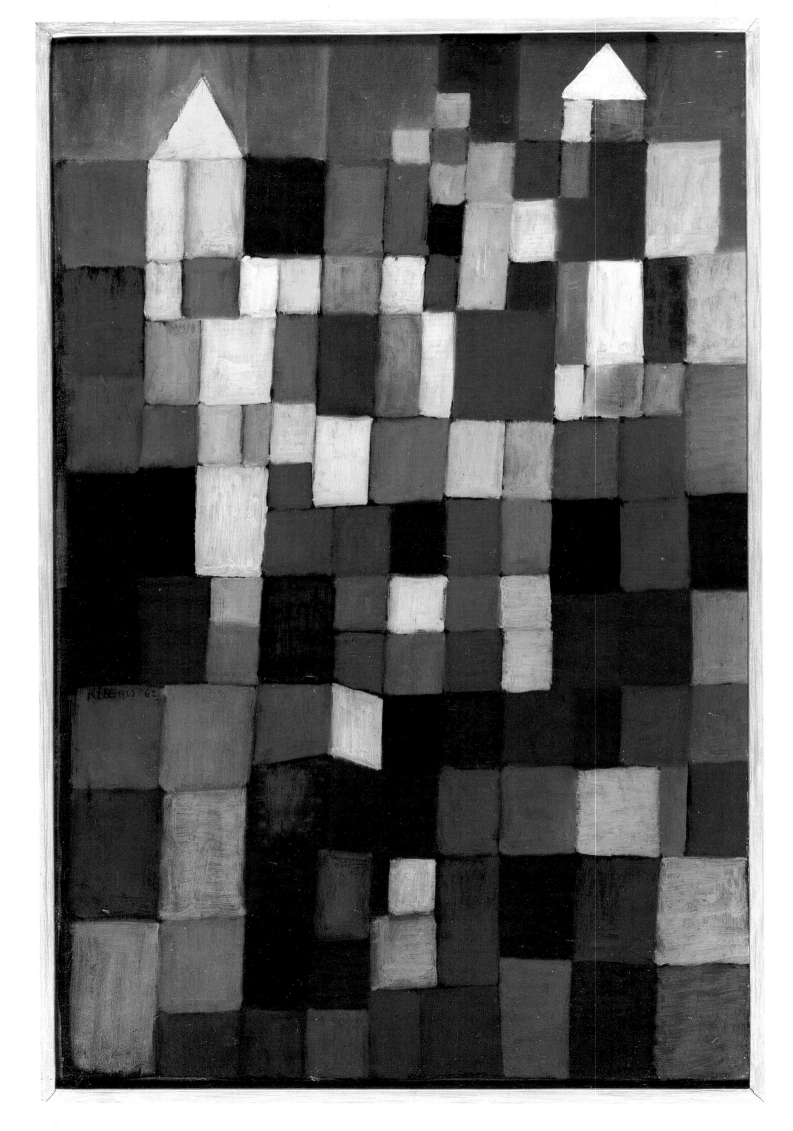

A few pages before, he had noted: "Once one has grasped the idea of measurability in connection with design, the study of nature will progress with greater ease and accuracy. The richness of nature, of course, is so much the greater and more rewarding by reason of its infinite complexity.

Our initial perplexity before nature is explained by our seeing at first the small outer branches and not penetrating to the main branches or the trunk. But once this is realized, one will perceive a repetition of the whole law even in the outermost leaf and turn it to good use." [1]

Nor should we forget the influence of Goethe, and his theory of the primordial plant, the origin, as he saw it, of all plants in their infinite variety. Klee was twenty-seven. His art was to draw on other important sources, as we have seen. But from the earliest years of learning his craft, though musicality was always present, for Klee this never meant vague dreaming.

A similar creative process was at work in respect of the human figure. At the beginning of his career Klee devoted a great deal of time to the study of artistic and medical anatomy before laying its insights aside in his later works. Anatomy is, of course, based on a knowledge that dates from the Renaissance, that is to say, from a period when medicine was taking its first halting steps and knew nothing of such important functions as the nervous system or the circulation of the blood. When Vesalius was a student in Paris, his teacher Jacobus Sylvus used a dog's organs to illustrate his lectures on the human body. At the risk of being excommunicated, the founder of modern anatomy was subsequently reduced, against all the principles of the society in which he lived, to nocturnal raids on cemeteries where he could steal the corpses he needed for dissection. This enabled him to show that the human body "is not made up of some ten or twelve parts, but of thousands". In such conditions, we can easily conceive how anatomy might enthral Leonardo da Vinci or Rembrandt, not merely for the new knowledge it brought, but because it represented a great *adventure*.

But anatomy has now been relegated to the first year of medical studies and is no longer considered among the achievements of civilization. Only the frontier zones of knowledge fascinate us. We are indebted to Carus for the first formulation of the idea of the

1 *Ibid.*, pp. 146-147.

**PAUL KLEE IN HIS STUDIO
AT THE BAUHAUS**

Photographed by Felix Klee
at Weimar in 1924.

Paul-Klee-Stiftung,

Felix Klee Photographic Archives,

Kunstmuseum, Bern.

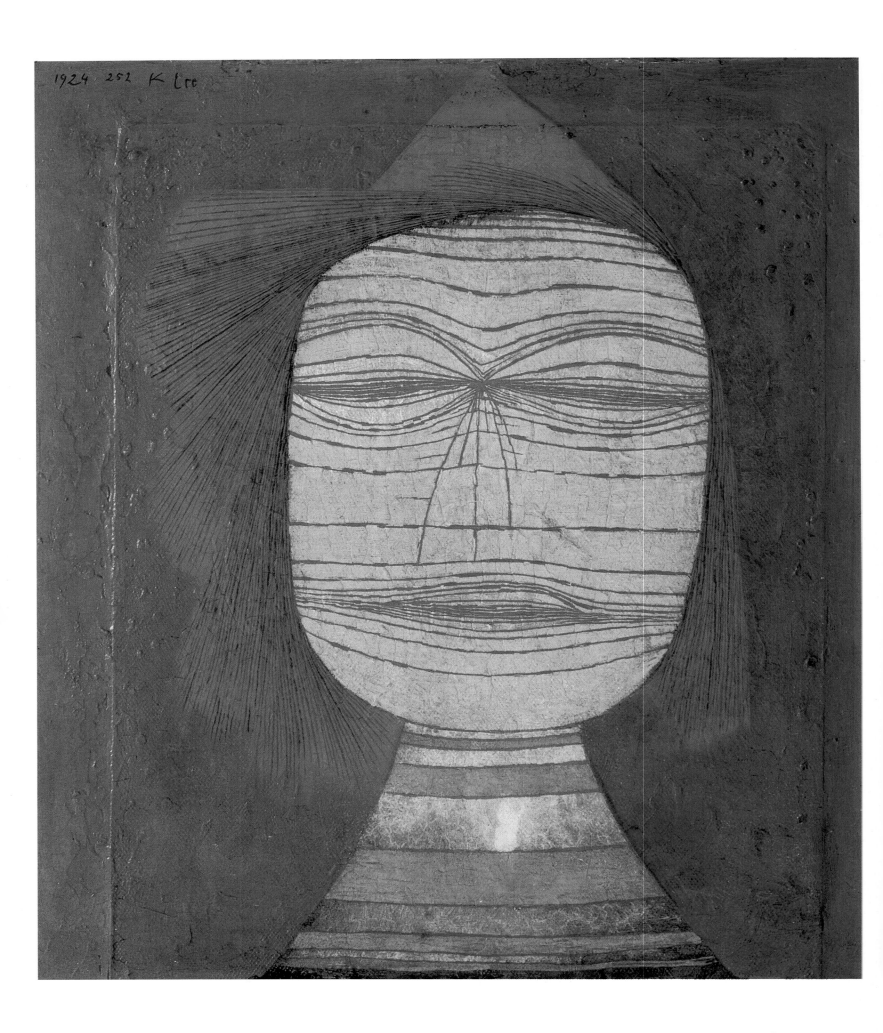

1924 252 K lee

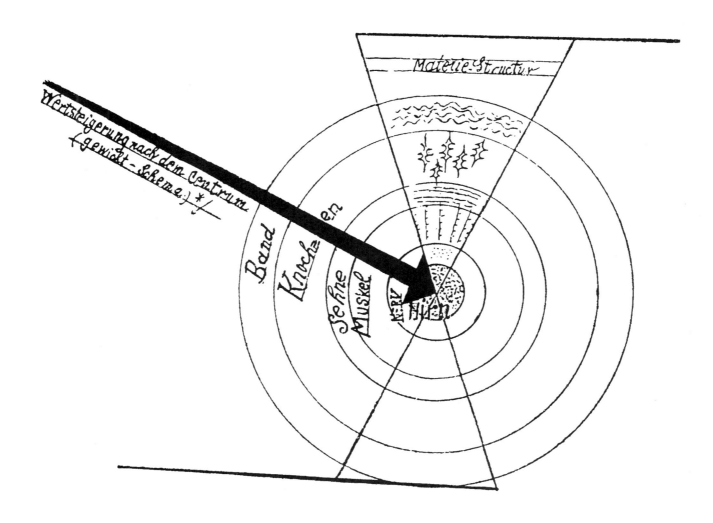

DIAGRAM
Comparable
to nesting toy boxes

ACTOR'S MASK
1924, 252,
oil on canvas, mounted on wood,
36.7 × 33.8 cm (14.4 × 13.3 in.).
The Museum of Modern Art,
Sidney and Harriet Janis Collection, New York.

unconscious. But we should remember that it was clinical reasons that led Freud to develop psychoanalysis (sessions were originally known as 'chimney sweeping'). The symptoms afflicting Anna O., Freud's first case, included various contractures, eye-movement disorders, disturbances of vision, intense nervous coughing and impairment of speech functions. They were so serious that, had they been the product of organic lesions, she would quickly have died. The theory of the anatomical localization of the cerebral functions, the crowning glory of positivistic science, which assigned a precise function to each region of the brain, was found wanting. The inadequacy of that theory was to lead to a revolution in our conception of human reality. In came a set of notions – repression, libido and sublimation – as fascinating as they are problematic.

As early as 1925, Klee brought together in his famous *Pedagogical Sketch Book* the key elements of his Bauhaus teaching, in which the anatomical model of Western tradition is replaced by a diagram of concentric circles. "The independence of the muscle function is of course relative. It applies only in relationship to bone function. Actually, the muscle is not independent but obeys orders, issued from the brain. The transmission of a brain order can be compared to a telegram, with nerves acting as wires."[1] Mechanistic, descriptive anatomy is overturned; from the cellular texture of bone to the controlling role played by the brain, everything has its place in the overall structure; there is a functional hierarchy, as is shown in the diagram (p. 99) that Klee drew for his students. And he adds: "This diagram employs an arrangement according to weight or importance, with increased values toward the centre; in an arrangement according to measurement, the brain would have to occupy the (peripheral) place of the greatest spatial expansion, and the position of the motoric faculties would be reversed."[2]

Claude Bernard confessed that at no time in his career had he found a soul beneath his scalpel. Here, on the other hand, the material structure that constitutes our environment and bodies forms the starting point for a movement leading from the periphery to the centre. For Klee, the psyche ceases to reverberate in the Mona Lisa's smile and becomes something much more complex; something like a force that simultaneously places us in physical reality and puts us into contact with the multifarious drives from which our being is woven. The human that it images – the being who really concerns us here – is none other than the subject of psychosomatic medicine and psychoanalysis.

The progressive interiorisation wrought by Klee can be felt in the various phases of his painting; it transpires very clearly from the development of the self-portrait in his *œuvre*. One of the first of these, *Threatening Head* (1905), remains relatively traditional in its respect for artistic criteria and technique. As we have already seen, the portrait in question is an etching, in which a tight-lipped Klee, with close-cropped hair and furrowed brow, is staring straight ahead. To illustrate the anxiety which torments him, a shrew with outstretched claws sits atop his head. We are in the dual grip of expressionism and symbolism here, exactly as in the Picasso of the

FLORENTINE VILLA DISTRICT
1926, *223 (W 3)*,
oil on board, original frame,
49.5 × 36.5 cm (19.5 × 14.4 in.).
Musée national d'art moderne,
Centre Georges-Pompidou, Paris.

1 Paul Klee, *Pedagogical Sketch Book*, Faber and Faber, London, undated, p. 29.
2 *Ibid.*, p. 29 (footnote).

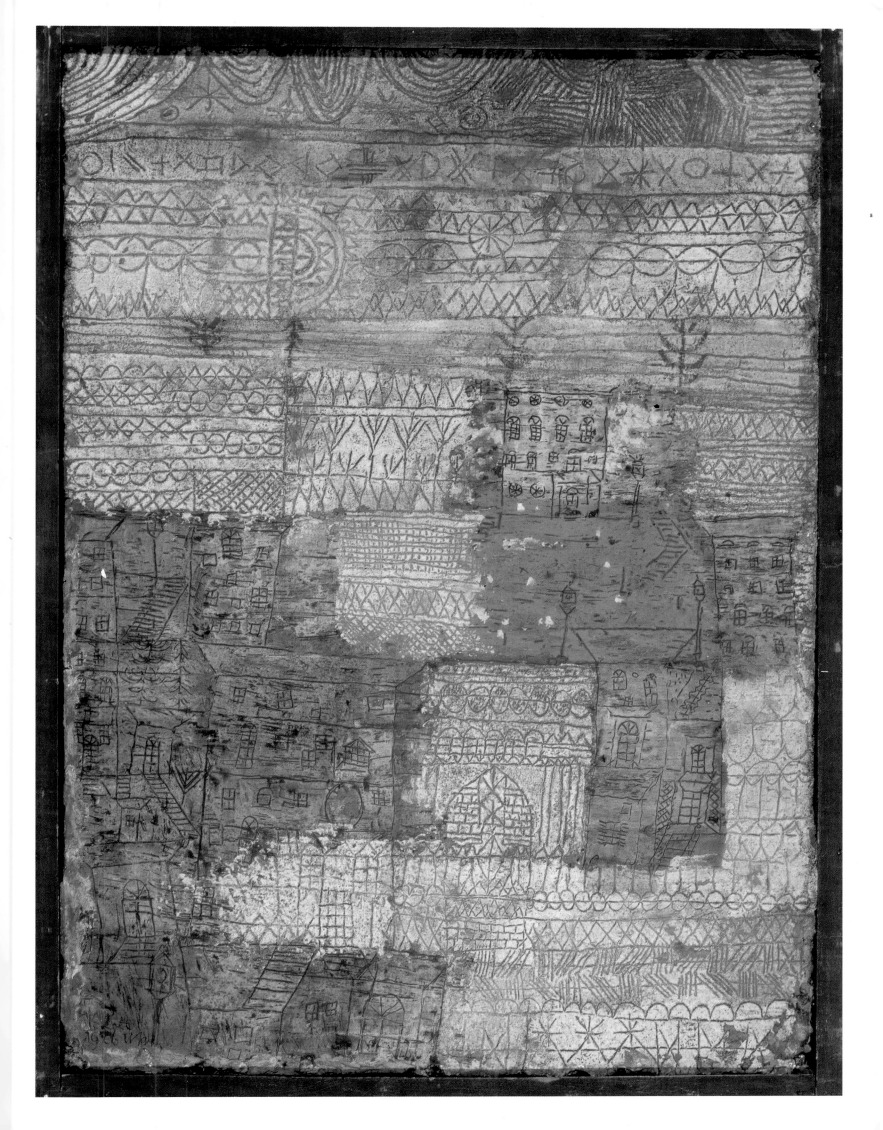

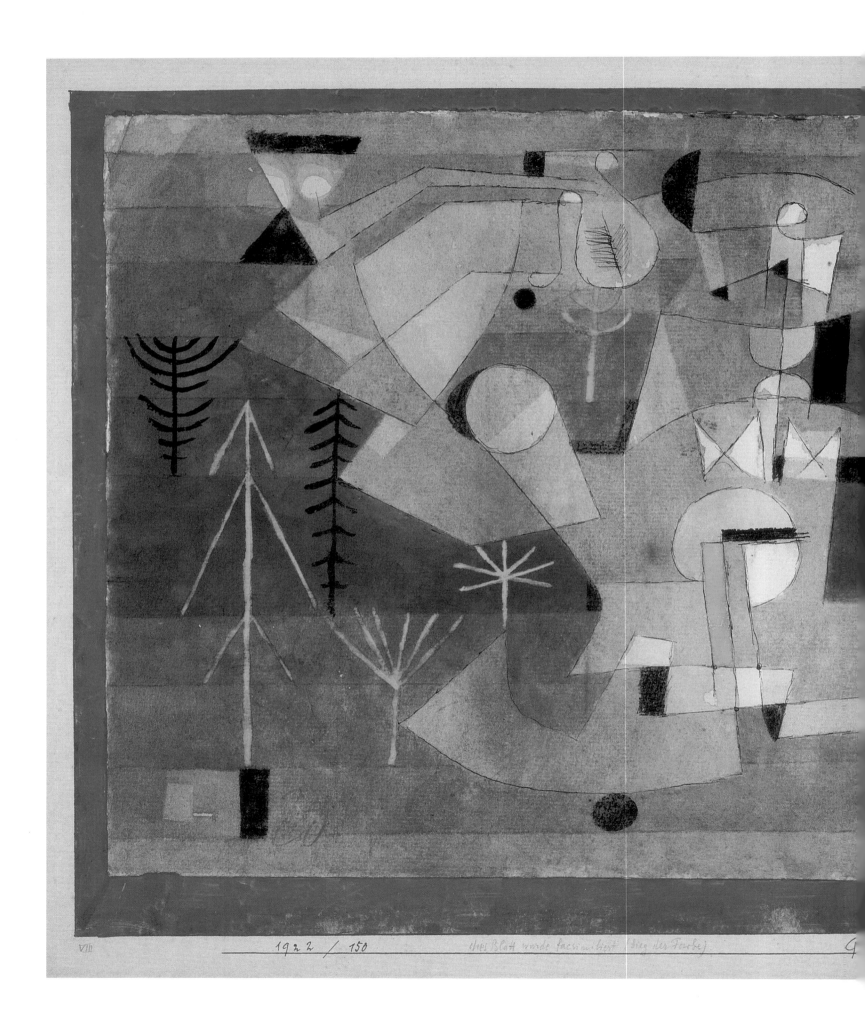

1922 / 150 dies Blatt wurde facsimiliert (Sieg der Farbe).

GARDEN PLAN

1922, *150,* watercolour and ink
on paper mounted on board,
26.6 × 33.5 cm (10.5 × 13.2 in.).
Paul-Klee-Stiftung, Kunstmuseum, Bern.

same period, who renders human misery by painting harlequins with faded ruffs. A few years later, however, in *Absorption*, Klee's self-portrait of 1919, a mere brushstroke suffices to register the shape of the face, and mark out the nose and mouth. The artist's beard gives way to an uninterrupted necklace of tiny spirals superimposed in counterpoint on the linear trace of the jaw-line. "Here's a line thinking. Another is fulfilling a thought. Lines at stake, lines of decision", is Henri Michaux's apt description of Klee's work. [1] A transformation has taken place, one which no longer relates to anatomical resemblance or expressiveness. "A line meets a line. A line avoids a line. Adventures of lines." [2] The destruction of the old rules of the art of portraiture – its emancipation from cultural, psychological and sentimental connotations – was required before the human psyche could yield itself up freely before our eyes.

Perspective gone mad

The notion of 'writing', since it does not duplicate that of drawing, is neither gratuitous nor extraneous to this context. To take a famous example: in his *Portrait of Yvette Guilbert,* Toulouse-Lautrec retains only the salient features of the singer's face, together with her long, talon-like hands in black gloves, leaving arms, chest and corsage out of account. He does not draw her: he *writes* her. This allows him to excavate, to dissect reality and, at the same time, to infuse it with meaning. This was better understood in the Middle Ages. The tree of knowledge from the Chapel of the Holy Cross Hermitage at Maderuelo sprouts tentacles that envelop Adam and Eve, stinging and paralysing them; its trunk becomes a coiled serpent. It thus deploys all its resources to *write*, to 'spell out' punishment. Many centuries later, writing disappeared;

1 Henri Michaux: 'Adventures of Lines', in *Darkness Moves. An Henri Michaux Anthology: 1927-1984.* Selected, translated and presented by David Ball, University of California Press, Berkeley and Los Angeles, 1994, pp. 317-318.
2 *Ibid.*

drawing took its place, seeking to 'render' the visible world. In Bouguereau and Meissonier drawing reaches its lowest point, seeking only to copy the world. In our own day, Klee did not content himself merely with rehabilitating writing or script; of all modern artists, it was he who raised it to its maximum intensity. "A line is germinating. A thousand others around it, bearers of thrusts... A line gives up, a line rests", notes Michaux.[1] Line is the chief instrument by which we can represent human beings and plants, relative to the new consciousness and knowledge we have of them. However, Klee's field of investigation does not end there. "A man of antiquity sailing a boat, quite content and enjoying the ingenious comfort of the contrivance. The ancients represent the scene accordingly", writes Klee in the passage which precedes the two of the *Cretive Credo* I have just quoted. "And now: What a modern man experiences as he walks across the deck of a steamer: 1. his own movement, 2. the movement of the ship which may be in the opposite direction, 3. the direction and velocity of the current, 4. the rotation of the Earth, 5. its orbit, 6. the orbits of the Moon and the planets around it."[2] For Klee, the Earth is no longer the immovable ground beneath our feet, which we survey in order to determine its bounds. It becomes a star launched into space, in all its dynamic relations with other stars. It was, then, no longer possible to lock nature away in a scenic cube, as most of Western painting has done since the Renaissance. In this, we revert to the concentric circles of the *Pedagogical Sketch Book*, which have expanded now to the dimensions of the universe. Klee in fact lived on a cosmic scale, not intellectually or by an effort of imagination, but perceptually, in his very flesh. This was so when he picked a flower, let the sun's rays shine upon him, bathed in a river, climbed a mountain or walked a country path.

Very serious disturbances in pictorial structure ensued from this. In Klee's work, the Euclidean perspective is at times dislocated or stretched to extremes, precisely in order to demonstrate the inadequacy of our ancestral conception of scale. This is the case in *Uncomposed Objects in Space* (1929), in which the human figures and the transparent cubes in the composition seem to be attracted by an invisible, magnetizing pole. Incapable of fitting in with, or into, one another, they are piled on the ground, all hope of

UNCOMPOSED OBJECTS IN SPACE
1929, *124 (C 4)*,
watercolour,
pen and Indian ink on paper,
mounted on board,
31.7 × 24.5 cm (12.5 × 9.6 in.).
Private collection, Switzerland.

1 *Ibid.*, p. 318.
2 *The Thinking Eye, op. cit.*, p. 79.

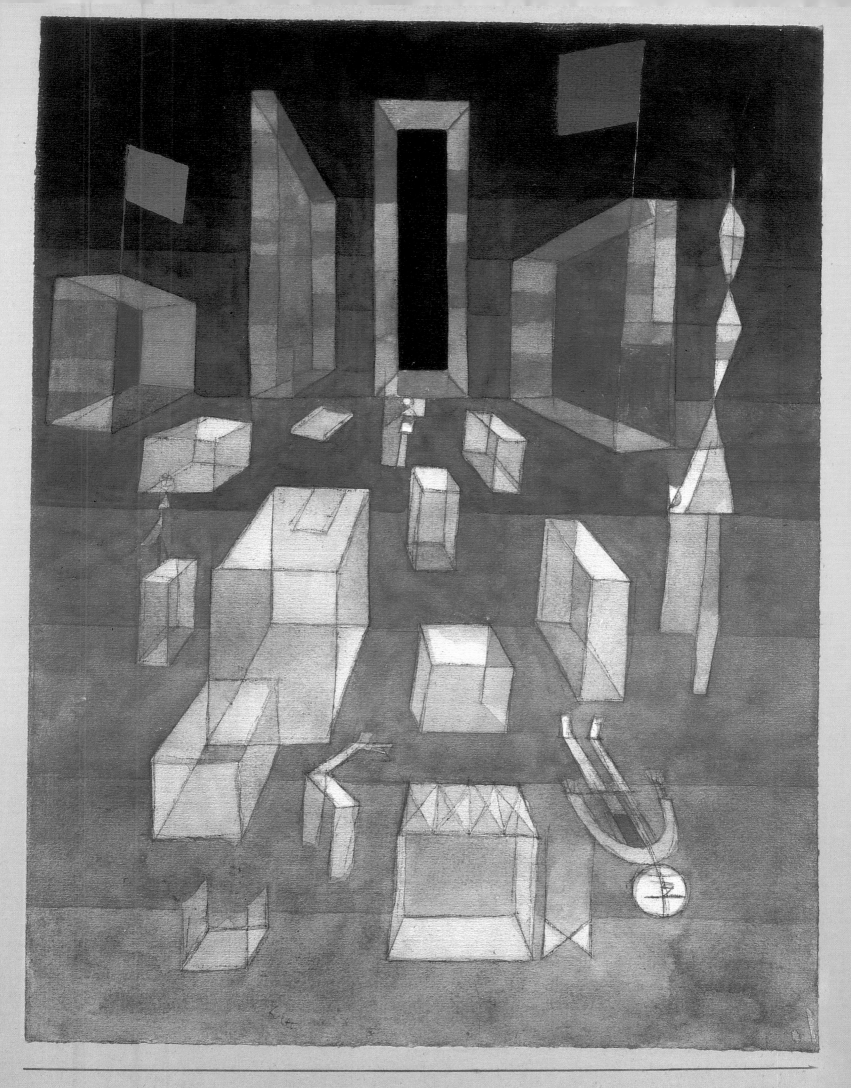

1929 C.4 Nicht componiertes im Raum

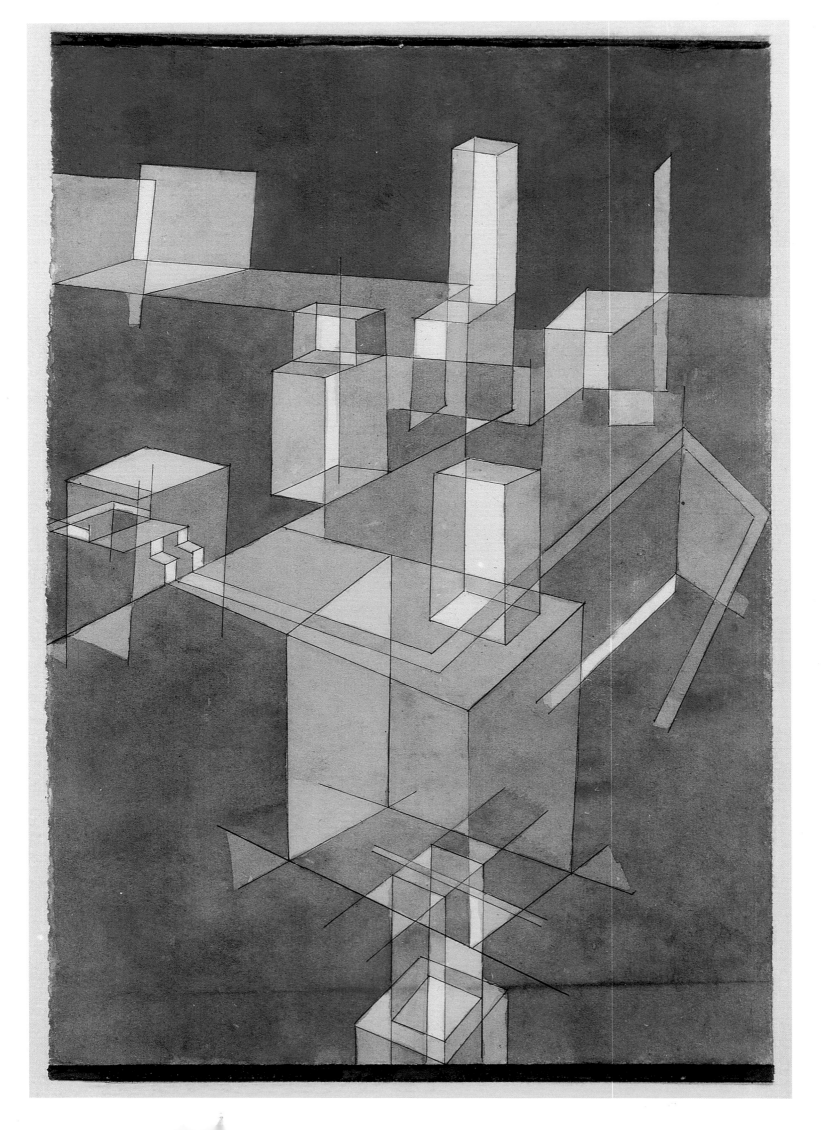

ITALIAN CITY

1928, 66, watercolour on paper,
34 × 23.5 cm (13.4 × 9.2 in.).
Private collection, Switzerland.

conjunction abandoned. At times we find a multiple perspective, as in *Italian City,* painted the year before, in which the multiplicity of divergent intersections and vanishing points and the unstable piling up of volumes produce a strong sense of imbalance. Those of Klee's works that do make play with Euclidean space express something we may term 'perspective gone mad'. And it is no coincidence that one of the first paintings in the series is called *Italian City;* Klee is attempting to destroy the traditional illusionism from within the tradition, and be done once and for all with the path opened up in Quattrocento Florence by Brunelleschi.

This leads Klee to the combined theme of the labyrinth and the tentacular city. In *The Way to the City Castle* (1937), the cellular composition, the little arrows, circuits, false *vedute* and trails leading nowhere all conspire to mislead the spectator's eye. Moreover, in his many works inspired by towns and cities perspective itself becomes a form of writing; it shifts between one street and another, links the districts of the city, and ends up covering the whole earth – and the moon over which it eagerly swarms – with an intense urban fabric. We seek in vain here for palaces spreading their harmonious wings, parkland drives stretching as far as the eye can see, clearly laid-out gardens, lakes and waterways, arcades and galleries. The dome of Santa Maria dei Fiori and the houses on the Ponte Vecchio give way now to the only city built on our scale: megalopolis. Klee turns Euclid into his opposite. He uses him merely to generate confusion. We lose ourselves in his pictures because, at the level of sensibility, as well as of knowledge and imagination, the reality we are obliquely aware of today is so vast that it can no longer be positively circumscribed.

The Quattrocento sought to triangulate reality in order to assign beings and things to their fixed positions in the visual hierarchy. Klee, by contrast, is haunted by the 'dissolution of frontiers' or, in other words, with a crossing of the intellectual and affective threshold beyond which the whole of reality is suddenly seen to *fit together.* Many have questioned the origin and meaning of the 'magic squares' which recur throughout Klee's work, and which are primarily responsible for the perception of him as a near-abstract painter. However, it would be wrong to neglect the realism – we might even say naturalism – of those squares. One of the most effective pictures in the series, a pastel of 1930 made up of interlocking, jostling coloured squares, stretching out to form an

1939 g 12

irregular pattern, is curiously entitled *Garden in Bloom*. Replacing perspective with a differential system in which forces and tensions come into play, it is, perhaps, not immediately legible in terms of a garden. But it loses its mystery once we grasp that it breaks with visual description to espouse olfactory perception. This is no dizzying flight of metaphysics; the 'magic squares' simply abandon the descriptive conception of landscape to create new distinctions. They are what happens to consciousness when it abolishes all distance between itself and the reality within which it arises.

The writings of one of Klee's contemporaries, the biologist Jacob von Uexküll, are often very close in tone to Klee's own. About the status of perception, Uexküll remarks: "The forest as objectively determined place does not exist; there is one forest for the forester, another for the hunter, yet another for the botanist, the walker, the lover of nature, the person gathering wood or picking berries,

K. Harbour

1939, *32 (G 12)*, pen and ink
on paper, mounted on board,
11.6 × 29.7 cm (4.6 × 11.7 in.).
Paul-Klee-Stiftung, Kunstmuseum, Bern.

Hafen von K.

and a forest of legend for Tom Thumb." The notion of objective
reality linked to form, colour, weight, and all the other charac-
teristics of the physical world is inadequate, if not indeed falla-
cious. Be it chopping down trees, hunting, walking or picking
berries, any human behaviour divides up the world of objects
differently and endows it with subject-centred meanings. In other
words, action shapes perception. Action is the vehicle of meaning.
Klee's aspiration is to attain that sense. In most of his works, the
image he presents of the visible world is an image endowed with
active characteristics, an *action image*.

This, along with writing, is one of the poles of the painter's
creative activity. The scattered funnels, the stem-posts, the frag-
ments of metallic hull which hover about *K. Harbour*, giving the
sense of a bustling harbour, actually express that action through its
schema, as we can see above.

Similarly, in *Village and Market Town* (1940), inspired by the little medieval towns still to be found in the Bernese countryside, an apparently artless drawing, a simple dab of paint are sufficient to express the cast of places and things: their inflections, their bulk, their secret interdependence. The truly vertiginous task is to go to things themselves, and *to find oneself* in them; the quest for an evasive transcendence is comparatively tame. Those who do not take the trouble to read Klee believe that his painting abstracts from, eludes or distorts reality. Far from it; it strips bare the thousand excitations, marvels and tiny wounds produced by the incredible reality of the world around and within us.

A visionary vision

There remains, however, the visionary dimension of Klee's work, an aspect from which one cannot turn away. It is present everywhere, from the earliest years, as we have seen, both in his etchings, which are not yet free of symbolist influence, in his paintings of vegetation or figures, and in his labyrinths and tentacular cities. Indeed, it is in and through that visionary dimension that the painter, in the last analysis, communicates with the 'greater universe'. This does not mean, however, that Klee was ever satisfied with the semi-spiritualist bric-à-brac that Hegel had long before denounced as the expression of a "false profundity". To his friend Schlemmer, who sent him the anthroposophic works of Rudolf Steiner, Klee replied, returning the package, "If this isn't trying to fool the world, then the aim is self-deception. It operates by suggestion. For truth to triumph, it does not need its opponents to be passive". No to pseudo-science, then. Reality does not end with the visible; Klee's *Creative Credo* famously opens with the phrase: "Art does not reproduce the visible, but makes visible." But to seek to berate the 'negativity' of the visible would be cheap trickery. It is on this essential point that Klee stands apart from surrealism, with which commentators have sometimes associated him. Not only did surrealist painting, in contrast with Klee's own, continue to use traditional, if not indeed, academic pictorial techniques, but it is almost entirely based on the notion of the incongruous. "Beautiful as the chance meeting on a dissection table of a sewing machine and an umbrella." Whether it be Max Ernst's elephant-cooking pot or Magritte's girl, whose breasts become eyes and whose navel becomes a mouth, surrealism only

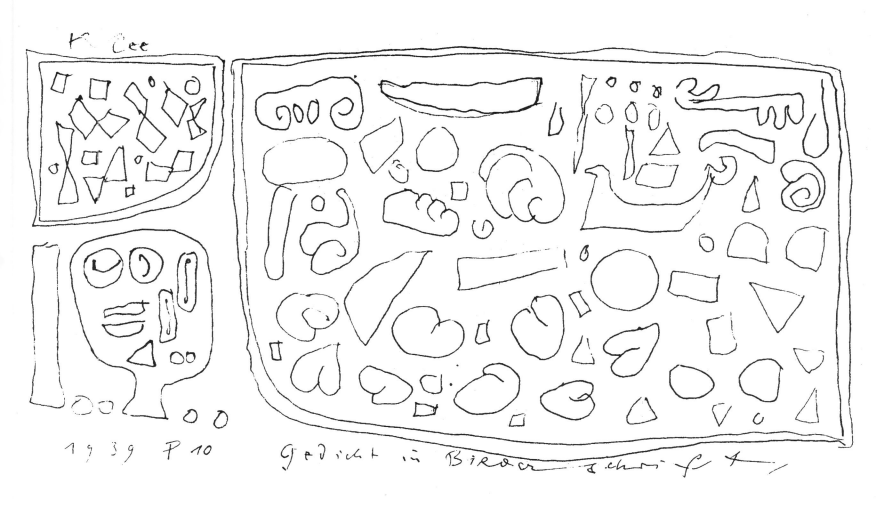

POEM IN PICTOGRAPHIC WRITING
1939, *170 (P 10),*
pen and ink on paper,
mounted on board,
10 × 21 cm (3.9 × 8.3 in.).
Private collection, Switzerland.

ever seeks the short-circuit, the stretching of metaphor to breaking-point. As specialists of the uncanny, the surrealists aim to 'disturb'. The significance of their paintings in the history of modern art is that they lay before our eyes the most extraordinary imagery ever seen. As Dali notes, surrealist painting consists in "photographing by hand and in colour the concrete irrational and the imaginative world in general". If we except Masson, who introduced automatic drawing into his experimental works of 1924-1927, the surrealist painters are mere "tracers of dreams".

Now, it is not dreams alone that fascinate Klee, but reality as it is. The beasts grazing in the meadows fascinate him, as do the trees, because their leaves grow back in spring. It is the phenomena that are apparently most natural which seem surreal to him. The fact that the moon is reborn again after disappearing: there lies the unfathomable mystery. "Living only on escape, surrealism did not

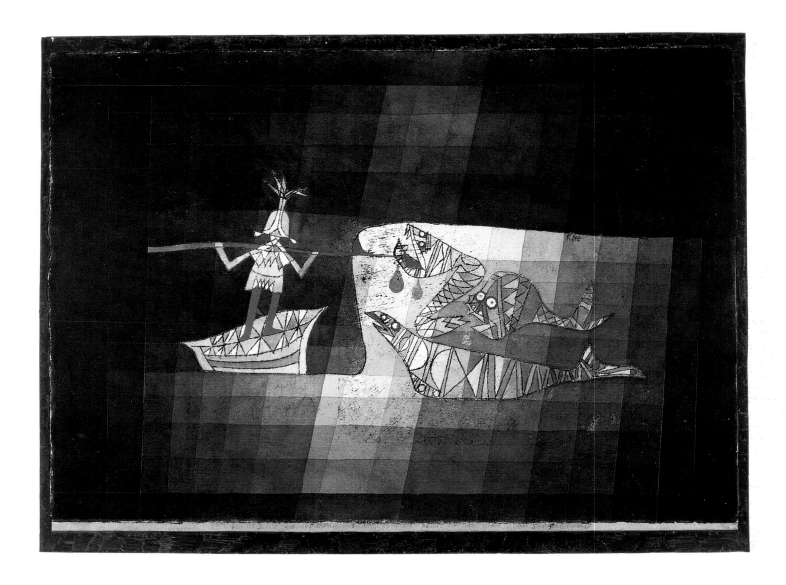

BATTLE SCENE FROM THE COMIC OPERA, "THE SEAFARER"

1923, *123*, watercolour on paper, mounted on board, 37 × 51 cm (14.6 × 20 in.).
Private collection, Switzerland.

wish to find, could not find its embodiment, its chance of life. Disquiet as instrument remains a half-way point. Like objects extracted from dream, the object removed from the world rapidly wears out when exposed to the air", observed Jean Bazaine. Where the surrealist painter *bounces off* the surface of things, at best revealing their soft underbelly, Klee uses painting to open up a breach in reality.

In this connection, his exceptional *Torrent*,[1] a pen and water-colour work of 1937, is particularly significant. Klee had been fascinated in childhood by the lines on the surface of the heavy marble tables belonging to his uncle, a restaurant-owner near Bern, who was, if Klee is to be believed, "the fattest man in Switzerland". The chaotic mass of lines in those tables and the

1 Unfortunately, it was not possible to obtain the actual owner's permission to reproduce this picture.

many possible figures one could pick out in them, prompted him to draw endless human grotesques and extraordinary invented landscapes. "I was fascinated with this pastime, my 'bent for the bizarre' announced itself." [1] Without knowing it, he was in his own way reproducing Leonardo's experience of the exemplary wall. But there was an important difference; the polished marble had a hallucinatory effect on his gaze, forcing him, all unaware, to explore the depths of his being as though in a mirror. Now in *Torrent*, it is probable that the currents which mingle, separate and re-form, the swirling waters which crash into invisible rocks, and the networks of tangled lines are the product, at half a century's remove, of his childish scribblings. A torrent is not a river. Or, more properly, it is a mountain river. It moves swiftly and impetuously. Its waters are not usually very deep, but rise with the slightest storm, becoming swollen as the snows melt, and sweeping away uprooted trees and dead branches. Far from being descriptive and thus external to the artist, the picture's plunging, rebounding *function* is 'performed' in his innermost heart – and his heart's function in it.

Two mountain rivers, the White and the Black Lutschine, work their way down from the glaciers in the valleys of Lauterbrunnen and Grindelwald and join forces before hurtling into the Lake of Brienz at the foot of the Alps, a hundred kilometres or so from Bern. Now, popular legend has it that those who fall into either of the two Lutschines disappear for ever, swallowed up by the foaming waves, and are forever held captive in the caves hollowed out in their beds; they die twice over. This legend is intended to teach the children of the area to be careful when playing at the water's edge, but in fact it fills them with terror. Klee must surely have known the legend; at the time, Alpine walks were all the fashion among Bernese families. Of all the rushing mountain streams the artist may have crossed – or peered into – in his native Switzerland (he returned every summer for long stays), the two Lutschines must have exercised an essential influence on him. At its various levels – perceptual hallucination, legendary narration and reminiscence – the *mythic image* here provokes and shapes the action image. Each time such an encounter occurs, Klee completes the circle and produces one of his best works.

Pages 114-115 |
THE GOLDFISH
1925, *86 (R 6)*,
oil and watercolour on paper,
mounted on board,
48.5 × 68.5 cm (19 × 27 in.).
Kunsthalle, Hamburg.

1 *Diaries op. cit.*, p. 8.

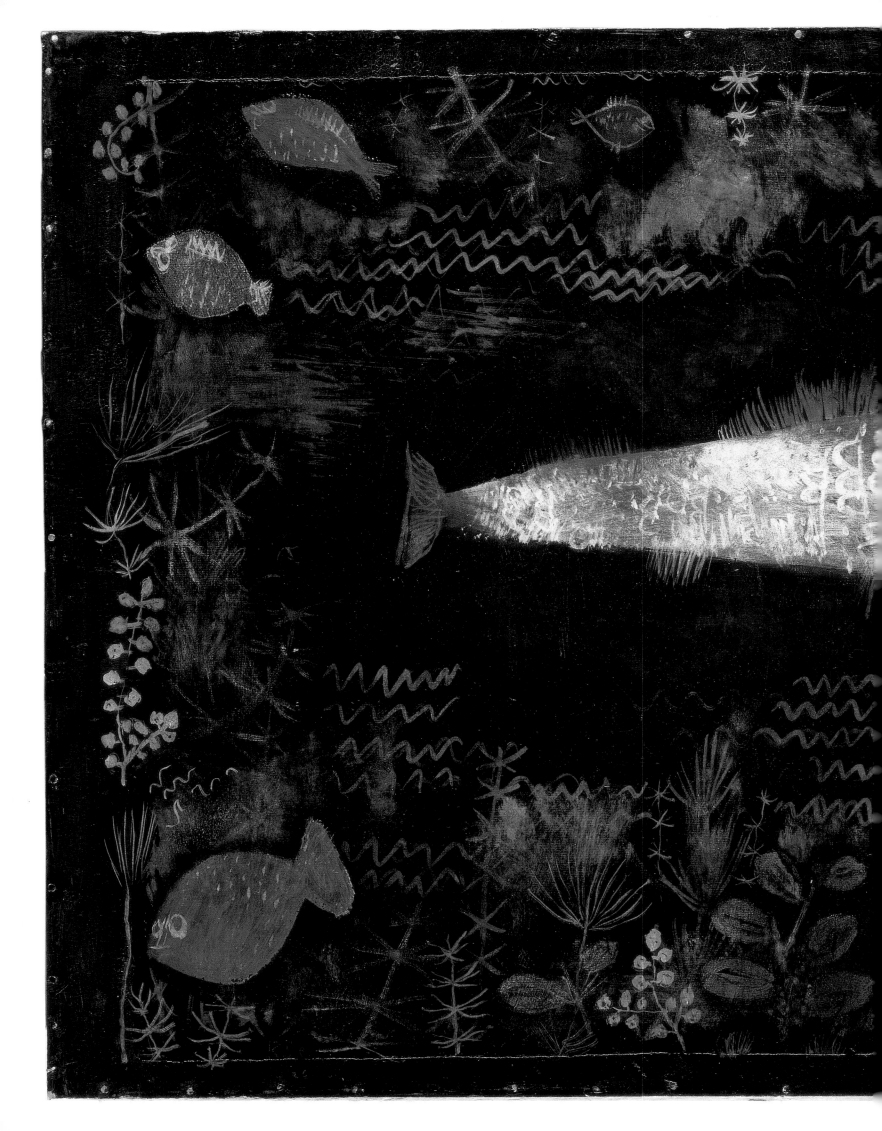

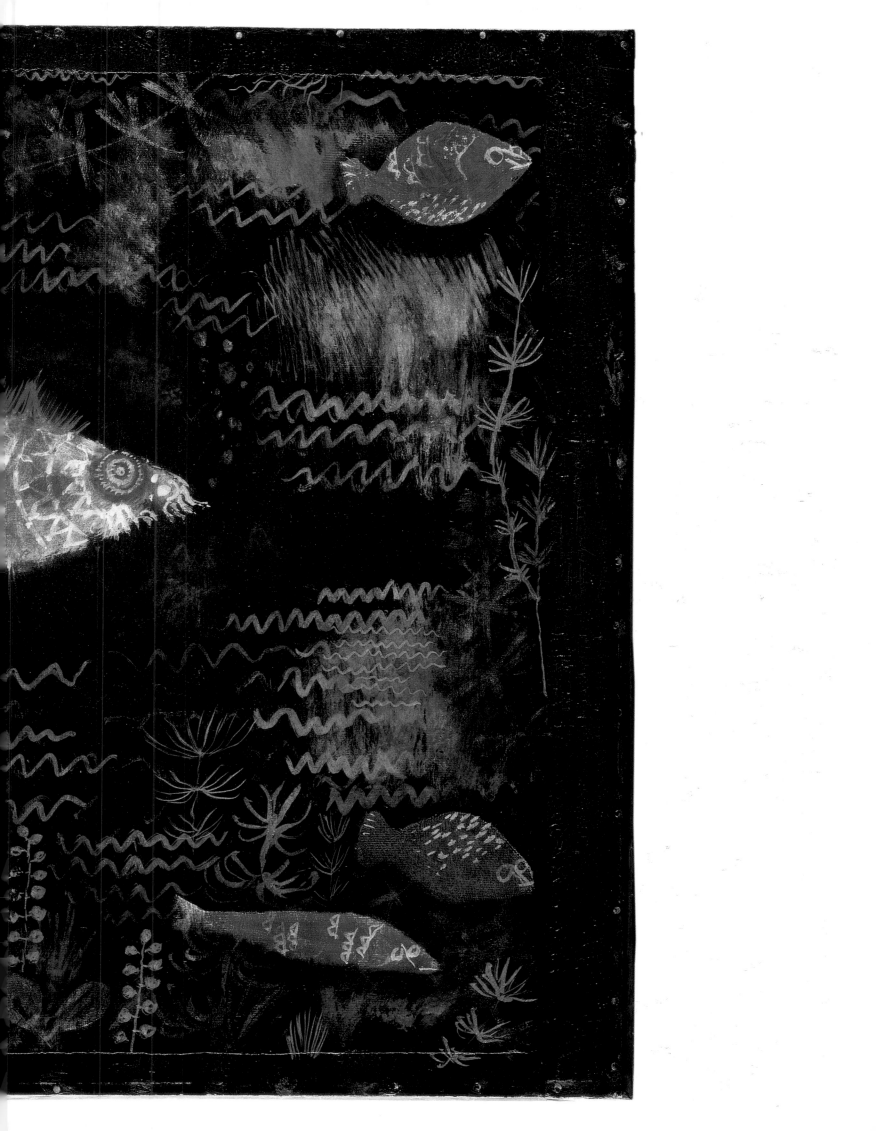

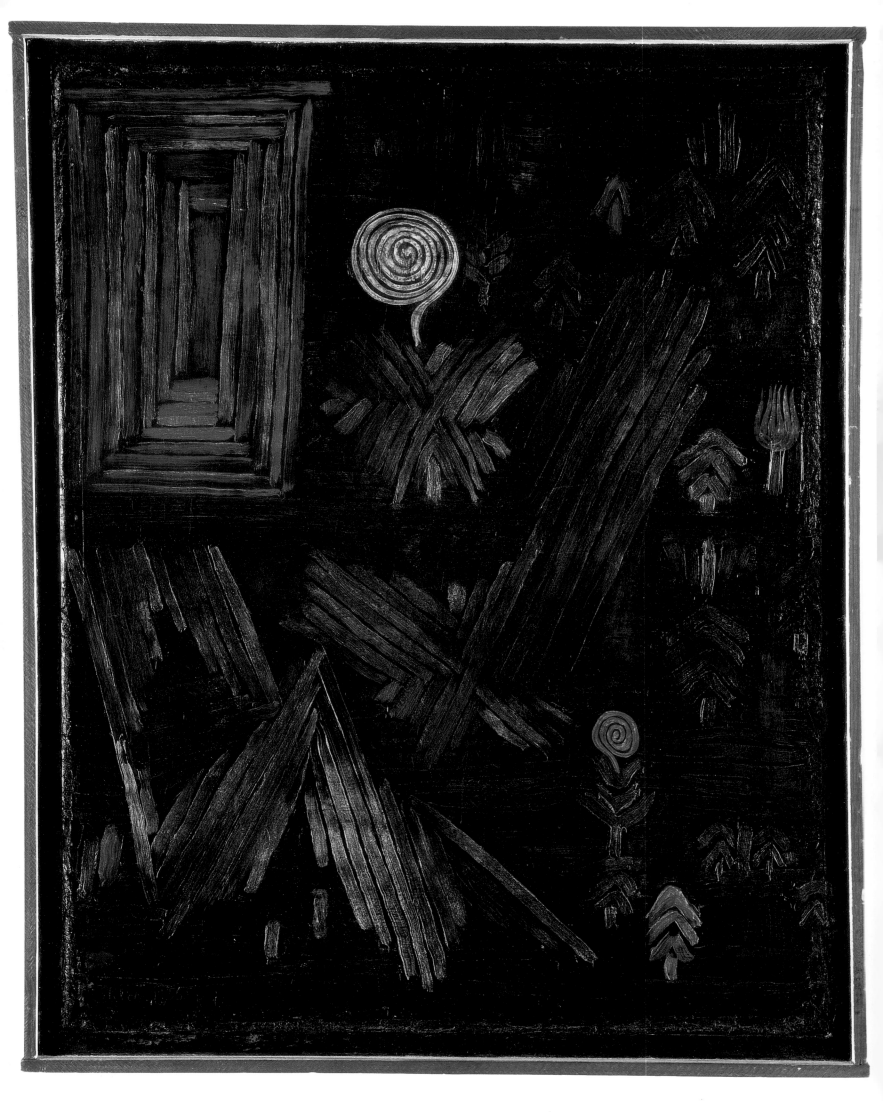

GATE IN THE GARDEN
1926, *81 (R 1)*, oil on board,
original frame,
54.7 × 44 cm (21.5 × 17.3 in.).
Max Huggler Collection,
Kunstmuseum, Bern.

We are now in a position to understand the meaning of the creative act in Klee's art. That act may be indissociable from the scientific, psychoanalytic and technical knowledge of our age, and it may, as we have seen with the works featuring vegetation or with his conception of anatomy, be essential to take account of that knowledge in order to 'read' him. But this does not mean that his creative work is the product or 'reflection' of that knowledge. One of Jung's most attractive hypotheses is the idea that, running parallel to the organic evolution that led to the formation of our species, there is a psychic transformism, of which Jung believes we still bear the traces in the depths of our being. This is a hypothesis corroborated by the recent discovery of the three constantly interacting brains – the archi-cortex, meso-cortex and neo-cortex – tightly coiled in our skulls. As a consequence of that discovery, we might all be said to have a little of the reptile and the lower mammal in our behaviour and thoughts, retaining an 'echo' of these origins that at times rises from the depths to stir up our fears. The intuition of this kind of transformism is constantly present in Klee's work, and it underpins the articulation of the visionary and operative dimensions of his painting.

The philosophy and, to a lesser extent, the literature of our century have not succeeded in integrating science into their purview. But science, whether we like it or not, is the single great adventure of modern man. As a result, our philosophy and literature are often left with no purchase on the world. However, what the philosophers and writers have so far failed to do has been achieved by a painter. He achieved it not with any kind of technical drawing – Klee's art is the very opposite of an engineer's – but by expressing our scientific 'becoming' in terms of Being. Only by the expression of that 'becoming' could he establish Being in its supreme Reality. In his youth, as we know, Klee was a talented violinist. Throughout his life he listened to – and played – music with a passion. If he preferred painting, it was, as he declared, because he felt painting lagged far behind, and he thought he could help it make a little progress. The 'little progress' turned out to be an enormous leap that set the visual arts on a new course. For all these reasons, the notions of metaphysical or poetic painting – notions approximate and condescending, but all too often applied to Klee's work – are completely alien to his achievement.

SHE BELLOWS, WE PLAY
1928, 70 (P 10),
oil on canvas, original frame,
43.5 × 56.5 cm (17.1 × 22.2 in.).
Paul-Klee-Stiftung, Kunstmuseum, Bern.

CROSS-BREED

1939, *10 132*,
distemper on burlap,
60 × 70 cm (23.6 × 27.5 in.).
Private collection, Switzerland.

4. Towards an Infinite Natural History

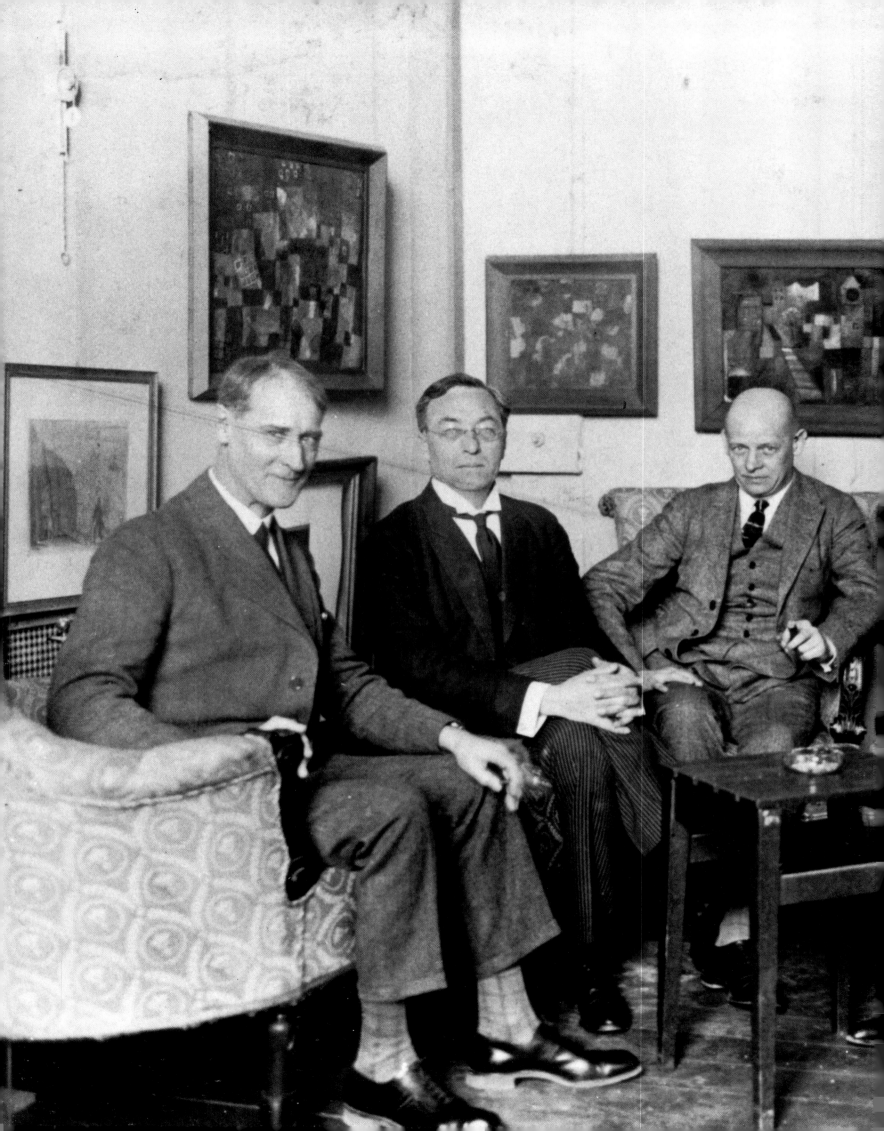

LYONEL FEININGER,
WASSILY KANDINSKY,
OSKAR SCHLEMMER,
GEORG MUCH
AND PAUL KLEE
At the Bauhaus
in Dessau in 1928.

PAUL KLEE AND WASSILY KANDINSKY

Photographed by Nina Kandinsky
at Hendaye, 1929.

Paul-Klee-Stiftung, Felix Klee Photographic
Archives, Kunstmuseum, Bern.

In 1920, the year Walter Gropius appointed Klee to teach at the Weimar Bauhaus, the artist had just published his main theoretical text, the *Creative Credo*, in number 14 of the Berlin-based *Tribüne der Kunst und Zeit*. I quoted two passages in the preceding chapter. Here is a third, longer, more complete extract:

"Let us develop: let us draw up a topographical plan and take a little journey to the land of Better Understanding. The first act of movement (line) takes us far beyond the dead point. After a short while we stop to get our breath (interrupted line or, if we stop several times, an articulated line). And now a glance back to see how far we have come (counter-movement). We consider the road in this direction and in that (bundles of lines). A river is in the way, we use a boat (wavy motion). Farther upstream

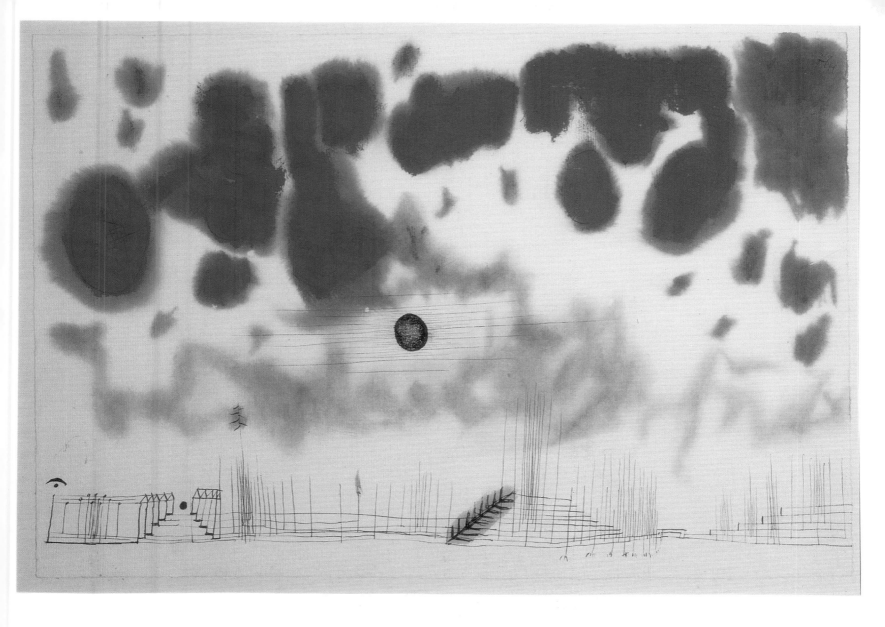

CLOUDS OVER BOR
1928, *155*, watercolour and ink
drawing on paper,
30.5 × 45.7 cm (12 × 18 in.).
Private collection, Switzerland.

we should have found a bridge (series of arches). On the other side we meet a man of like mind, who also wants to go where Better Understanding is to be found. At first we are so delighted that we agree (convergence), but little by little differences arise (two separate lines are drawn). A certain agitation on both sides (expression, dynamics, and psyche of the line).

We cross an unploughed field (area traversed by lines), then a dense wood. He gets lost, searches and once even describes the classical movement of a running dog. I am no longer quite calm either: another river with fog (spatial element) over it. But soon the fog lifts. Some basket-weavers are returning home with their carts (the wheel). Accompanied by a child with the merriest curls

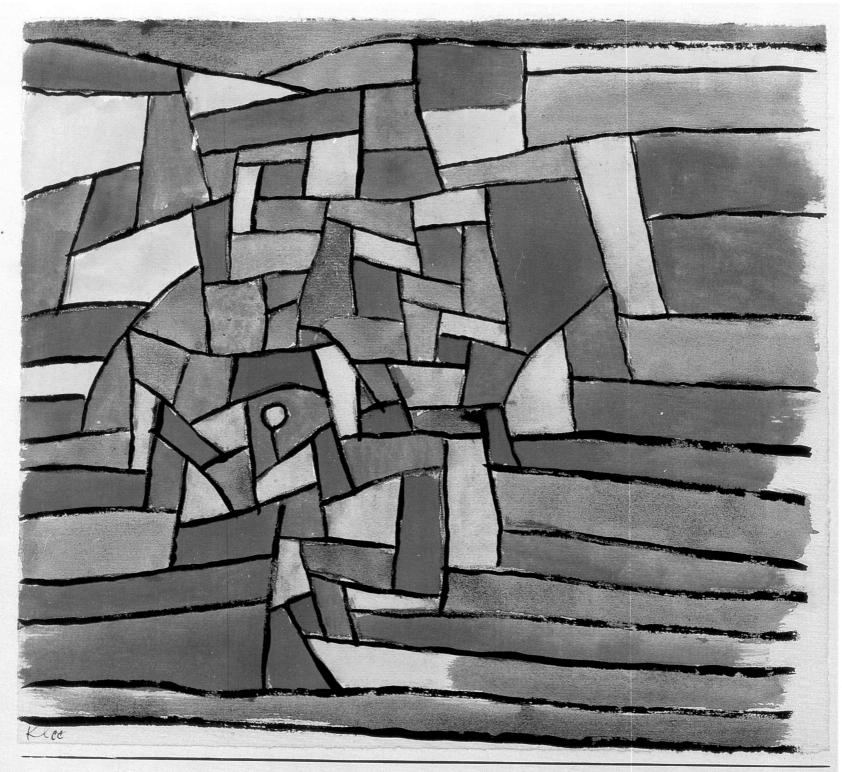

Klee

1927 V 10. Garten am Bach

(spiral movement). Later it grows dark and sultry (spatial element). A flash of lightning on the horizon (zigzag line). Over us there are still stars (field of points). Soon we come back to our original lodging. Before we fall asleep, a number of memories come back to us, for a short trip of this kind leaves us full of impressions.

All sorts of lines. Spots. Dots. Smooth surfaces. Dotted surfaces, shaded surfaces. Wavy movement. Constricted, articulated movement. Countermovement. Network and weaving. Brickwork, fish-scales. Solo. Chorus. A line losing itself, a line growing stronger (dynamics).

The happy equanimity of the first stretch, then the inhibitions, the nervousness! Restrained trembling, the caress of hopeful breezes. Before the storm, the gadflies' attack. The fury, the murder. The good cause a guiding thread, even in the thick of twilight. The lightning shaped like the fever curve. Of a sick child... Long ago."[1]

GARDEN BY THE STREAM
1927, 220 (V 10),
watercolour on paper,
27.5 × 30.6 cm (10.8 × 12 in.).
Private collection, Switzerland.

This remarkable academic exercise is quite self-contained and does not refer precisely to any single picture by Klee, unless perhaps *Landscape with Gallows*, which he had worked on the previous year while composing his text. But the fact is that these principles are at work in most of Klee's pictures. The passage consolidates the notion of the action image; indeed, it completes it insofar as, in the first sentence, there is an announcement that we are going to journey to the "land of Better Understanding", halfway between the real and the imaginary. As with the painters of the Renaissance and, closer to our own day, the impressionists, the dialogue with nature remained for Klee an essential condition of his work; the artist, as a human being, is part of nature, and it was, in his view, delusive to believe that one could detach oneself from it. However, whereas Alberti in *De pictura* defines perspective as a window opened on to the world, Klee jumps out of the Albertian window and moves around in the world – every line, every shape, every surface, every volume being first and foremost, for him, a movement in time and space. Klee was, moreover,

1 *The Thinking Eye, op. cit.*, pp. 76-77.

anxious to ensure a perfect correspondence between his theoretical discourse and his painting. The parentheses in the passage just quoted are therefore crucial; they indicate the graphic signs required for the expression of each stage and for each of the external and internal aspects of the journey on which he wishes to take us. This insistence on never theorizing *in abstracto* can be seen throughout his writings. It is obvious in those published in his lifetime, which comprise a small number of articles and the *Pedagogical Sketch Book*, a short work published by the Bauhaus press in 1925. It is equally obvious in his lecture notes; these, scrupulously drafted and accompanied by diagrams, provide the content of two posthumous volumes.[1]

The pedagogic spirit

Klee's early career had not been easy. He had suffered many an affront, such as being exhibited in the corridors of the Thannhauser Gallery in Munich in 1911. But he was on the path to celebrity when, on 25 October 1920, the following telegram reached him in Ticino, where he was staying: "Dear Mr Klee. We unanimously invite you to join us in Weimar as a master of the Bauhaus. Signed Gropius, Feininger, Engelmann, Marcks, Itten, Klemm." He could not let this opportunity pass, and accepted immediately, moving to Weimar to begin his teaching in January 1921. His pleasure at the invitation was enhanced by the fact that, the year before, Oskar Schlemmer had attempted to have him appointed to the Stuttgart Academy of Fine Arts. The initiative had come to nothing; it was, it seems, impossible to consider for a teaching post an artist so absorbed in his own personal reflections, and Klee was insufficiently serious to satisfy "the powerful impetus towards structure and composition that the new movement rightly demand[ed]" of its teachers.[2]

By contrast, at the Bauhaus, Klee's arrival was eagerly anticipated, the students being overjoyed at the prospect of his coming. Founded in 1919 by Walter Gropius, the Bauhaus was not an official educational institution; its aim was to reconcile the fine arts with craft work, in order to achieve a total art, one capable of illuminating all aspects of individual and collective life, as in the

RAGGED GHOST
1933, 465 *(J 5)*,
Coloured paste,
applied with a palette knife
over a watercolour sketch
on paper mounted on board,
48 × 33.1 cm (18.9 × 13 in.).
Paul-Klee-Stiftung, Kunstmuseum, Bern.

1 Paul Klee: *Notebooks. Volume 1: The Thinking Eye, op. cit.*, and *Notebooks. Volume 2: The Nature of Nature*, tr. Heinz Norden, Lund Humphries, London, 1961.
2 *The Thinking Eye, op. cit.*, p. 22.

1933 J 5 Lumpen gespenst

Middle Ages. The four-page manifesto in which Gropius laid out his programme has as its frontispiece a *Cathedral of the Future*, engraved by Feininger and decorated with stars. Some have seen this as an allusion to the Bolshevik revolution and the hope it aroused. To underscore their relationship with the craft world, the teachers did not bear the academic title of professor, but that of master *(Meister)*, as used in manual crafts, and the students were called 'apprentices' or 'journeymen'. They underwent an apprenticeship in carpentry, weaving, pottery, painting on glass, and mural or decorative painting at one of the Bauhaus workshops. There was also a one-semester preliminary course on the rudiments of form and its problems. However, art clearly predominated over crafts at the Bauhaus, since the teaching staff was largely made up of painters. Among them were Kandinsky, who joined the school in 1923, and Muche and Schlemmer, who had come to prominence through the *Almanach* and the two *Blaue Reiter* exhibitions in Munich of 1911 and 1922.

The teaching in the studios at Weimar laid great emphasis on the study of materials: wood, stone, glass and fabric. The student was familiarized with the potential of all these materials. However, after the school was transferred to Dessau in 1926, the accent was increasingly on the creation of objects and furniture in metal for industrial production, with the result that the name Bauhaus is strongly associated with a particular notion of design. Breuer and Stam's chairs made of leather stretched over a chrome tubular frame and Mies van der Rohe's 'Barcelona' chair, all of which have been in production almost uninterruptedly since their inception, are famous examples of this. Office lamps providing functional lighting also originated with the Bauhaus, as did the ingenious Waterman inkstand, whose shape made it possible to extract the very last drop of ink with one's fountain pen and which, with the coming of the ballpoint, is now a museum piece.

The *Pedagogical Sketch Book* begins with a reflection on lines. A first drawing shows an 'active' line, which moves with extreme freedom wherever it pleases. The line is next accompanied by others that both complement and relativize it; it then twists back on itself; then two secondary lines play with each other, in such a way that the main line produced by this game becomes an 'imaginary' one. Reproductions of six variations on these line games can be

| Pages 132-133
Six Schemata
| Illustrating Klee's thinking
| on the subject of the line.

found on the following pages, for they are indicative of Klee's method, both in the realization of his own works and his teaching. They show how he liked to go straight to the heart of creative activity.

But the *Pedagogical Sketch Book* does not, of course, end there. Nor does Klee's line; its 'slow-motion' movement is then subjected to 'delays', and stretches between definite points before forming surfaces such as rectangles, triangles, circumferences. In these, the line encloses itself, in the process abolishing its status as free form. Klee goes on to discuss many questions, including the representation of a swimmer's leg movements.

Klee also examines the question of human anatomy. In the previous chapter, I presented the diagram that symbolizes a functional hierarchy between the parts of the body in terms of concentric circles, with the brain lying at the centre as a kind of command post. Other considerations follow, explained via diagrams, on the forces governing a water-mill. Then come some remarks on equilibrium, on unbalancing and re-balancing, on the steps of a staircase, which, as an effect of fatigue, increase in height as you climb them, or the growing intervals between the bounces of a stone as it tumbles down a precipice. Earth, water, air, mountains, the movement and countermovement of the pendulum, and the transformation of the circle into a spiral by the increase of its radius; all these are accorded explanations rich in descriptive and subjective implications. Klee was thoroughly *au fait* with the exact sciences, and knew that, for modern epistemology, knowledge is approximate, and the more efficacious for being aware of its own relativity. In the intermediate area between efficacy and subjective interpretation, this incisive *vade mecum* was wrought. The Bauhaus students for whom Klee wrote it were privileged indeed.

The thousand or so pages of notes he used as the basis of his teaching are too numerous and complex to summarize. Klee's method is laid out in them clearly, from the very first lesson. This is devoted to the notions of cosmos and chaos, which had, as his *Diaries* show, preoccupied him since his youth. The following is a passage from that lesson: "Chaos as antithesis is not complete and utter chaos, but a locally determined concept relating to the concept of the cosmos. Utter chaos can never be put on a scale, but will remain forever unweighable and unmeasurable. It can be Nothing or a dormant Something, death or birth, according to the

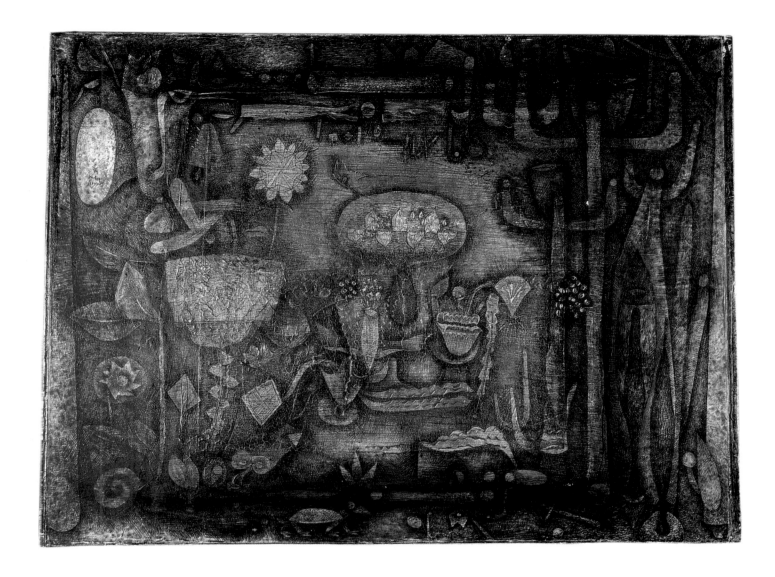

BOTANICAL THEATRE
1934, *219*, oil and watercolour
on board, mounted on wood,
50 × 67 cm (19.7 × 26.4 in.).
Lenbachhaus Gallery, Munich.

dominance of will or lack of will, of willing or not-willing… The pictorial symbol for this 'non-concept' is the point that is really not a point, the mathematical point. The nowhere-existent something or the somewhere-existent nothing is a non-conceptual concept of freedom from opposition. If we express it in terms of the perceptible (as though drawing up a balance sheet of chaos), we arrive at the concept Grey, at the fateful point between coming-into-being and passing-away: the grey point. The point is grey because it is neither white nor black or because it is white and black at the same time. It is grey because it is neither up nor down or because it is both up and down. It is grey because it is neither hot nor cold; it is grey because it is a non-dimensional point, a point between the dimensions".[1]

1 *Ibia*, p. 3.

SEA SNAIL KING
1933, *279 (Y.19),*
brush, oil and water-based
paint on muslin with
a plaster ground over
plywood, original frame,
28 × 43 cm
(11 × 16.9 in.).
Paul-Klee-Stiftung,
Kunstmuseum, Bern.

As we can see here, Klee doesn't exactly ease his students into his teaching, and those not much given to philosophical speculation, however good their drawing skills, had to cope as best they might! However, quite apart from these speculations, the main point here is the decisive importance he accords to the grey point. This preponderance of grey seems to originate once again with Goethe, who – unlike Newton, whom he accused of having falsified his results on the breakdown of the spectrum of light – asserts that black is an integral element in the formation of colours. As a result, the Newtonian array of coloured waves, expressed in millimicrons between infrared and ultraviolet, is supplanted in Klee's thinking. Instead, starting out from the central grey point, the colours radiate out along axes – to the left towards blue, to the right towards orange, forwards towards green and yellow, backwards towards violet and red, upwards towards white, and downwards towards black. Thus the grey point is, in the end, a seed, and the colours are germinations whose end point is the fusion of the animal, vegetable and mineral kingdoms in the framework of an infinite natural history. Over the years, Klee had built up a sort of cabinet of curiosities. When he observed these, he found in them an echo of that fusion. His collection contained, among other things, seaweed that he had gathered on his Baltic seaside holidays; this he dried, placed between two glass plates and labelled as 'Baltic Sea Forest'. From Sicily and the Mediterranean he had brought back sea-urchins, sea-horses, coral and molluscs. He also had a collection of butterflies. His mineral collection included crystals, fossils, yellow amber, multicoloured sandstone, quartz and mica. This enabled him to study the form, composition and essence of the most diverse living or inanimate beings, to make comparisons, and establish classifications. A 1933 painting, *Seasnail King*, is particularly remarkable in this regard. It shows how, in Klee's mind, the animal and plant kingdoms could mingle and even merge. The heavy, enveloping lines of the drawing *Clumsily Impregnated* emphasize the fact that random effects sometimes occur in the course of germination, leading to the formation of defective creatures.

He also devoted some of his teaching to music, which he saw as having profound correspondences with painting, while admitting that these were largely beyond the scope of his analysis.[1] In a

SEPARATION IN THE EVENING
1922, 79, watercolour on paper,
mounted on board,
33.5 × 23.5 cm (13.2 × 9.2 in.).
Private collection, Switzerland.

1 *Ibid.*, pp. 271-292.

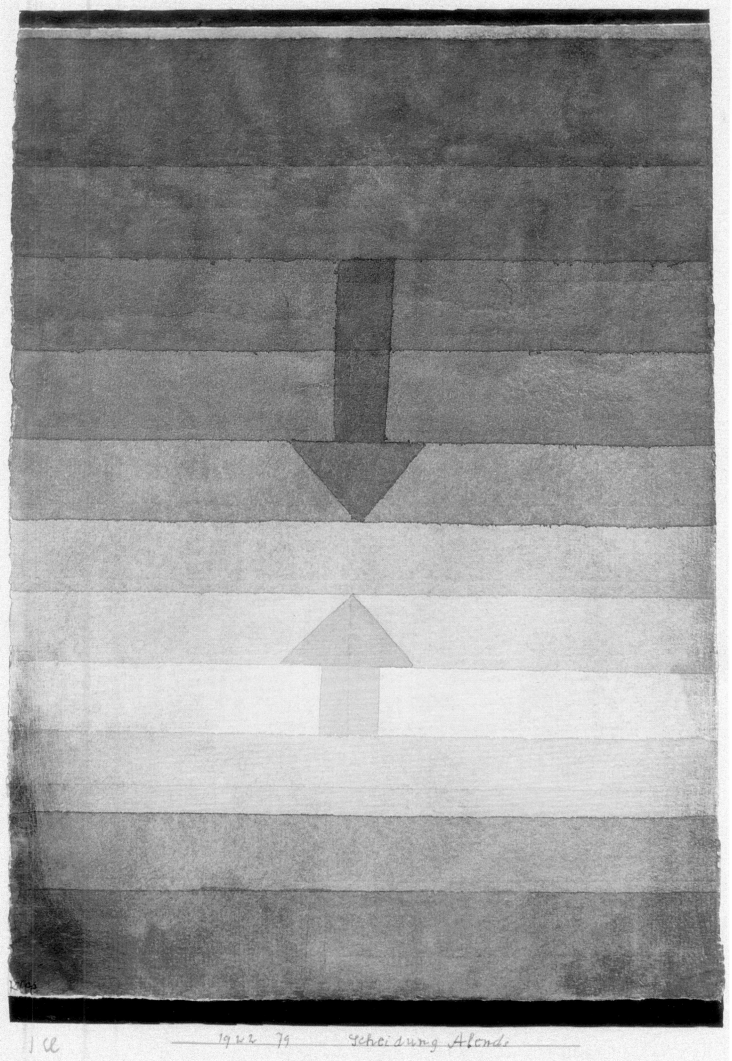

1 cc 1922 79 Scheidung Abends

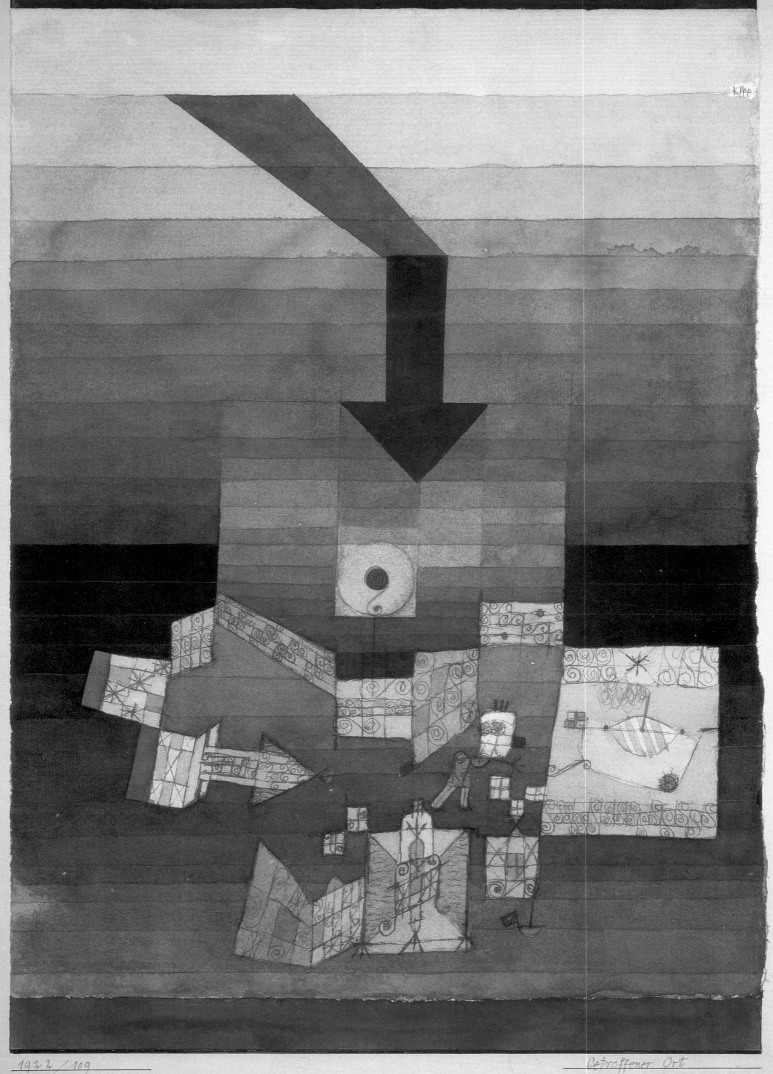

1922 / 109
S. CL

Betroffener Ort

section entitled 'Cultural Rhythms', he focuses on the notion of "beat", which he regards as the fundamental structure of music. He comes at this question through variants of the time signature communicated by the conductor's baton: two-, three- or four-time, and then the subdivision of these into six-, nine- and twelve-time. He shows how, and with what graphic resources, it is possible to obtain images of time signatures, which he categorises as "rigid", "fluid" and "flexible"; he also gives examples of "polychrome polyphony". The language becomes increasingly technical here. But the drawing, *Sailboats in Gentle Motion*, which he presents alongside the theory, and the way that he represents *The Rhine near Duisburg* using angles in motion, illustrates his notion that there can be a disjunction between line and surface, with the two acting as independent elements. This is a principle we shall encounter in many works from his last period.

During his Bauhaus years, his highly-characteristic arrows attain great prominence. "The father of the arrow is the thought: how do I expand my reach? Over this river? This lake? That mountain?" he writes in the *Pedagogical Sketch Book*.

**FORMATION
OF THE BLACK ARROW**

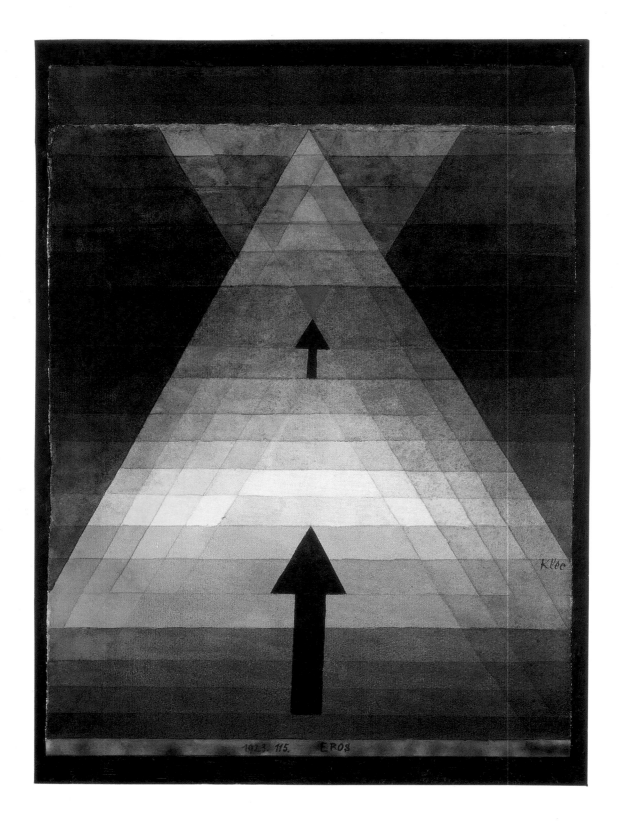

EROS

1923, *115*, watercolour
on paper, mounted on board,
33.3 × 24.5 cm (13.1 × 9.6 in.).

Angela Rosengart Collection, Lucerne.

DOUBLE TENT

1923, *114*, watercolour on paper,
mounted on board,
50.6 × 31.8 cm (19.9 × 12.5 in.).

Angela Rosengart Collection, Lucerne.

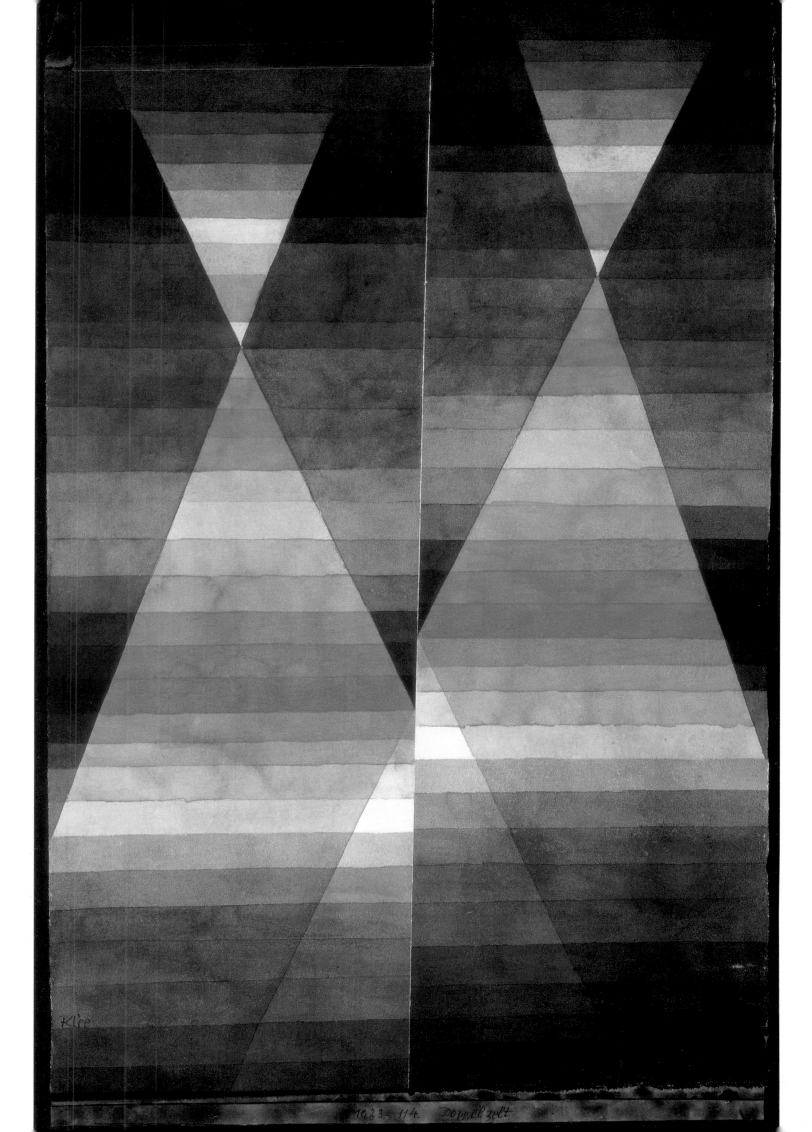

"The contrast between man's ideological capacity to move at random through material and metaphysical spaces and his physical limitations, is the origin of all human tragedy. It is this contrast between power and prostration that implies the duality of human existence. Half-winged – half-imprisoned, this is man! Thought is the mediary between earth and world. The broader the magnitude of his reach, the more painful man's tragic limitation. To be impelled toward motion and not to be the motor! Action bears this out. How does the arrow overcome the hindering friction? Never quite to get where motion is interminate. Revelation: that nothing that has a start can have infinity. Consolation: a bit farther than customary! – than possible? Be winged arrows, aiming at fulfilment and goal, even though you will tire without having reached the mark".[1]

There follows a naming of the parts of the arrow. Klee divides this into three components: the shaft, the point and the feathers. He explains that "equal length of the point-rudder and equal degrees of the point-rudder from the shaft result in straight flight", while "uneven lengths and uneven angle-degrees of the point-rudder" produce either an upward or downward deviation. He then provides the diagram of the 'Formation of the Black Arrow' (p. 141), which "forms when a given, or adequate, or actual white receives intensified energies from additive, acting or futural black".[2]

In the pictures themselves, the dynamism of the arrow is often accelerated by graded colour laid out in horizontal bands. Klee plays here on the crescendo and diminuendo of chromatic relations, which he achieves by a distribution of tones similar to the

1 Paul Klee: *Pedagogical Sketch Book, op. cit.,* p. 54.
2 *Ibid.,* p. 57.

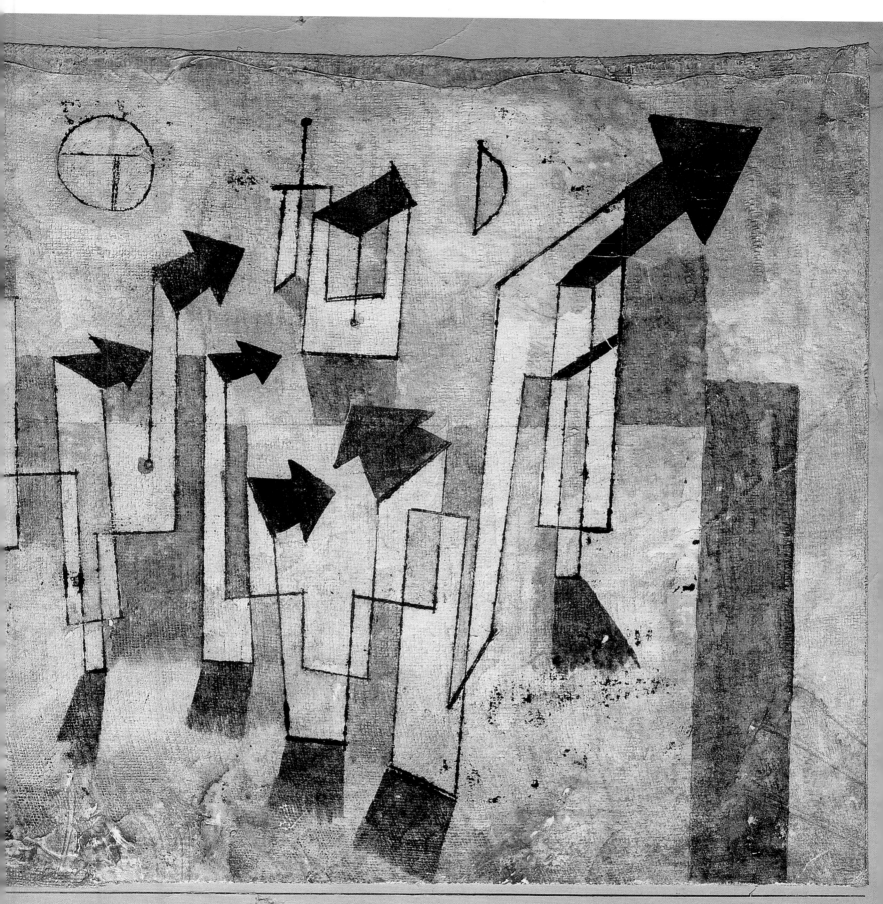

Wandbild aus dem Tempel der Sehnsucht "dorthin"

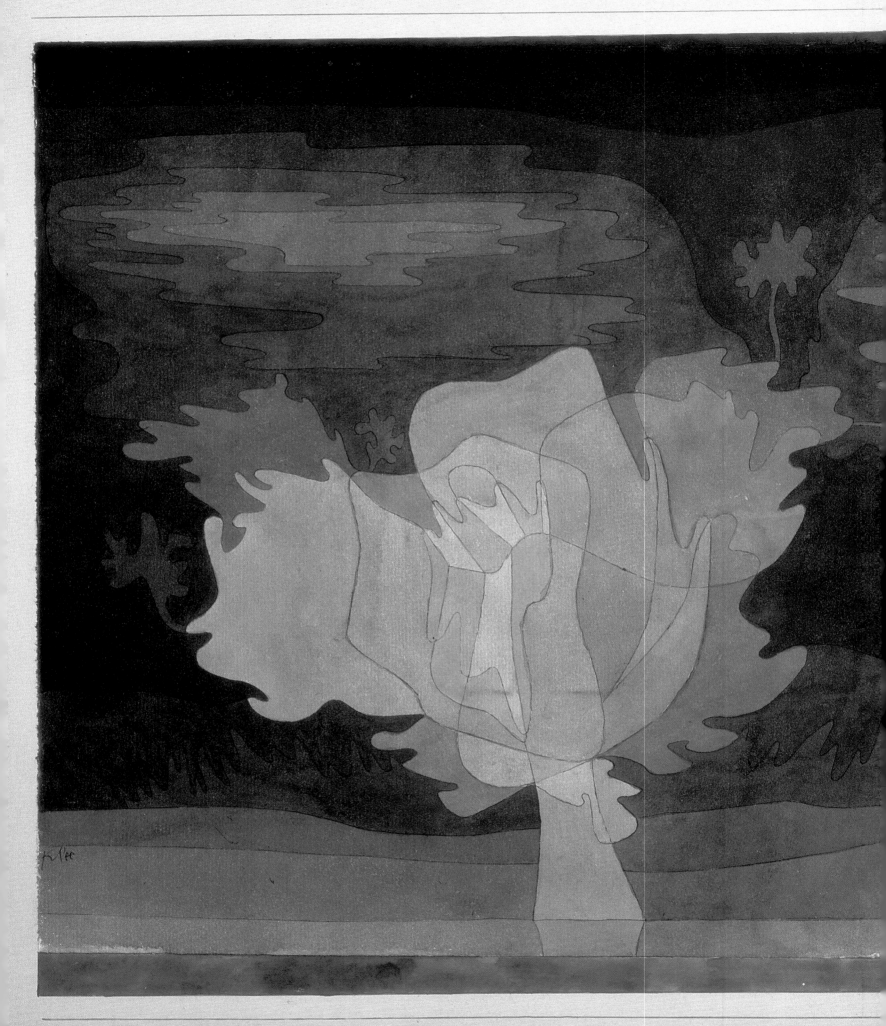

Klee

1929 3.H.19. 2 o.

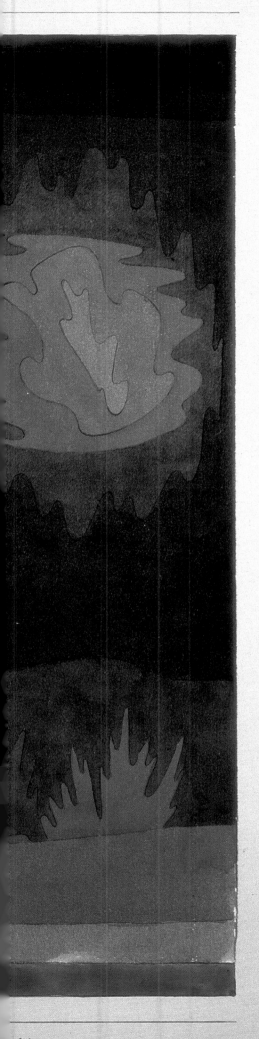

BEFORE THE SNOW

1929, *319 (3 H 19)*,
watercolour
on coloured paper,
33.5 × 39 cm (13.2 × 15.3 in.).
Private collection, Switzerland.

distribution of notes on a musical keyboard. The arrows are generally directed vertically, upwards or downwards. Since, for the artist, the triangle represents a tension between a point and a straight line, their heads are in many cases set against each other. As a consequence of the deployment of energy in this arrangement, their head-to-head becomes, in Klee's conception, a symbolic figuration of Eros; this refers to the cosmogonic role that Love played in ancient mythology. Sometimes the arrows are themselves made up of coloured bands, as in *Double Tent*. That image suggests two tepees set side by side, in colours running from sea green to flame red; Klee speaks of "arrows of heat". But the most surprising work in the series is the *Mural for the Temple of Longing,* in which arrows cleave the air in all directions.

A host of stylistic innovations

In 1921, when he became a teacher at the Bauhaus, Klee was forty-two. He was at the height of his powers and many of his most striking pictures were produced there. He spent happy years in both the Weimar and Dessau Bauhaus. Admittedly, like the other teachers, his pay was not handsome, but a small group of collectors had formed, which regularly bought watercolours and drawings from him, ensuring him a comfortable existence. There were many visits from foreign artists, philosophers and scientists, and frequent lectures. There was also an intense musical life in Dessau; Klee met Hindemith whose chamber music he liked and with whom he felt affinities, both men being extremely discreet and reserved. He particularly appreciated the city of Dessau and its environs, taking long walks there. The Junkers aircraft factories were located quite near the Bauhaus, and very soon exchanges of ideas were taking place between the engineers and the 'masters'.

Friendships also formed between them, to such an extent, indeed, that on 18 December 1929, his fiftieth birthday, Klee saw to his great surprise a small Junkers plane drop flowers and presents on to the terrace of his house to wish him many happy returns!

Most of the works I have described in the previous chapters, such as the fabulous *Landscape with Yellow Birds* or the 'fugue-like' *City of Dreams* date from this period of maturity. We could add many other paintings to the list. *Before the Snow* is one such. This atmospheric watercolour, painted on coloured paper, dates from 1929. It fully expresses the constantly self-renewing originality of Klee's genius. As Will Grohmann writes, "One is surely reminded of late autumn when viewing this picture, clouds bringing snow above the tree, the earth turned brown-red and grey below it. The two clouds with their peripheral colours come close to touching tree and earth, planes overlapping without touching. By contrast, the coloured planes of the tree intersect, but the compartments are filled with one colour only, pink at the centre, reseda green and light violet next, a darker violet and a violet-grey at the edges. The space is black-brown and black-green. Will the tree survive? Its colours are reassuring, suggesting fall and spring at the same time: Indian summer. The snow will cover it and keep it warm until the buds and the pointed tips of the leaves are allowed to unfold."[1] The painter's vision is an 'Oriental' one here; the play of transparent tones and the suppleness of the drawing evoke Hokusai or Hiroshige.

Still Life with Dove also dates from this period. It is an enigmatic masterpiece; the dead dove in the foreground, with its broken wings and twitching head, goes back to the 18th-century aristocratic source of the genre – the painting of game animals and birds as hunting trophies. But what has been killed here is not a game bird, it is the dove of peace flying towards Mount Ararat. Its olive branch has fallen from its beak. Behind the dove we can pick out a number of partially differentiated objects, among them a bowl of fruit and a mortar, set out on a tablecloth. The dilute pink, green, blue and brown tones of these objects are such as to create an almost monochrome effect, with overtones of insubstantiality and depredation. As is often the case with Klee, the difference in conception and execution is so profound that, outside the small

VEGETAL STRANGE
1929, *317 (3 H 17)*,
brush drawing in water-based paint over watercolour partially sprayed, on paper with a black ground, backed with a watercolour-toned paper, mounted on board, 31 × 23 cm (12.2 × 9 in.).
Paul-Klee-Stiftung, Kunstmuseum, Bern.

1 Will Grohmann: *Paul Klee (The Library of Great Painters), op. cit.,* p. 114.

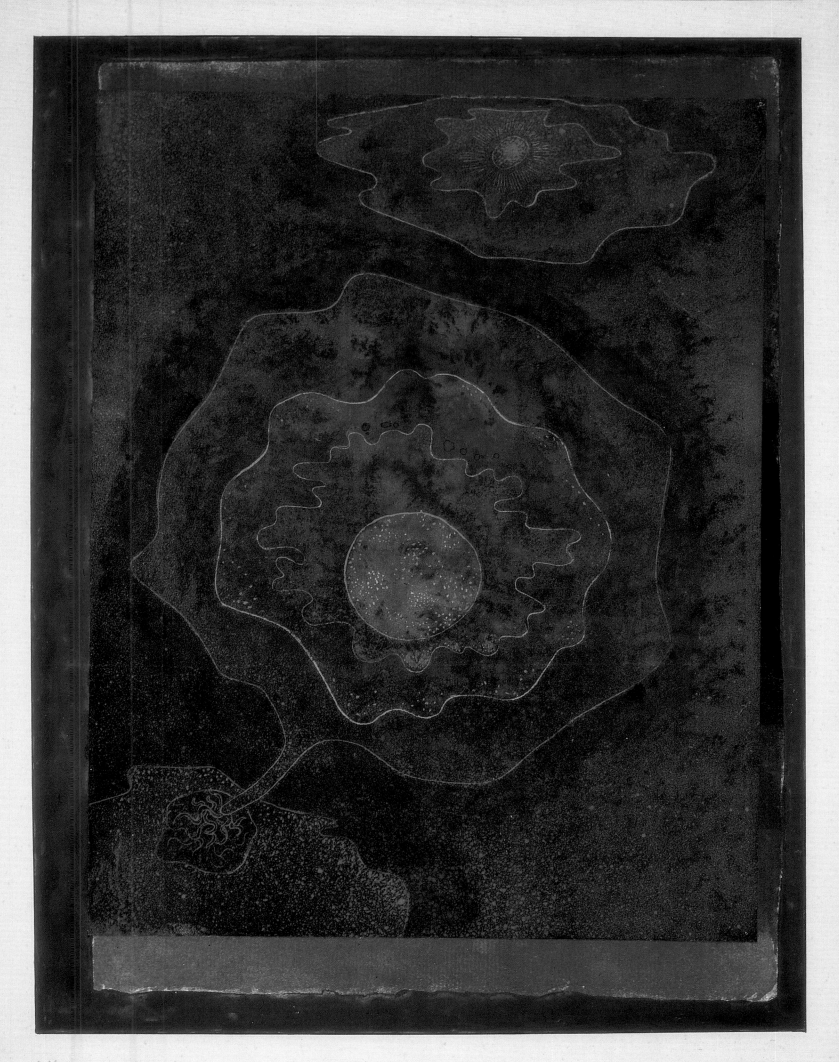

1929 3ª. A pflanzlich-seltsam für Lily Weihnachten 1929

1925 Z i. Wald architectur (31 12 25)

circle of friends and enlightened art-lovers, his contemporaries were disturbed by what they believed to be his eclecticism. His work is not easily divided into distinct periods, but it has a warp and a woof to it; though the constitutive threads do not, as with other great painters, succeed each other chronologically, they nonetheless *interconnect* across time.

This does not mean, however, that there were no innovations during the Bauhaus years. If we put aside Klee's arrows, the two most important of these innovations were "parallel figurations" and "individualized measurement of strata", to adopt the terms of Geelhaars' magisterial work.[1]

Just as veins define the form of a leaf, so the image is formed, Geelhaar explains – in reference to the first of these two great stylistic innovations – by the juxtaposition and interpenetration of parallel lines. This is the case with *Forest Architecture* (1925) and *A Garden for Orpheus* (1926), which the artist particularly liked. We might add that their fantastical quality connects these works to Max Ernst's series of *frottages*, which took their inspiration from wood grain. This inspiration seems to have been crucial in Klee's case, when we recall what was mentioned in the previous chapter: Klee's interest in the growth rings of a tree trunk. In *Forest Architecture*, even before one has identified the entangled motifs, such as strings of paths, unfolding branches, and rows of clustered trees, the tiered and intersecting parallel lines give the impression of forming a magical floor. This is neither the forest of the forester, nor that of the walker, nor that of the gatherer of berries, nor of Tom Thumb, to return to Jacob von Uexküll. It is the *basis* for all these forests – their common ligneous texture – which forms as it were an *Urwald*, one of those rare primal forests, of which examples still survive in the Alps.

Another parallel figuration, *Olympus in Ruins* (p. 33 of this book) attests to a quite different spirit. Since Giulio Romano's *Sala dei Giganti* at the Palazzo del Te at Mantua, there has perhaps never been so hilarious a depiction of the victory of Zeus over the Titans, those giants who attempted to scale the sacred mountain and dethrone the king of the gods. At Mantua, hirsute giants grimace with pain and boulders are hurled down from the sky. Klee eschews these. And his work, unlike Giulio Romano's, is on a

1 Christian Geelhaar: *Paul Klee and the Bauhaus*, Adams and Dark, Bath, 1973, pp. 98-120.

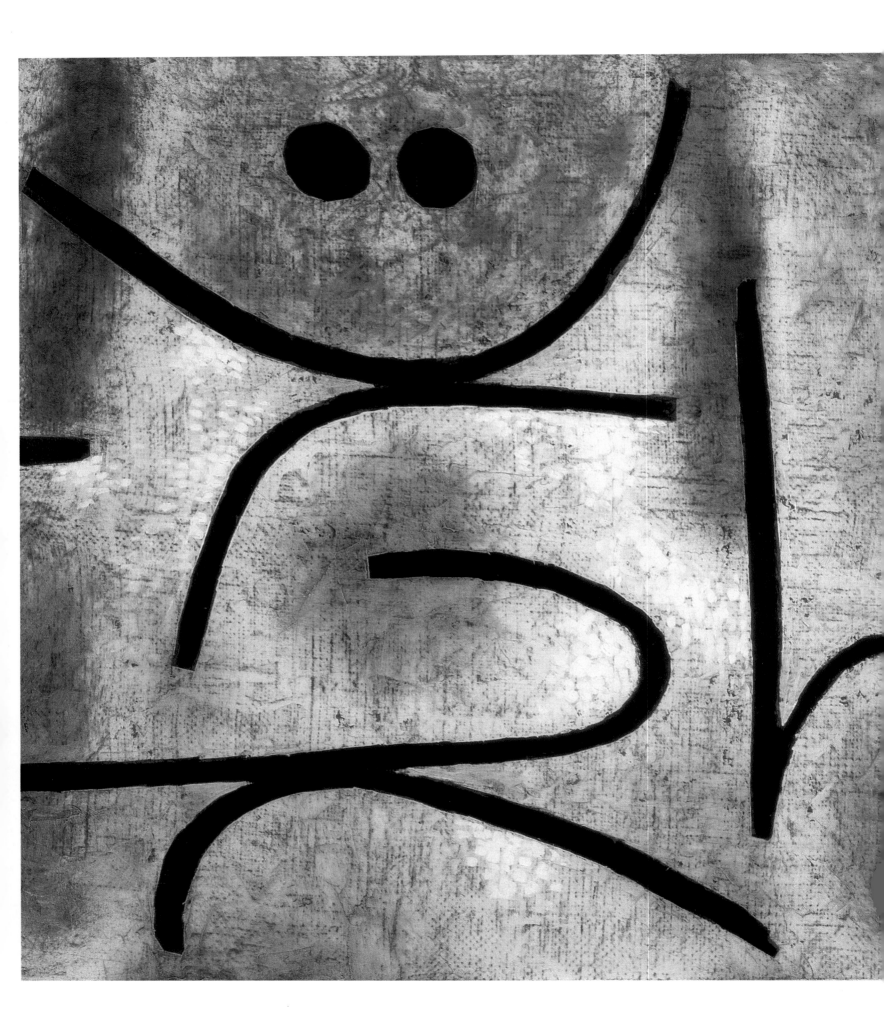

SHATTERED KEY

1938, 136, (J 16),
oil on canvas,
50.4 × 66.4 cm (19.8 × 26.1 in.).
Sprengel Museum, Hanover.

small scale. However, the humour is the same: the sharply-crested mountain peaks, arrayed like the teeth of a saw, the chaotic rock faces and the fluted columns tilting at dangerous angles are so many elements reproducing Hesiod's fable in tragicomic vein. Did the Greeks believe in their gods? As we know, this remains an open question. Clearly Klee did not believe in them! Proof of this is the figure of conquering Zeus, a pointed helmet on his head. From the summit of Olympus, against a baby-blue and candy-pink background, he waves conspiratorially to the amused spectator.

The second major innovation defined by Geelhaar, "individualized measurement of strata", originated in Klee's trip to Egypt in the winter of 1928-1929. This was a journey in which every landscape and every monument revealed to Klee the unity of life and eternity, and it gave rise to the most rigorously mathematical pictures he ever painted. The analysis Christian Geelhaar offers of *Monument on the Edge of Fertile Country* (p. 154), one of the most significant paintings of the series, is particularly illuminating. He demonstrates how that work, which is made up of horizontal strata, has to be read from right to left. The broadest strata are to be found on the right, symbolizing the infinite sands of the desert. Then, as the eye moves towards the left, we see that these strata are intersected by vertical and oblique lines; at their junctions, bisections occur, so that the original stratum is subdivided into halves, quarters, eighths or sixteenths, depending on the number of such intersections between oblique and strata. The narrowing of the bands produces density in the colour pigments and the effect of this is to increase the intensity of the colour. The middle zone is that of the monuments, which halt the migration of the dunes, whilst the left-hand zone, with the narrowest bands and the most intense tones, is that of the fertile land and of blue irrigation channels cutting across the cultivated fields.

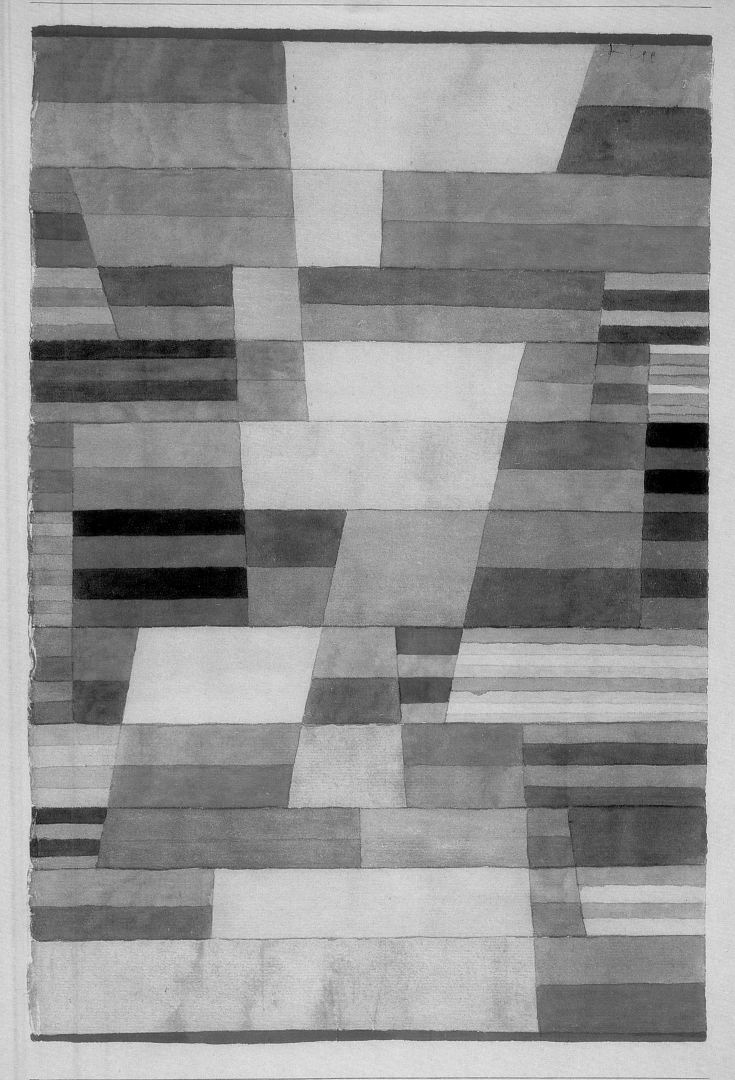

Klee

1929 n.1. Monument im Fruchtland

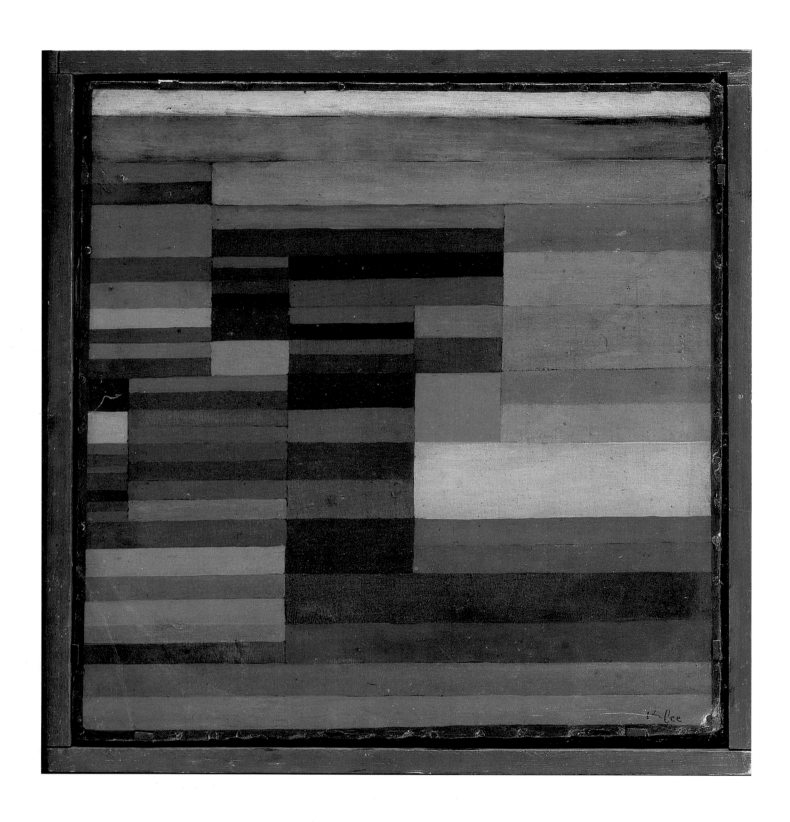

FIRE IN THE EVENING

1929, 95 *(S 5)*, oil on board,
original frame,
33.8 × 33.4 cm (13.3 × 13.1 in.).
Museum of Modern Art, New York.

1929 UE.9 · bewegungen in schleusen

Klee followed this procedure in several paintings. *Fire in the Evening* is one such, with its red central square. In this painting, too, there is play on the reduplication and division of strata. The procedure also gave rise to a number of drawings, the most artful of which is, without doubt, *Movements in Locks*, in which the slack water is divided, rippled and wrinkled by the pressure exerted when the locks are closed. These are, once again, highly intellectual compositions, but Klee refused to regard them as abstract, insofar as they were inspired by the nature and culture he had discovered on the banks of the Nile.

The Nazis transferred the Bauhaus to a disused Berlin telephone factory in late 1932, and finally closed it on 11 April 1933. The pretext for their action was Communist propaganda material allegedly concealed on the premises, which the Nazis claimed to have uncovered when they raided the building. They took

MOVEMENTS IN LOCKS
1929, 289 (UE 9),
pen drawing on paper,
mounted on board,
11 × 30 cm (4.3 × 11.8 in.).
Private collection, Switzerland.

| Page 154
MONUMENT IN FERTILE COUNTRY
1929, 40 (M 10),
watercolour on paper,
mounted on board,
45.8 × 30.7 cm (18 × 12.1 in.).
Angela Rosengart Collection, Lucerne.

| Page 155
MONUMENT ON THE EDGE OF FERTILE COUNTRY
1929, 41 (N 1),
watercolour on paper,
mounted on board,
45.7 × 30.8 cm (18 × 12.1 in.).
Paul-Klee-Stiftung, Kunstmuseum, Bern.

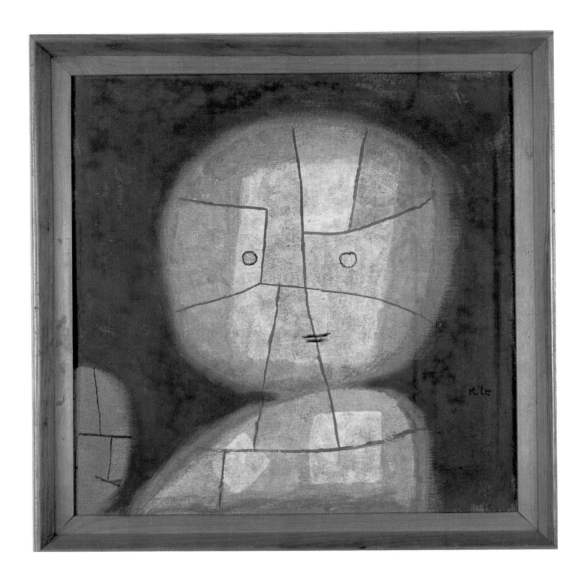

BUST OF A CHILD

1933, *380 (D 20),*
water-based paint, waxed, on muslin,
mounted on plywood, original frame,
51.5 × 51.5 cm (20.3 × 20.3 in.).
Paul-Klee-Stiftung, Kunstmuseum, Bern.

thirty-two students in for questioning. This was the inevitable conclusion to the repeated attacks of the Nazi authorities on an institution that they saw as a "hotbed of cultural Bolshevism". Wearied by internal struggles and political passions, which had restricted his freedom to implement his teaching methods, Klee had resigned from the Bauhaus in 1931. That same year, he took up a professorship at the Düsseldorf Academy, a less controversial institution where he had more time to pursue his own work.

5. Wrestling with the Demon

Klee's last years were framed by two catastrophes, the one collective, the other personal: the victory of National Socialism in Germany and an incurable illness, scleroderma, which made its appearance in 1935, and of which he died five years later, on 29 June 1940.

Immediately after Hitler was elected Chancellor of the Reich, on 30 January 1933, Klee became the target of virulent articles denouncing him as 'a Jew and a foreigner'. Like many Germans of his generation, he did not immediately grasp the scale of the disaster that had befallen his country and, though he was dismissed from his post at the Düsseldorf Academy, he thought he could retire to the country and let the storm pass. As to the certificate of parentage, which might have prevented the racial attacks on him, he never remotely considered producing it. "It would be unworthy of me to become involved in such clumsy mudslinging", he wrote in a letter to his wife. "Even if it were true that I am a Jew from Galicia, it would not in the slightest affect the value of my personality or my achievement. And I must never of my own accord abandon my personal point of view, which is that a Jew and a foreigner is not *per se* inferior to a home-bred German. Otherwise I shall make a fool of myself forever. I would rather accept any amount of personal discomfort than become a tragicomic figure trying to ingratiate myself with those in power."[1] With all his illusions now behind him, he returned to Bern at the end of December 1933 and drew up a *curriculum vitae*, in which

1 Cited in Grohmann: *Paul Klee*, Lund Humphries, London, 1956, p. 82.

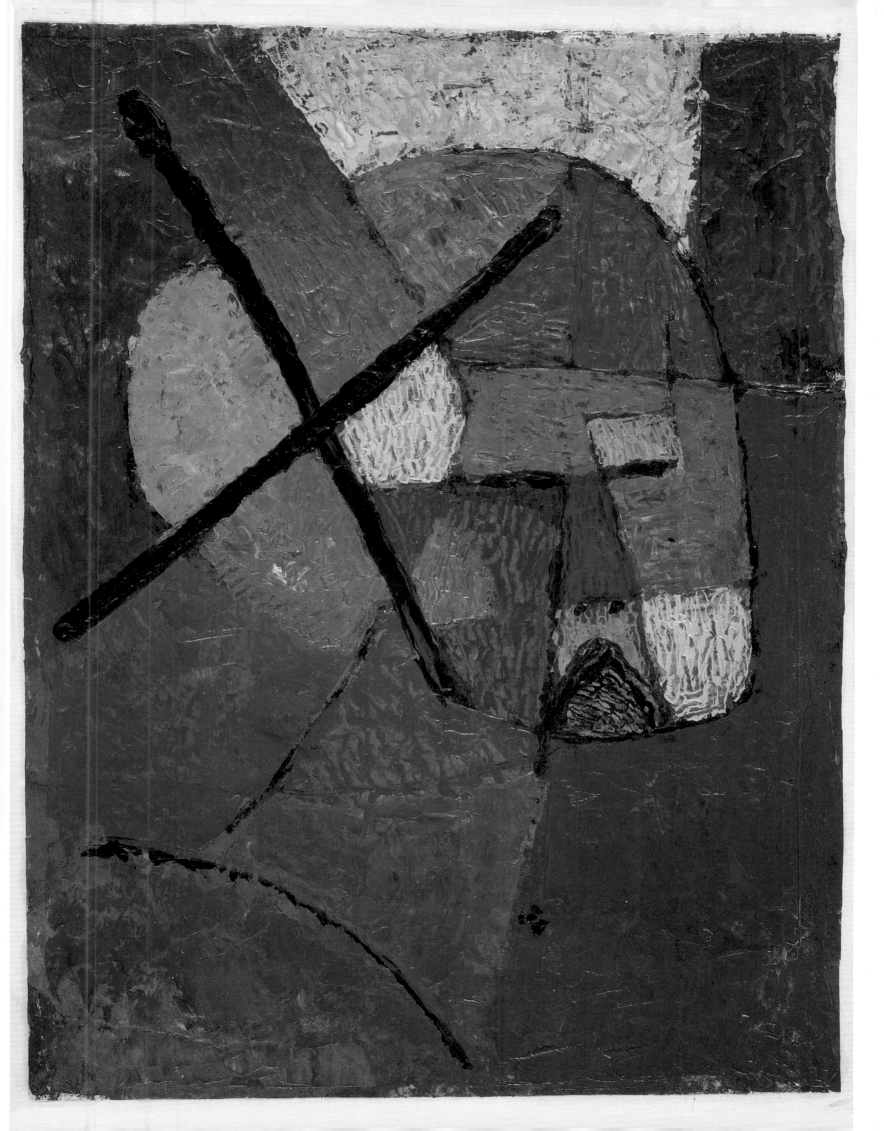

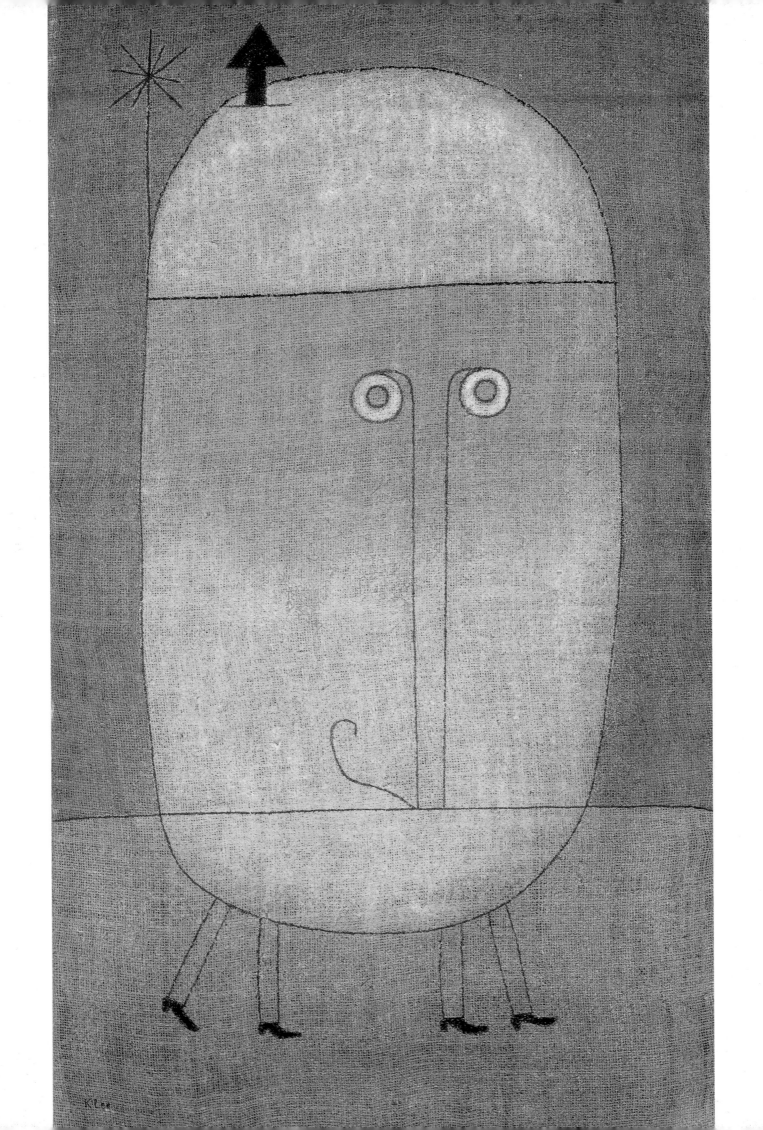

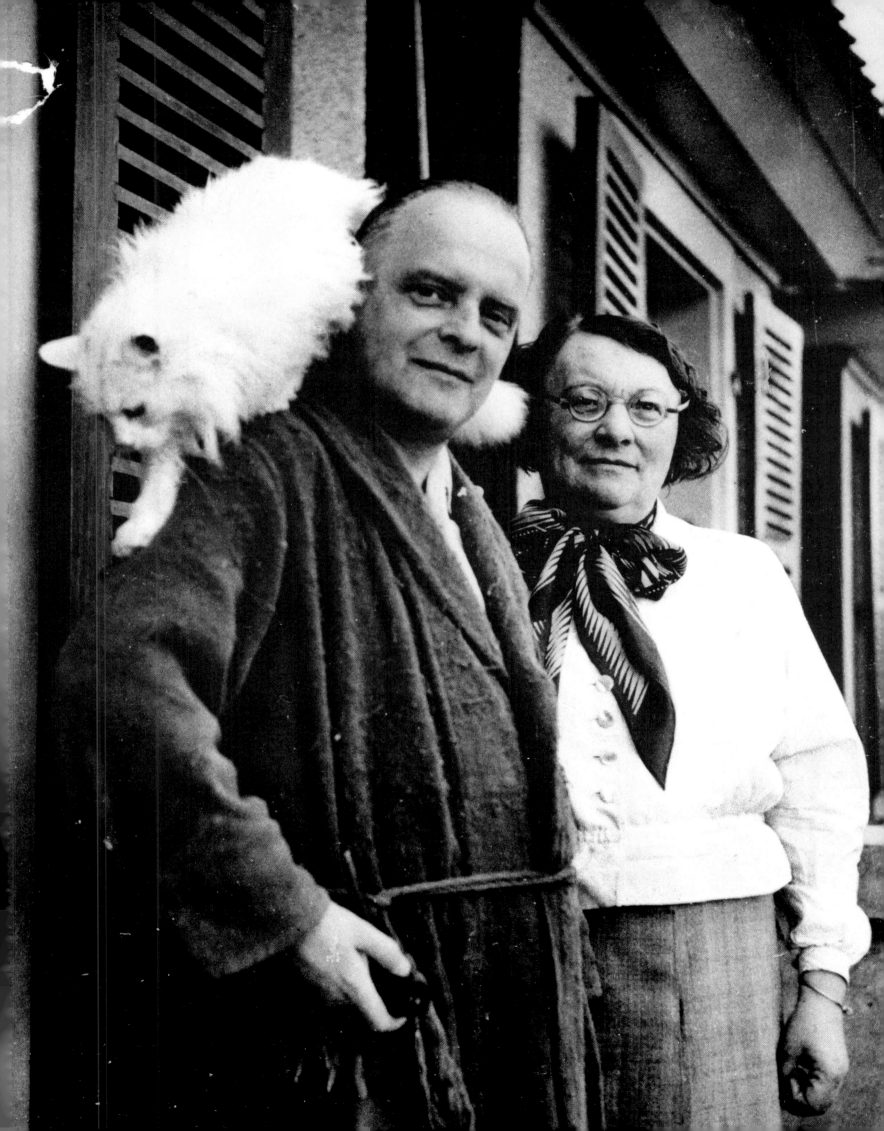

he expressed his attachment to his native city and requested Swiss nationality. This he was granted posthumously.

A number of works express Klee's sense of helplessness in these cruel circumstances, including a self-portrait entitled *Struck from the Lists*, which immediately discloses its meaning. It is a portrait depicting a man's face, suggestive of a death's head with a cross through it. The dark colours used by the painter betray a sense of sadness and despair. *Mask of Fear* shows a somnambulant person with no torso, whose two pairs of hesitant legs support an immense staring head; an arrow sticks out of the top of its skull like a chimney. With this image, Klee seems to be taking stock of the exactions, deportations and autos-da-fé that were then taking place all over Germany. *Grieving* is somewhat later in date; using a single line on a squared mosaic background to trace the bust of a man, his head bent forward, his eyes closed, the corners of his mouth turned down, it is also an expression of intense unhappiness. Farewell, then, to the fusion of the animal and plant kingdoms; to fugues and polyphonies, to cosmic resonance. Nothing remains but bewilderment in the face of the monstrous calamity. After briefly staying with his father and sister in the family house, Klee moved into a modest three-room apartment, the largest of the rooms serving as a studio. Before 1933, Germany had had exceptional exhibitions, and the best theatres, operas and concerts. But Bern was no longer the little city with the second-rate orchestra that he had known in his youth. There was substantial artistic activity there, and friends drove him to Zurich, Basel or Lucerne when important events were taking place. This was a period, too, in which he read a great deal.

As a German immigrant, he did admittedly suffer some petty annoyance from the Swiss authorities, but, contrary to what has been argued in a recent work, he was never in any sense seriously troubled by them.[1] The author of the work in question states unhesitatingly that he was put under strict surveillance, there being, at the time, a powerful National Socialist party in Switzerland. There is no truth in this. Klee's art, as one might imagine, shocked many people, but he also had some fervent admirers. This is attested by the large-scale retrospective of his work which opened on 23 February 1935 at the Bern Kunsthalle, before transferring

1 Susanna Partsch: *Paul Klee 1879-1940*, tr. Hilary Schmitt-Thomas, Benedikt Taschen Verlag, 1993, p. 81.

1939 JJ ii *hungriges Mädchen.*

HUNGRY GIRL

1939, *671 (JJ 11),*
Distemper on paper,
27.1 × 21.3 cm (10.7 × 8.4 in.).
Private collection, Switzerland.

to Basel, an event which drew many visitors not just from Switzerland but from all over the world. Furthermore, the Bern Kunstmuseum acquired *Ad Parnassum,* whilst a number of private collectors bought important works. As we know, Picasso and Braque went to Bern to see Klee, so he was not exactly a persecuted artist, as some ill-informed commentators might wish us to believe. On the other hand, the Nazis had confiscated all the modern works from the German museums, with the aim of destroying them or selling them off. The Führer had used the press and radio to announce a pitiless campaign cleansing the country of "culturally destructive elements". Categorizing avant-garde artists as insane or criminal, he threatened them with confinement in mental asylums or prisons and with sterilization – the only appropriate remedies, in his view, for "people who saw the sky as green and lawns as blue". Then, on 10 July 1937, a two-part exhibition

SEVERE COUNTENANCE
1939, 857 *(UU 17)*, watercolour
and tempera on newsprint,
32.9 × 20.9 cm (12.9 × 8.2 in.).
Paul-Klee-Stiftung, Kunstmuseum, Bern.

opened in Munich. It comprised, first and foremost, everything official German art had to offer in praise of the simple life – rustic scenes, idyllic portraits of mothers and children – all done in the academic style of the 19th century. This was located in a newly-built, heavily colonnaded building. Alongside, in the disused Hofgarten, seven hundred and thirty works of so-called 'degenerate art' were put on display. Amongst these were works by Picasso, Kokoschka, Nolde, Kandinsky, Chagall and Kirchner (who went into exile in Switzerland and committed suicide not long afterwards) and, of course, Klee himself. He was deeply upset to see his life's work held up for popular condemnation in the land where he had spent his happiest years.

Two years earlier he had fallen ill, and his doctor had at first diagnosed bronchitis with pulmonary complications. Many ineffectual treatments were prescribed before it was discovered that

Klee was actually suffering from scleroderma, a rare and little-understood condition that results in a fatal drying up of the mucous membranes. Klee rarely spoke of his illness and was hopeful, to the last, of being cured. He continued to paint normally in the following years – with the exception of 1936, when he produced only twenty-five works – and in 1939 he produced more than a thousand items, a not inconsiderable output. Nonetheless, his physical condition was deteriorating to a distressing degree. At Kandinsky's 1937 exhibition at the Bern Kunsthalle, he could walk from one room to another only with his wife's assistance, and had to sit down at each picture to view the work of his friend and former Bauhaus colleague.

These last years were years of wrestling with the demon. The fact is discernable in a number of his works, not just those which were the product of his expulsion from the Düsseldorf Academy in 1931. Among these, *Park of Idols*, *Outburst of Fear III* and *Tragic Metamorphosis* are some of the most disturbing. The first-mentioned, painted in 1939, shows three clearly delimited greenish-yellow and reddish-brown figures, which have something both of the foetus and the primitive deity about them. Their skin is covered in patches, like little scales or a tissue of prematurely dead, necrotised cells. The space of the park, laid out vertically, serves as a context for the idols, as if they were three statues carved out of an extraterrestrial material, the blue sky, while the black background of the picture, in which we can identify pathways, completes the composition. However, black is no longer, as in the past, a release of energy, but the presence of nothingness. "With works such as this one, we are getting closer to the Requiem Klee composed for himself. Now what comes to the fore is tension between time and eternity, the question of the questioner's existence, and the meaning of his art becomes the elucidation of existence", notes Will Grohmann [1].

The black of darkness

In his book, *Concerning The Spiritual in Art*, Kandinsky gives the following description: "A totally dead silence… a silence with no possibilities, has the inner harmony of black." And he goes on, "Black is something burnt out, like the ashes of a funeral pyre,

PARK OF IDOLS
1939, *282 (V 2)*,
watercolour on paper
on a black ground,
32.7 × 20.8 cm (12.9 × 8.2 in.).
Private collection, Switzerland.

1 Will Grohmann: *Paul Klee* (The Library of Great Painters), *op. cit.*, p. 150.

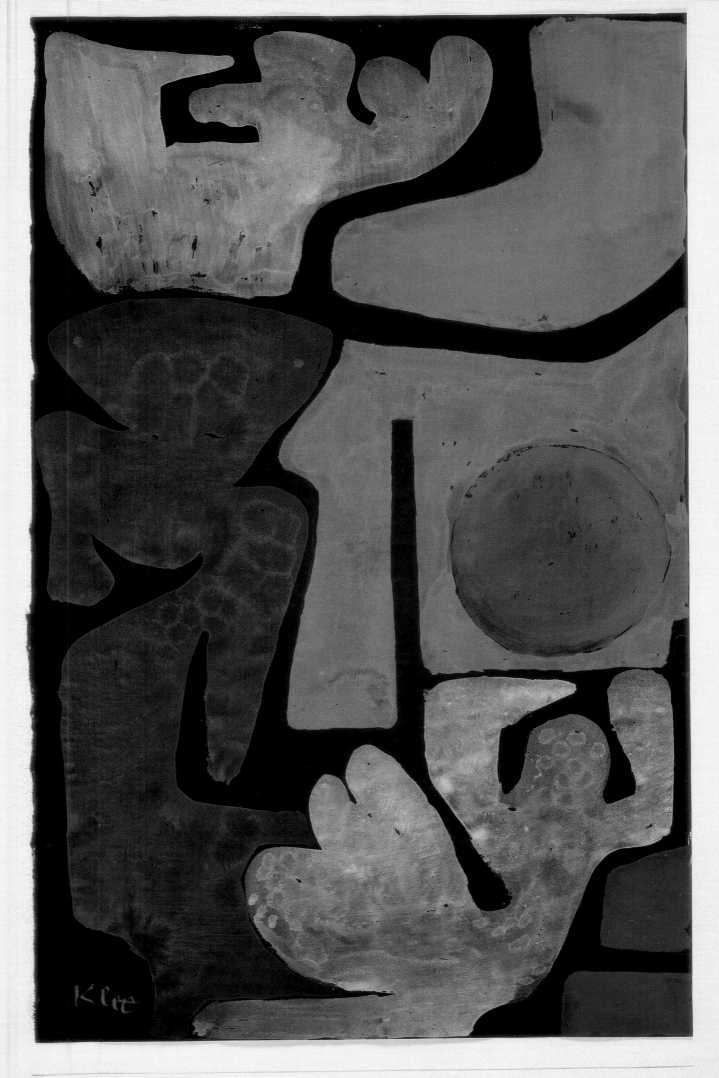

1939 V 2 Götzen-Park

OUTBURST OF FEAR III
1939, 124 (M 4),
watercolour on paper,
mounted on board,
63.5 × 48.1 cm (25 × 18.9 in.).
Paul-Klee-Stiftung, Kunstmuseum, Bern.

something motionless like a corpse. The silence of black is the silence of death."[1] This is a remarkable description, in that it raises to maximum intensity a material perception, here elevated to the rank of a philosophical concept. Kandinsky contrasts *this* black with white, which is also "silence" and "nothing", but is understood, by contrast, as "pregnant with possibilities". In other words, the two "nothings" – quasi-Hegelian in inspiration – are not identical; an emergent becoming distinguishes the one from the other. Klee had certainly read *Concerning the Spiritual in Art,* and the significance of black had doubtless given rise to extensive discussions between the two, as in the past they had discussed Prinzhorn's work and the pictorial works of mental patients.

It seems Klee had by this point renounced his quest for the meeting of a diurnal night and a nocturnal day illuminated by the moon. Black is symbolically linked to the primordial darkness; it evokes anxiety, affliction, misfortune and mourning. The Greek mariners associated black sails with death and the Romans marked ill-omened days with a black stone. From youth onwards, Klee had made chaos his own, and instituted black as the metaphysical principle of his work. In so doing, he set himself up in opposition to the light of Ficino, which, in the Western tradition, from Leonardo da Vinci onwards, illuminates the world and gives objects their brilliance. He is not far removed here from the alchemical *œuvre au noir,* the supposed basis of spiritual liberation, and perhaps he had seen black as fertile soil: a *materia prima.* But now he had put fertile soil behind him. In his last works, black retreats into itself; deprived of any future, it spells 'end'. We can see this, in particular, in *Embrace,* a strikingly atmospheric work produced in 1939. The theme is a creature reduced to three heavy, curved lines. The semicircular form of the creature's head, with the eye-sockets set exaggeratedly close together, rests on an upright neck, and only the right-hand side of a torso is visible; the left-hand side is reduced to the gesture of an arm leaning on another vertical line, forming a kind of question-mark. At the top left of the picture are two extinct stars: a baleful black sun and a black moon. The large, spare signs comprising the composition are downward strokes made with a dry brush, the effect being a modulation of the line. But make no mistake, the embrace, tender as it may

1 Wassily Kandinsky: *Concerning the Spiritual in Art,* tr. M.T.H. Sadler, Dover Publications Inc., New York, 1977, p. 39.

EMBRACE

1939, *IK 1*, Distemper,
watercolour, and oil on paper,
24 × 31 cm (9.4 × 12.2 in.).
Sprengel Museum, Hanover.

be, is indeed the embrace of death, and knows that its prey cannot escape. The whitish, pale blue and light brown colours, which provide a background to the figure, together with the dark brown halo around the head and the two stars supporting the black writing, accentuate the funereal character of the picture.

In the same register, only months before Klee's death, this same theme takes a dramatic turn in *Death and Fire*. Some have, paradoxically, interpreted that work as the artist's acceptance of his fate. But the unity of life and death has not been achieved here; all the signs are that this is a depiction of the triumph of death after the fashion of the Middle Ages. *Danses macabres* then played a prominent role in the sculpture and painting of Germany, and were performed by mummers in the squares of towns and villages and even in churches. In those performances, the grim reaper entered like a thief in the night and disappeared with meteoric suddenness, leaving behind mothers dying in childbirth, and a trail of other victims, old and young. This is what is evoked by the pitiless grin, the sardonic gaze of the misshapen head that occupies the centre of the composition in close-up. The picture is reminiscent of Hans Holbein's *Dance of Death*, a series of woodcuts in which the grim reaper enters the bedchamber of an astronomer, a doctor and a miser, whose knowledge and wealth afford them no protection. From a poor hovel, Death takes a handsome child who turns back towards his horrified mother, not understanding why he must so soon be parted from those he loves. Cunning death: Klee knows he too must follow.

In Itself, a drawing dating from 1940, suggests a monstrously evil swelling streaked with quivering fibres. Acceptance of his fate was not easy for Klee. Obsessive fear of the void pours out here, like pus from a wound. *In Itself* is the culmination of a series of 'sick'

Umgriff

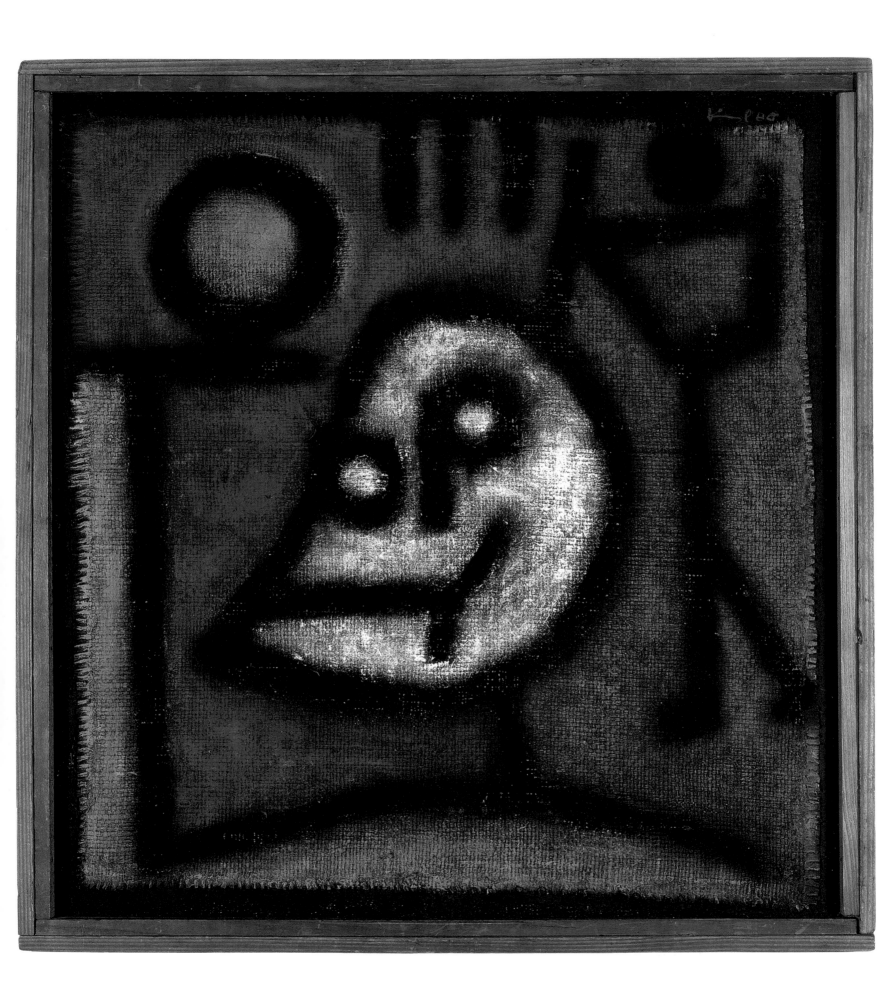

1938 R 14 in sich

drawings and paintings; works which face up to the progressive deterioration of an organism and transcribe it as no other artist has done. In one of the most remarkable of these, *Symptom to Be Recognized in Good Time*, the lines that coil and unwind like thread, hesitantly returning to leave jagged shapes behind them, sketch out the very image of disintegration. This is not an injured body, but a being impaired in its functioning, experienced from the inside; the organs increasingly falter or fail in their work, the muscles atrophy and tug on the apophyses, and the nerves strain under the effect of pain. Scleroderma is an illness that begins by hardening the skin, then the deep tissues, before attacking the lungs, kidneys and heart. It was one of Klee's essential principles, as we know, to seek not the form but the function. Applying that principle to his sick body led to the presentation of its *dysfunctioning*, as may be confirmed from the following pages.

Klee's drawing was never so close to automatism as here. This is an outpouring of lines on to a blank sheet, without any prior figurative intention, and in that respect analogous to the work

SYMPTOM TO BE RECOGNIZED
IN GOOD TIME
1935, *17*, pencil on paper,
mounted on board,
17.9 × 27.9 cm (7 × 11 in.).
Paul-Klee-Stiftung, Kunstmuseum, Bern.

of Masson, who invented the technique. But there is one major difference: instead of bringing to the surface uncontrolled psychical drives, he sets down the painfully conscious trace his illness dictates. As psychiatry has established, serious psychological disturbance can occasion a disintegration of the body image. The American psychiatrist Paul Schilder, a specialist in this area, tells how one of his female patients felt she was literally falling apart when stared at in the street, and had to take refuge in a doorway to regroup herself. One of his male patients in a state of depressive psychosis spent anxiety-ridden nights searching the bed for his limbs.[1] This is clearly not what is going on in Klee's pain-ridden drawings. What we have here, rather, is a slow extinction of the will to live registered with the greatest sensitivity.

There are not many drawings of this kind in Klee's work, and *Symptoms* is undoubtedly the best example. Elsewhere, however, in the pathos of line and colour, a patch of red evokes the arterial, a patch of blue the venous blood. These are not, however, expressive of tragedy, but works in which something is surreptitiously imploding and coming apart. Maybe autumn leaves feel something of a similar pain, if they have feelings, as perhaps, when their time has come, do those old hollow trees in which the sap has ceased to rise. Klee himself was becoming a part of that infinite natural history which so fascinated him. There is a calm in his 'sick' drawings and pictures, a silent acceptance of the imminence of the end. It is as if, in the fusion of plant and animal 'kingdoms', one component of the human experienced an almost vegetal passivity in the face of death.

Final accomplishment

But in these dark years, as in the other periods of his life, his work did not draw all its inspiration from a single source. For instance,

1 Paul M. Schilder: *Image and Appearance of the Human Body*, International Universities Press, Madison, 1972.

Symptom, rechtzeitig zu erkennen

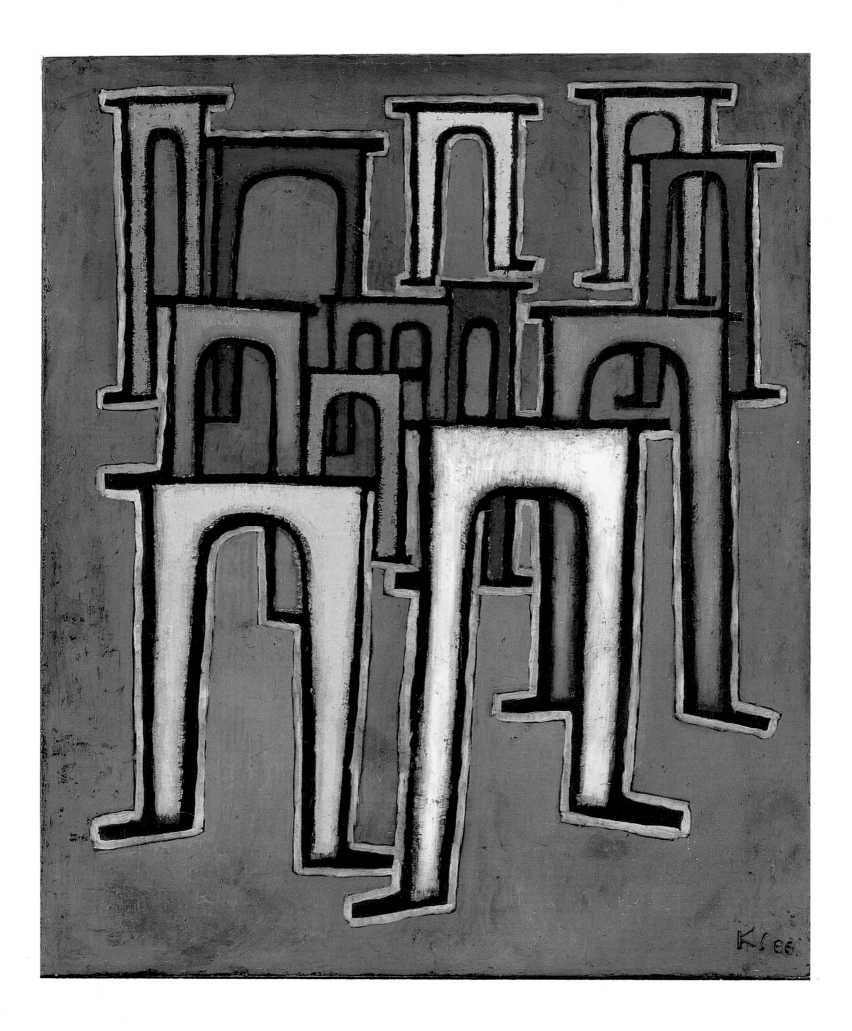

REVOLUTION OF THE VIADUCT
1937, *153 (R 13)*, oil on canvas,
60 × 50 cm (23.6 × 19.7 in.).
Kunsthalle, Hamburg.

some have seen *Revolution of the Viaduct,* a painting done in 1937, as a declaration of war on National Socialism, arguing that its disunited arches marching towards us, ready to bury us underfoot, are a protest at the thunderous march of the brown-shirted cohorts. One author has even contended that, since repetitively symmetrical bridges were becoming so widespread in Nazi Germany as a result of *autobahn* building, the disparate arches of Klee's picture, unequal in size and various in colour, are a riposte to the uniformity of totalitarianism.[1] These are clever interpretations, but they sit poorly with a work that, more than any other in the painter's richly varied production, brings a smile to the spectator's face. A simpler interpretation seems to me more likely: we should see these moving arches as an evocation of the stone viaducts built in the 19th century to carry the railways across valleys. These have been stuck in one place for too long, Klee is saying, and they want to go and view the scenery somewhere else. Neither illness, nor the prospect of imminent death, nor even Hitler, had impaired Klee's sense of humour.

The series of musicians, the existence of which I mentioned in my first chapter, also belongs to this period, as does the series of angels. These are sets of outline drawings, the former done roughly, the latter with affection. There are two versions of the *Kettledrummer,* both inspired by the percussionist Knauer, whose technical mastery Klee had admired at the Dresden Opera. Grohmann reports Klee's remark that, one evening, when he was drawing excitedly, he had felt as though he were playing the kettledrums.[2] This does not mean that Klee hammered at the page like a man possessed, of course. In spite of its resemblance to a cauldron, the kettledrum is an instrument that requires subtle handling; its intonation is modified by levers or pedals that adjust the skin, and the use of the sticks permits of infinite subtlety. The other drawings include a harpist who, though having no harp, strikes the pose required for playing the instrument, arms outstretched and head bowed, and a pianist carrying a keyboard on his chest. There is less of a musical rhythm running through these drawings than in many of the artist's other works, largely because the kettledrum is the corners-

1 Susanna Partsch: *Paul Klee, op. cit.,* p. 92.
2 There is also a picture, *The Kettledrummer,* inspired by Knauer's memory, but this is more properly seen as one of the canvases concerned with death.

1937 T. 17 Musiker

tone of the orchestra, as is shown in *Powers of the Drummer*, the most geometrically constructed of the series.

Nor do the angels have the traditional swan's wings; these are not the six-winged seraphim that surround the throne of God, with "two wings to cover their faces", "two to cover their feet" (a euphemism for the sexual organs) and "two for flying". No, they have the charm of timid, uncertain creatures. Did Klee, like Rilke, believe that the angel symbolizes "the creature which embodies the transformation of the visible into the invisible"? It is not impossible that he did. However, the medieval belief that the angels infuse the stars with life seems to me more in tune with the roguish side of his thinking. In that conception, the angels each tend their own stars, between them causing the entire firmament to revolve. That human beings could have imagined the existence of a cosmic machinery driven by semi-divine, semi-human

KETTLEDRUMMER
1940, *270 (L 10)*,
distemper on paper,
mounted on board,
34.6 × 21.2 cm (13.6 × 8.3 in.).
Paul-Klee-Stiftung, Kunstmuseum, Bern.

MUSICIAN
1937, *197 (T 17)*,
watercolour on paper,
on chalk and paste ground,
27.8 × 20.3 cm (10.9 × 8 in.).
Private collection, Switzerland.

EIDOLA: KNAUEROS,
FORMER KETTLEDRUMMER

1940, *102 (U 2)*,
graphite on paper mounted on board,
29.7 × 21 cm (11.7 × 8.3 in.).
Paul-Klee-Stiftung, Kunstmuseum, Bern.

POWERS OF DRUMMING

1940, *189 (Qu 9)*,
graphite on paper,
mounted on board,
29.8 × 21 cm (11.7 × 8.3 in.).
Private collection, Switzerland.

1936.5. Südliche Gärten

SOUTHERN GARDENS
1936, 5, oil on paper,
mounted on board,
26.3 × 31 cm
(10.3 × 12.2 in.).
Sprengel Museum, Hanover.

beings must have amused him greatly. But, at the same time, his angels, by contrast with those in medieval painting, are forgetful and unfinished creatures, who do their work badly and allow the universe to be overtaken by entropy. Klee's angels live in that vast unity which encompasses life and death; they regard invisibility as a superior sign of reality. But the last angel of the series is a 'sceptical' one, and scepticism might well be the last word in Klee's thinking.

However, is not the Earth ultimately the finest among the stars? And, more particularly, the part of Earth that is Africa? There Klee, on his trip to Tunisia, had experienced a revelation that marked the beginning of his career. *Southern Gardens*, a painting executed in 1936, is actually reminiscent of the lower half of *Hammamet with Mosque* (1914), which, as we have seen, owes much to Delaunay. The freedom and maturity of *Southern Gardens* demonstrate a paradox: Klee – an artist with an immense thirst for the cosmic – was one of the most sensitive landscape painters of the 20th century. A black sun and an enormous white half-moon are once again to the fore in the composition. However, the essentials of the painting lie elsewhere: in the red and green trees conjured up in a few sap-gorged pictograms and contriving to evoke all Mediterranean plant life; in the pale olive-green, white, bluish and orange fields, whose contours interlock like the pieces of a jigsaw puzzle; in the denuded spaces where sparse vegetation grows, separated by patches of brown earth. The landscape is a bird's eye view, with the horizon pressed high against the top edge of the composition, leaving space for only a thin strip of blue sea. A house and wall complete the composition, together with a red arrow pointing weightily downwards. Nature, fresh as a young shoot in the spring, is found in a number

of other landscapes inspired by memories of Kairouan and Egypt. *Oriental Garden* is one such; it shows an Arab property, with elegant entrance, staircase, windows and magical plant life. Another is *Oriental Sweetness*, where the pyramid and palms stand out like hieroglyphs in the polychrome space of the picture. Once again, we find the chequerboard layout of the magic squares; in each of them, too, a framework of bars and signs independent of the polychrome surface appears. These manifest a principle that Klee often followed towards the end of his life: the dissociation of line and surface. Klee was aware that he had not long to live, and cannot have been unremittingly joyful. There is an eerie quality to some landscapes of this period, such as *Deep in the Woods*, where the dark green tones stir the age-old fears of primitive man, or *Undersea Landscape*, in which the leafless plants barely illuminated by daylight evoke the kingdom of the dead. But Klee drew sustenance, nonetheless, from his faith in the secret of life. This was, as he saw it, a genesis of which we know neither the origin nor the goals. And it was in Africa that colour had taken hold of him, as he wrote in his *Diaries*, and in Africa that he had felt in perfect harmony with himself, to the point that he claimed a mysterious Arab ancestry.

Alongside the great number of works Klee produced in his years of illness, the fantastic diversity of new techniques that he invented is perhaps the best indication of his constant creative vitality. Grohmann meticulously enumerates these innovations. "Klee now returned to gouache, which he had already used before on occasion. He employs it as a thick impasto or thinned out, and he likes to combine it with oil, tempera, and watercolour, so that it is not easy to see just how the surfaces obtained in this way were produced, especially when he uses the gouache only for the first coat and goes over it with other media, or when he mixes gouache and gesso for the first coat. He also paints on unusual materials such as wrapping paper or sacking; or he coats jute or linen with

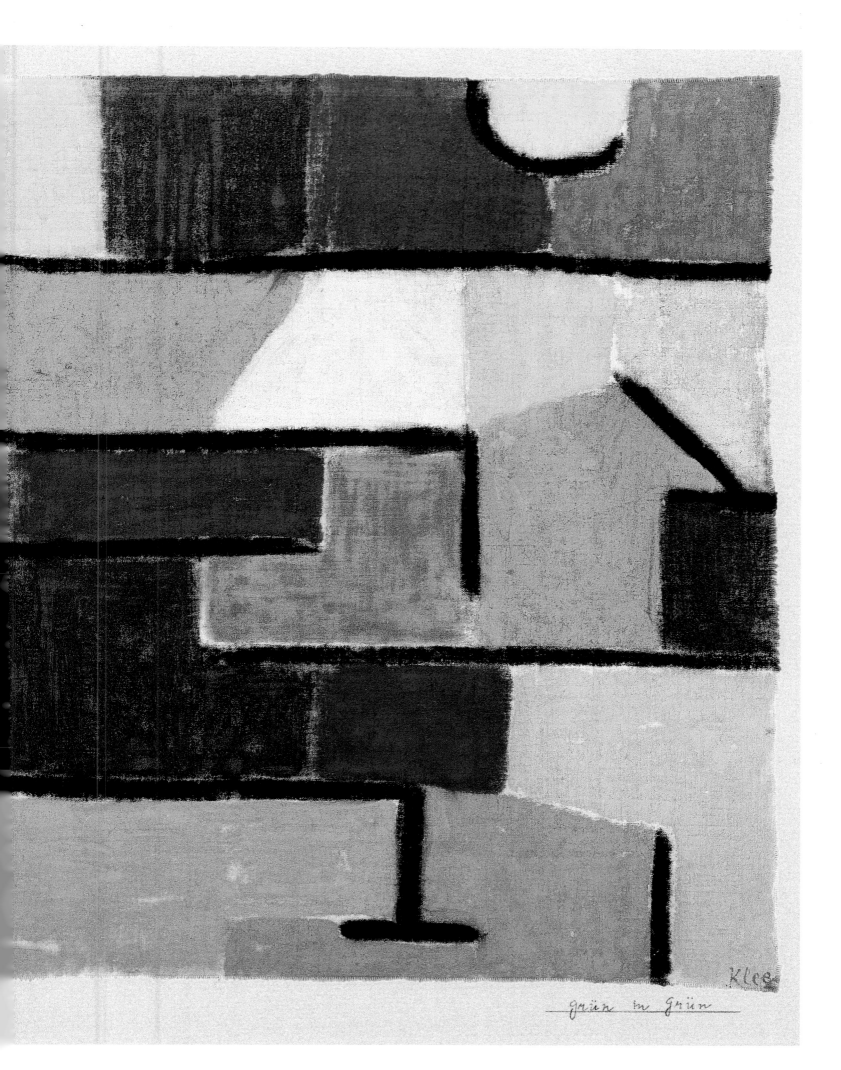

Klee

grün in grün

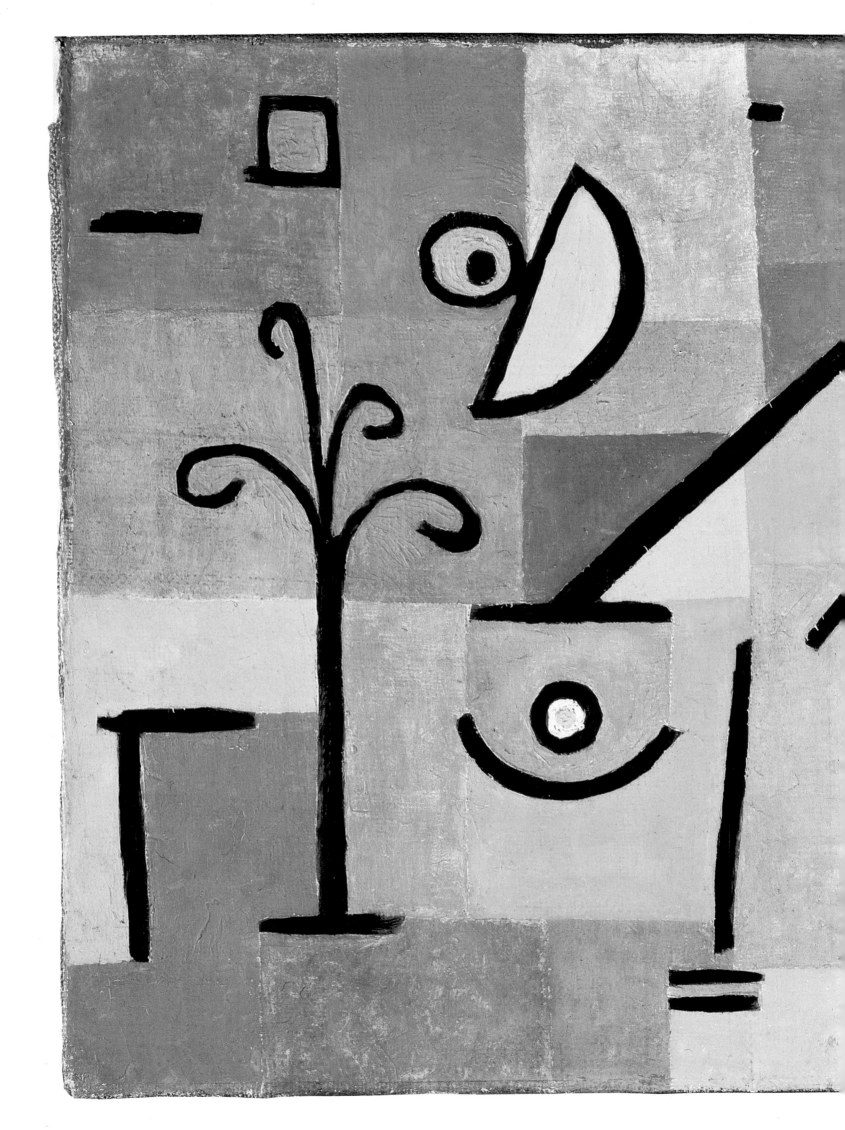

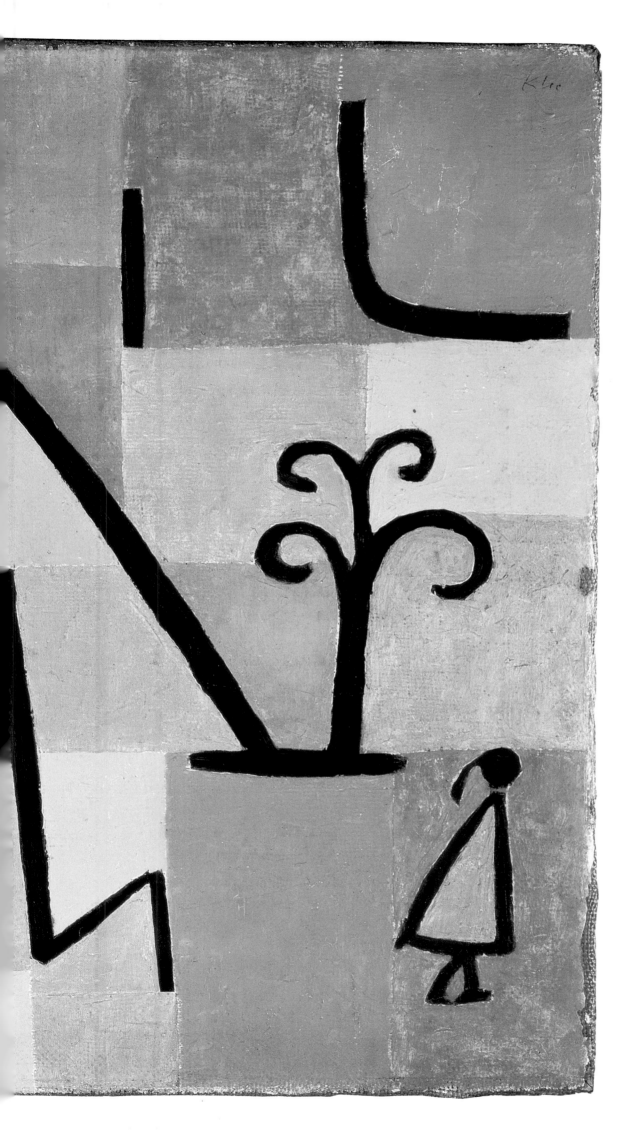

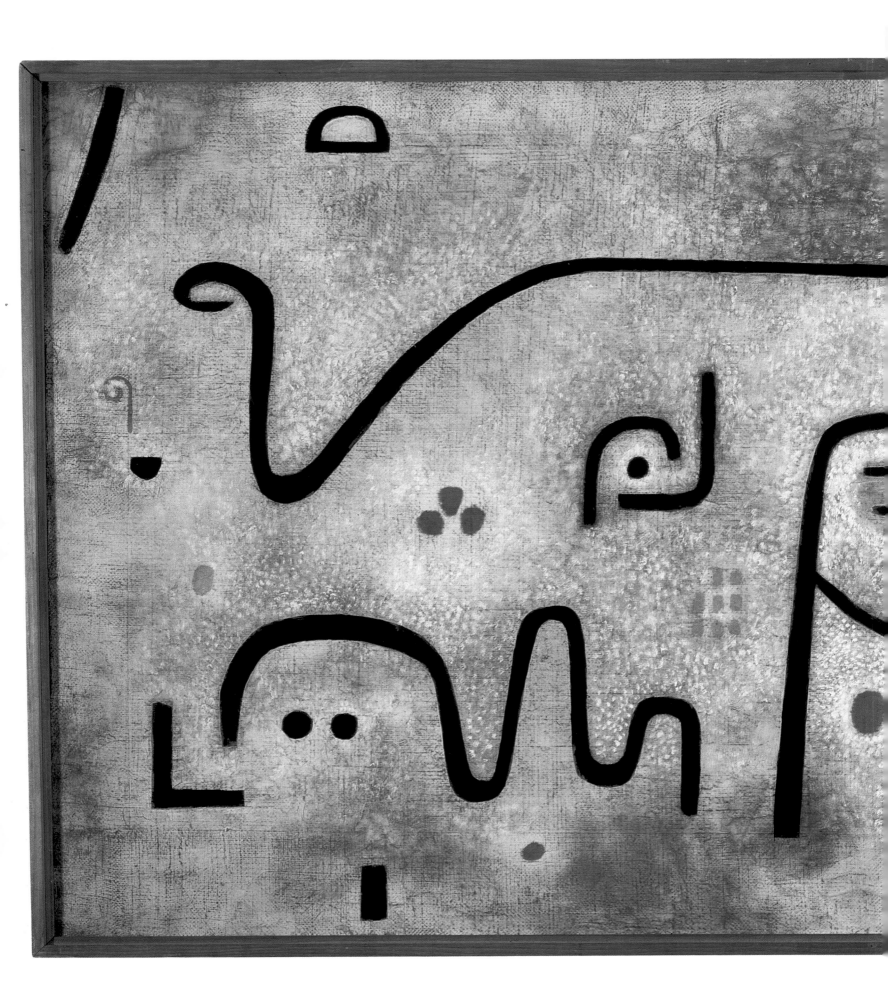

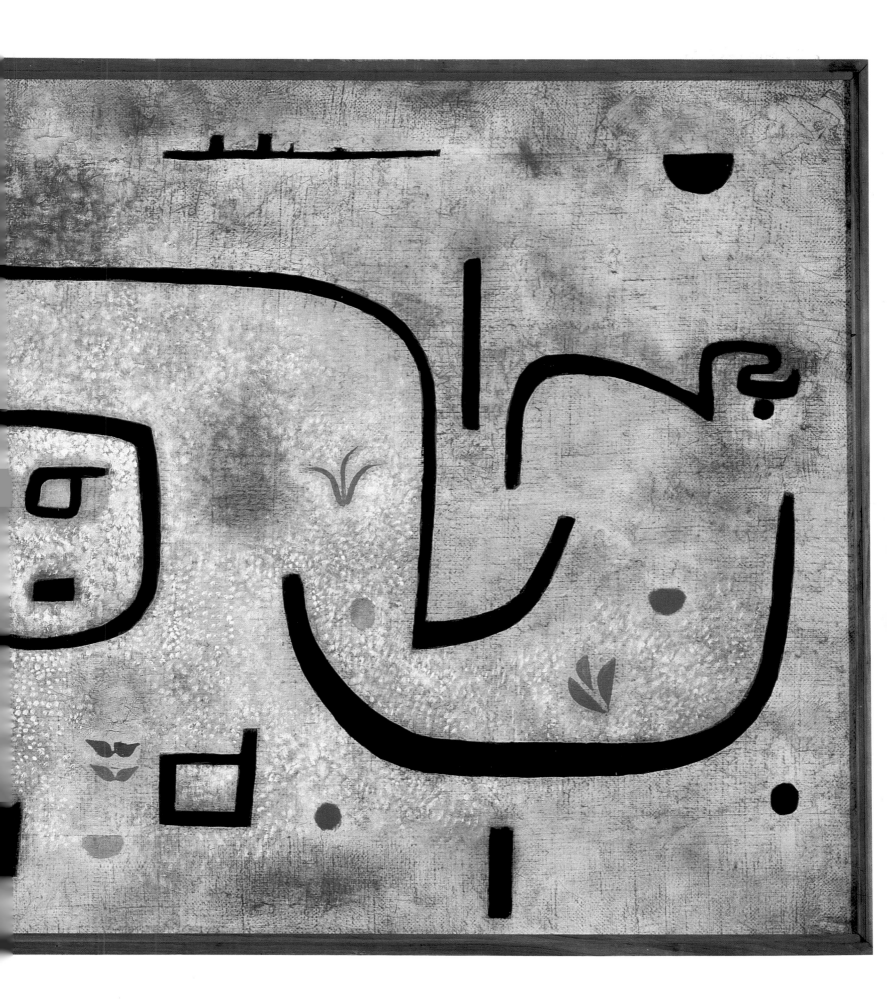

DROUGHT EMERGENCY
1940, *K 13*, distemper
and watercolour on paper,
29 × 41 cm (11.3 × 16.1 in.).
Musée national d'art moderne,
Centre Georges-Pompidou, Paris.

newsprint, which is absorbed into the fabric and yields a surface that is both rough and smooth. Sometimes the printed type shows through, which gives this ground a certain haphazard quality. Klee also continued to work with earlier techniques, such as painting in oils either alone or combined with tempera or watercolour, on linen or gesso. But he also uses watercolours on linen and then applies a coat of wax, and he employs crayons and pastels more than before."[1]

The use of these new techniques led Klee to make seven large panels in landscape format, the best known of which is *Insula Dulcamara*. This takes as its subject Ulysses' shipwreck on the island of Ogygia, home of the nymph Calypso, and the latter's efforts to keep him there, which she was unable to do, though she had promised him immortality. Like the six others, the panel was originally sketched with charcoal on newsprint, which the artist then stuck on to burlap or canvas with paste. At various points, fragments of advertisements and articles show faintly through the paint, producing a mild alienation effect. This is again a work made up of strokes contrasting with transparent tones; the lineaments of those strokes wind freely around within the painted surface. In this case, however, there is no modulation of the line, which thus retains a certain dryness. The picture is an incursion into the Homeric world: the black outlines mark the shores of the island and the raised head of a staring idol. Two moons, seen rising and setting, signal a derangement of the heavens, whilst a steamboat with two funnels, which is visible on the horizon, links the myth to the present-day world, as though the artist had wished to suggest its permanence among us.

1 Will Grohmann: *Paul Klee*, 1956, *op. cit.*, pp. 326-327.

Not durch Dürre

POOR ANGEL

1939, *854 (UU 14)*,
watercolour and tempera
on newsprint,
48.6 × 32.5 cm (19.1 × 12.8 in.).

Private collection, Switzerland.

ANGEL, STILL FEMALE

1939, *1016 (CD 16)*,
coloured lithographic crayon over blue paste
on scratch paper, mounted on board,
41.7 × 29.4 cm (16.4 × 11.6 in.).

Paul-Klee-Stiftung, Kunstmuseum, Bern.

1939 CD 16 Engel, noch weiblich

Klee's last work is a large *Still Life*, found on the easel in his studio where he left it, never to return. On a round table covered by an orange cloth studded with little flowers, we see a grey-violet statue and a green coffee-pot. In the top left-hand corner, three vases of differing shades of green, a blue receptacle and its violet appendage sit on a red circle, forming a counterpoise. Between the two groups of objects, the yellow disk of a moon stands out sharply against the black ground. At bottom left, on a large white sheet, there is an angel apparently being held back by two hands: Jacob's struggle with the angel. The last meeting between a diurnal night and a nocturnal day, to which Klee had often come so aspired, was not vouchsafed to him.

Exhibitions celebrating Klee's work were now being held both in New York and in Paris. For his sixtieth birthday on 18 December 1939, telegrams and gifts flooded in from all over the world, with the exception of Germany, where his potential admirers were silent. He was very touched by these expressions of respect, and replied to a number of them with joyful gratitude. However, as the war began, his condition deteriorated. On 10 May 1940, he was taken to the Sanatorium of Orselina-Locarno, and on 8 June he had to be transferred to the Sant'Agnese clinic at Muralto-Locarno. There he died on 29 June, at half past seven in the morning, from paralysis of the cardiac muscle. The cremation took place at Lugano on 1st July, and the funeral service followed on 4 July in the chapel of the Bürgerspital at Bern. In September 1942, the urn was buried at the Schlosshalden cemetery in Bern. The gravestone bore this extract from his *Diaries* as epitaph: "I cannot be grasped in the world. For I am as much at home with the dead as with those beings who are not yet born. A little closer to the heart of creation than is usual. And yet not as close as I would wish."

UNTITLED (STILL LIFE)
1940, oil on canvas,
100 × 80.5 cm (39.4 × 31.7 in.).
Private collection, Switzerland.

Conclusion

Klee always had a special relationship with his cats. Among the students of the Bauhaus, Fritzi was almost as famous as Klee himself. With Bimbo, a superb angora who shared the last years of his life, he communicated in a coded language that they alone understood. Klee is a 'cat' artist, and this explains a certain wildness in his nature. He was particularly fascinated by the fact that the cat *sees further* in the field of visible reality; details that escape the human eye are immediately clear to the cat. Like the Egyptians, who worshipped cats as divinities, he believed that cats saw further in the spiritual realm too. But this last insight should not be taken to imply that his work is other than solidly anchored in the most advanced scientific and mathematical knowledge of his age, nor to downplay the prime importance his painting has had in the revolution of modern art. Klee's creative range was, in fact, considerable, and he found solutions to a dizzying multiplicity of problems. It would, consequently, be an error to try to reduce Klee to a Fritzi or a Bimbo. His 'catlikeness' nevertheless seems to cast light on a quality that connects him, beyond the outward marks of civilization, to that enigmatic beast, the sense of the sacred.

CAT AND BIRD
1928, 73 *(Qu 3)*,
oil and ink on canvas,
mounted on wood, original frame,
38.1 × 53.2 cm (15 × 20.9 in.).
The Museum of Modern Art,
Sidney and Harriet Janis Collection, New York.

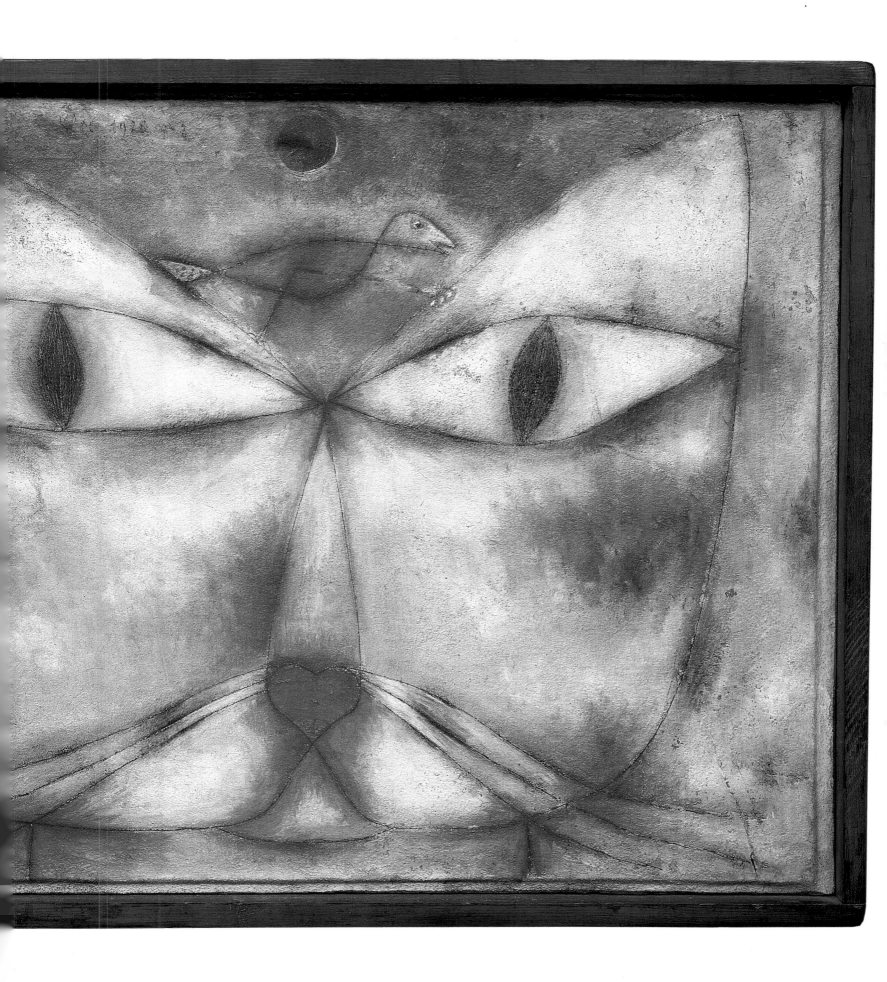

Paul Klee : *The Thinking Eye*
(extracts)

Let me use a parable. The parable of the tree. The artist has busied himself with this world of many forms and, let us assume he has in some measure got his bearings in it; quietly, all by himself. He is so clearly oriented that he orders the flux of phenomena and experiences. I shall liken this orientation, in the things of nature and of life, this complicated order, to the roots of the tree.
Seized and moved by the force of the current, he directs his Vision into his work.
Visible on all sides, the crown of the tree unfolds in space and time. And so with the work.
No one will expect a tree to form its crown in exactly the same way as its roots. We all know that what goes on above cannot be an exact mirror image of what goes on below. It is clear that different functions operating in different elements will lead to sharp divergencies. And yet some people would like to deny the artist the very deviations that his art demands. They have even gone so far in their zeal as to accuse him of incompetence and deliberate distortion. And yet all he does in his appointed place in the tree trunk is to gather what rises from the depths and pass it on.
He neither serves nor commands, but only acts as a go-between.
His position is humble. He himself is not the beauty of the crown; it has merely passed through him. [...]

The relation of art to creation is symbolic. Art is an example, just as the earthly is an example of the cosmic.
The liberation of the elements, their arrangement in subsidiary groups, simultaneous destruction and construction towards the

whole, pictorial polyphony, the creation of rest through the equipoise of motion: all these are lofty aspects of the question of form, crucial to formal wisdom; but they are not yet art in the highest sphere. A final secret stands behind all our shifting views, and the light of intellect gutters and goes out.

We can still speak rationally about the salutary effects of art. We can say that imagination, borne on the wings of instinctual stimuli, conjures up states of being that are somehow more encouraging and more inspiring than those we know on earth or in our conscious dreams. That symbols console the mind, by showing it that there is something more than the earthly and its possible intensifications. That ethical gravity coexists with impish tittering at doctors and priests.

For, in the long run, even intensified reality is of no avail. Art plays in the dark with ultimate things and yet it reaches them. [...]

The investigation of appearance should not be underestimated; it ought merely to be amplified. Today this way does not meet our entire need any more than it did the day before yesterday. The artist of today is more than an improved camera; he is more complex, richer and wider. He is a creature on the earth and a creature within the whole, that is to say, a creature on a star among stars. [...]

Everything (the world) is of a dynamic nature; static problems make their appearance only at certain parts of the universe, in 'edifices', on the crust of the various cosmic bodies. Our faltering existence on the outer crust of the earth should not prevent us from recognizing this. For we know that, strictly speaking, everything has potential energy directed towards the centre of the earth. If we reduce our perspective to microscopic dimensions, we come once more to the realm of the dynamic, to the egg and to the cell. Accordingly, there is a macroscopic dynamic and a microscopic dynamic. Between them stands the static exception: our human existence and its forms. [...]

In art, too, there is room enough for exact research, and the gates have been open now for quite some time. What was accomplished in music before the end of the 18th century has hardly been begun in the pictorial field. Mathematics and physics provide a lever in the form of rules to be observed or contradicted. They compel us – a salutary necessity – to concern ourselves first with the function and not with the finished form. Algebraic, geometrical and mechanical problems are steps in our education towards the essential, towards the functional as opposed to the impressional. We learn to see what flows beneath, we learn the prehistory of the visible. We learn to dig deep and to lay bare. To explain, to analyse.

We learn to look down on formalism and to avoid taking over finished products. [...]

Formalism is form without function. When we look round us today, we see all sorts of exact forms; whether we like it or not, our eyes gobble squares, circles, and all manner of fabricated forms, wires on poles, triangles on poles, circles on levers, cylinders, balls, domes, cubes, more or less distinct or in elaborate relationships. The eye consumes these things and conveys them to some stomach that is tough or delicate. People who eat anything and everything do seem to have the advantage of their magnificent stomachs.

They are admired by the uninitiated formalists. Against them the living form. [...]

From the cosmic point of view, movement is the primary datum, an infinite power that needs no extra push. In the terrestrial sphere matter obstructs this basic movement; that is why we find things in a state of rest. It is a delusion to take this earthbound state as the *norm.* The history of the work, which is chiefly genesis, may be briefly characterized as a secret spark from somewhere, which kindles the spirit of man with its glow and moves his hand. The spark moves through his hand, and the movement is translated into matter. [...]

Nature is full of ideas about colour. The world of plants and animals, mineralogy, the composition that we call the landscape; all give us something to think about and to be thankful for. But there is one colour phenomenon that rises above all the rest as a symbol of all use of colour, all mixing and blending of colours. As far as its purity of colour goes, we may call it abstract. I am referring to the rainbow. Quite significantly, this exceptional phenomenon, this pure colour scale is to be found not on the earth but in the atmosphere, the intermediate realm between earth and outer cosmos. We may therefore expect it to have a certain degree of perfection, but, since it is only half-transcendent, not yet the highest.

But here again our creative faculty enables us to transcend the inadequacy of appearances and to arrive at a synthesis, at least, of transcendent perfection. We assume that what comes to us only imperfect as appearance exists somewhere without any imperfections; the artist's instinct in us must help us conceive the form of this flawless state.

Biography

Paul Klee was born into a family of musicians on 18 December 1879, near Bern. His father was of German origin; a formidable and remarkable pedagogue, he taught music at the cantonal teacher training college. Paul displayed a precocious talent for the violin and played in the municipal orchestra even before graduating from the *Literarschule.*

After graduating, he went to Munich in 1898 to study painting. He spent 1901-1902 in Italy. From 1902-1906 he continued his art school studies at Bern. He made his first trip to Paris in 1905. In 1906, Klee married the pianist Lily Stumpf, the daughter of a Munich doctor, and settled in that city. Lily was to subsidize the household for ten years by giving piano lessons. It is at this time that Klee discovered the work of Van Gogh, then that of Cézanne, the "master par excellence".

In 1911, he met Kubin, Jean Arp and some of the artists of the *Blaue Reiter* school – Kandinsky, Marc and Macke – and developed a passion for Delaunay's paintings. He made a second journey to Paris to visit Delaunay, and translated Delaunay's text 'Light'. In Paris he got to know the avant-garde galleries.

In the spring of 1914, a three-week trip took him to Tunisia in the company of the painters Moilliet and Macke. That journey marks a crucial turning point in the development of his art. Klee was, however, mobilized between 1916 and 1918.

His reputation was consolidated after the war. In 1920 he was appointed a professor at the Bauhaus, which Walter Gropius had founded at Weimar in 1919 (Kandinsky was appointed to a teaching post there in 1922). In 1925, the Bauhaus was transferred to Dessau. In the same year, Klee took part in the first Surrealist Exhibition in Paris, and his first solo exhibition took place at the Vavin-Raspail gallery.

In 1929, he journeyed to Egypt. In 1931, he left the Bauhaus for the Düsseldorf Academy of Fine Arts. Two years later he was dismissed after pressure from the Nazis.

Shattered by this, Klee took refuge in Bern, his native city. However, his health declined rapidly. In 1935, he was struck down for the first time with scleroderma. In 1937 Braque and Picasso travelled to Bern to visit him. Those works by Klee in German public collections were confiscated; seventeen of them featured in the exhibition of 'Degenerate Art' at Munich.

In 1940, the Zurich Kunsthaus put on an exhibition of Klee's post-1935 work.

On 29 June 1940, Paul Klee died from paralysis of the cardiac muscle. He was buried at the Schlosshalden cemetery in Bern.

Bibliography

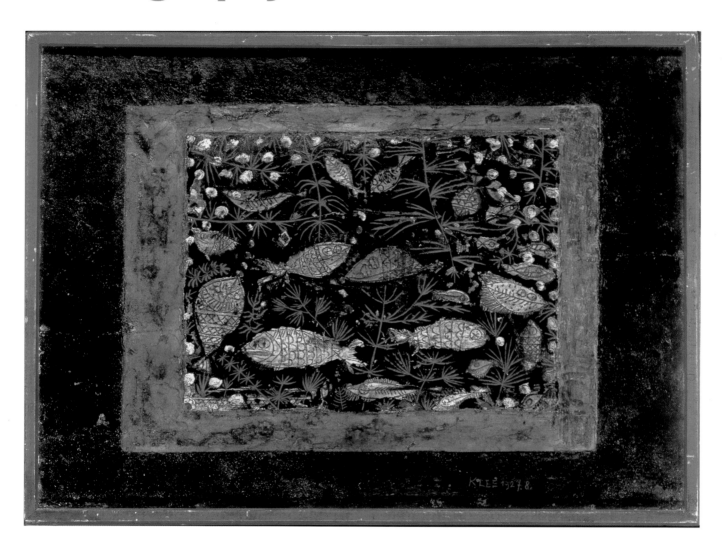

THE AQUARIUM
1927, 8,
oil and gesso on board,
mounted on wood,
original frame,
35.5 × 49.5 cm
(14 × 19.5 in.).
Private collection.

Klee's own writings

- *The Diaries of Paul Klee 1898-1918*, University of California Press, Berkeley/ Los Angeles/London, 1964.
- *Notebooks. Volume 1: The Thinking Eye*, Lund Humphries, London, 1961.
- *Notebooks. Volume 2: The Nature of Nature*, Lund Humphries, London, 1961.
- *Pedagogical Sketch Book*, Faber and Faber, London, undated.

Principal works on Klee

- Christian Geelhaar: *Paul Klee and the Bauhaus*, Adams and Dark, Bath, 1973.
- Will Grohmann: *Paul Klee*, Lund Humphries, London, 1956.
- Will Grohmann: *Paul Klee (The Library of Great Painters)*, Harry N. Abrams, New York, undated.

Photo credits

AKG photo, Paris: pp. 56, 106, 120, 122-123, 125, 126, 139, 205.
Artephot, Paris: pp. 44, 81 (R. Perrin). Artothek, Peissenberg: pp. 14-15, 51, 64, 112, 178, 187, 194 (H. Hinz); pp. 16, 35, 48, 50, 52, 206 (Christie's); p. 54 (Bayer et Mitko); p. 75 (J. Blauel). Bildarchiv P. K., Berlin: p. 42. Collection A. Rosengart, Lucerne: pp. 33, 142, 143, 154. Paul-Klee-Stiftung, Kunstmuseum, Bern: cover and pp. 2, 5, 10-11, 17, 18-19, 21, 22-23, 24, 25, 28, 29, 32, 38-39, 45, 46-47, 53, 60-61, 68-69, 72-73, 77, 79, 80, 83, 85, 91, 93, 96-97, 102, 105, 108-109, 111, 116, 118-119, 124, 129, 130, 136-137, 140, 146, 149, 150, 155, 157, 158, 161, 163, 166, 167, 169, 170, 174, 175, 177, 180, 181, 182, 183, 188-189, 190-191, 195, 197 (P. Lauri). Lenbachhaus, Munich: pp. 26, 59, 135. Kunsthalle, Hamburg: pp. 114-115 (E. Walford). Kunstsammlung Nordrhein-Westfalen, Düsseldorf: p. 164 (W. Klein). The Metropolitan Museum of Art, New York: pp. 6 (1986), 13 (1984), 71, 145 (1986). Musée national d'art moderne, Centre Georges-Pompidou, Paris: pp. 62, 193 (P. Migeat), 101. Museum Folkwang, Essen: pp. 88-89. The Museum of Modern Art, New York: pp. 30, 36, 63, 98, 156, 162, 199. Öffentliche Kunstsammlung, Basel: pp. 31, 41, 66, 74, 90 (M. Bühler). Sprengel Museum, Hanover: pp. 152, 184 (M. Herling), 173. Staatliche Museen zu Berlin/Preussicher Kulturbesitz Nationalgalerie, Berlin: p. 94 (J. P. Anders).

© ADAGP Paris, 1998.
© Schwabe & Co Verlag, 1999, *Das Bildnerische Denken*, Bâle/Stuttgart, Jürg Spiler, third edition 1971.

Acknowledgements

Éditions Pierre Terrail would like to thank the staff of the Paul-Klee-Stiftung of Bern, particularly Frau Heidi Frautschi and Herr Michael Baumgartner for their kind assistance.